D1131823

Semiotics and Lighting

**A Study of
Six Modern French Cameramen**

Studies in
Photography and Cinematography, No. 2

Diane M. Kirkpatrick

Associate Professor, History of Art
University of Michigan

Other Titles in This Series

Semiotics and Lighting

A Study of
Six Modern French Cameramen

by
Sharon A. Russell

RESEARCH PRESS

V. S. W.
Gift of the publisher
May 2, 1984

Produced and distributed by
UMI Research Press
an imprint of
University Microfilms International
Ann Arbor, Michigan 48106

Library of Congress Cataloging in Publication Data

Russell, Sharon A., 1941-
 Semiotics and lighting.

 (Studies in photography and cinematography ;
no. 2)
 "A revision of the author's thesis, Northwestern Univer-
sity, 1978."
 Bibliography: p.
 Includes index.
 1. Cinematography. 2. Cinematography–Lighting.
3. Semiotics. 4. Cinematographers–France–Interviews.
I. Title. II. Series.
TR899.F87 1981 778.5'343 81-3377
ISBN 0-8357-1189-7 AACR2

What we see, we see
and seeing is changing

the light that shrivels a mountain
and leaves a man alive

Heartbeat of the pulsar
heart sweating through my body

The radio impulse
Pouring in from Taurus

 I am bombarded yet I stand

I have been standing all of my life in the
direct path of a battery of signals
the most accurately transmitted most
untranslatable language in the universe
I am a galactic cloud so deep so invo-
luted that a light wave could take 15
years to travel through me And has
taken I am an instrument in the shape
of a woman trying to translate pulsations
into images for the relief of the body
and the reconstruction of the mind.

Adrienne Rich, "Planetarium"

Acknowledgments

Of the many people who helped me with this study, I would especially like to thank the six men—Nestor Almendros, Ghislain Cloquet, Henri Decae, Willy Kurant, Jean Rabier, Edmond Richard—who gave so generously of their time, often interrupting their own work to be interviewed. I would also like to thank Peter Wollen who provided direction at the beginning when it was needed, and the Northwestern University Graduate School whose grant helped in the transcription of the interviews. And of course there is no way to acknowledge the help and encouragement of my friends and especially of my parents.

A shorter version of the interviews has been published as "Conversations with Cameramen" in *Film Reader* 2 and an abbreviated version of Chapter 3 has appeared in the *Second Purdue Film Annual*.

Contents

1

Introduction:
Style and Cinematography

The film is an infernal machine. Once it is
ignited and set in motion, it revolves with
an enormous dynamism. It cannot pause.
It cannot apologize. It cannot retract
anything. It cannot wait for you to under-
stand it. It cannot explain itself. It simply
ripens to its inevitable explosion.

Christopher Isherwood, *Prater Violet*

The importance of cinematography to the general style of a film has long been recognized, but while certain theoretical approaches have been developed or are being explored to deal with some of the key figures in the filmmaking process, namely directors and writers, there have been no attempts to deal with the style of the visual image as a function of the role of the cinematographer. In general the entire concept of style has presented problems in all areas of expression. In film this problem has been magnified both by the nature of the creative process and the lack of any unified theoretical approach to film study. The first part of the theoretical section of this study reviews approaches to style in general and those few statements made about film style. But ultimately new ways of dealing with this problem must be found. This study proposes an approach for isolating one aspect of the larger problem by dealing specifically with the stylistic contribution of the cinematographer recognizing that this is but part of the whole—not the royal road to the golden city of stylistic solutions, but a small path through the forest of theories. In fact, the role of the cinematographer is ideal for a new approach to stylistic study precisely because it has been ignored for so long. That weedy undergrowth which persists in trapping so much of film theory has never really taken hold in this area. Except for the occasional interview, even the role of the American cinematographer has never attracted the attention of the errant auteurist off on a new quest. And recent explorations of the image deal with the problems of reproduction and not with those responsible for its creation. Meanwhile, as Rabier describes it in discussing his work with Chabrol,

> And then everybody disappears. . . . Well, I find myself with the electrician. Sometimes, the cameraman is there, not always. And I light, that's to say I begin. . . . I light, I light, peacefully, alone with my electricians, no one bothers me. They don't come to push, to tell me to hurry up. I don't see anyone.

The cinematographer's importance has long been recognized; it must now be analyzed and defined.

Individual and Context

The postwar French cinema, especially that of the late fifties to the present, is a cinema in flux, a cinema in revolt against accepted standards. Often such moments of change which call into question accepted stan-

dards can, through their very opposition to the norm, clarify both old and new. For tradition to be questioned it must first be defined; a rejection of the status quo implies a prior recognition just as absence implies presence. A stylistic study of any aspect of this period must tacitly acknowledge the classical tradition which preceded it. And in such a confrontation it is often easier to disentangle important stylistic differences which are foregrounded precisely because they are being challenged. In the same way, the absence of traditional narrative structures in the American independent cinema foregrounds Hollywood's insistence on cohesive narratives.

The changes which have taken place in the recent French cinema are the result of a complex interplay of forces—economic, aesthetic, and technological—which have affected film production on an international scale. Thus even though there have been similar challenges to accepted patterns in the past, few have had such an enduring influence as those generated in postwar France. The Italian neo-realist movement, while important for a few years, had about as lasting an effect on its country's film production as did the Free Cinema movement in Britain. In France, however, the early developments have already been assimilated into film culture in general (to the extent that many of the early films have completely lost their shock value for the audience), while many of the early adherents have continued to experiment and develop so that they consider their early work so traditional that it too must be attacked.

Within this context six cameramen have been chosen, both as individuals and as representatives of certain backgrounds and approaches: Henri Decae, Ghislain Cloquet, Willy Kurant, Nestor Almendros, Jean Rabier, and Edmond Richard. They all began their active careers after World War II, although Decae did some amateur work during the war. They have all been associated with at least one area of change (aesthetic, economic, technological) occurring during this period. And by their own statements they present remarkably similar attitudes toward their work and toward a theoretical conception of their role in a film. While stylistically they operate as examples of a specific approach to filmmaking, even as individuals they represent different aspects of the French film industry. Decae, the oldest and perhaps the best known of the six, began his feature film work with a director who was himself a rebel and was one of the principal heroes of the New Wave, Jean-Pierre Melville. Decae is also closely associated with the New Wave and filmed the first films of both Claude Chabrol and François Truffaut. Many of his assistants have gone on to become cinematographers and directors. Alain Levant began as Decae's assistant, moved on to head his own crew, and now has become a director. Rabier, too, was associated with Decae, and they both talk

about their relationship. Rabier moved up in Decae's crew and then took over as Chabrol's cinematographer. This relationship between assistant and chief is quite common in the French cinema, and the Decae-Rabier association is just one example of it.

Cloquet is the clearest example of those people who began their careers working with emerging directors on short films and who then moved to features with these same directors. Sacha Vierny (Alain Resnais's cinematographer) worked with Cloquet on several shorts and is another example of this approach to filmmaking. Decae and Cloquet have the widest range of work experience outside of France. Their careers indicate the extent to which foreign directors are aware of its particular attractions. Cloquet's later association with Robert Bresson is similar to that of Decae with Melville in that Bresson is another postwar director also greatly admired by the younger French filmmakers. Cloquet, who was born in Belgium, shares this birthplace with Willy Kurant, and these two, along with Almendros, are also indicative of the way in which the modern French cinema has attracted people interested in experimentation who want to work outside the constraints of the normal studio situation, and who want to have more freedom in the way they work.

Willy Kurant began as a news photographer developing those skills which would allow him to shoot in situations normally considered too difficult for the feature filmmakers with a 35mm camera—streets, cafes, interiors, exteriors during normal business periods—without being observed, without creating a special situation where people other than the actors would play to the camera. Shooting in these kinds of situations was, of course, one of the distinguishing characteristics of many early New Wave films, especially those photographed by Raoul Coutard. Coutard also began his career as a news photographer, and so it was very natural for Godard to turn to Kurant, a man with a similar background. Kurant insists that he wishes to maintain a certain kind of integrity in the films that he photographs. In statements made during the interview in Chapter 7, he suggests that the situation in France has changed recently, that filmmaking has become more commercial, that it is harder to find interesting projects. In recent years he has turned to the filming of commercials, where he feels that there is still room for experimentation. He privately confided that he had been one of the cinematographers considered for Robert Altman's *Thieves Like Us*, but the deal had not worked out because of problems with salary. (Jean Boffety got the job.) Although he has never worked in the United States, Kurant has worked on a certain number of American productions shot in Europe.

Almendros, who was born in Spain, really started his career in the United States. His family moved to Cuba after the Spanish civil war, and

then, during Batista's rule, they came to the United States. As he indi-
cates in his interview, he grew up with an interest in film which gives him
a background similar to that of the New Wave directors with whom he
would eventually work. He also has certain ties to the United States. His
real interest in filming began when he lived here, and he taught and
worked here after leaving Cuba. Recently he filmed *Cockfighter (Born to
Kill)* for Monte Hellman. His appreciation of the history of film helps him
articulate his concept of the role of the camera in film. He sees lighting
not just in terms of today but also in terms of the past, looking for ways
to recreate and reinterpret the old masterpieces like those of Dreyer while
avoiding the mannerism of the sound period. Almendros's work with Eric
Rohmer in television has given him a background which makes him also
representative of those cinematographers who work in both media, com-
bining the advantages of each in the final image.

Although he has not been a director of cinematography until re-
cently, Edmond Richard has a long-standing relationship with the more
technical aspects of filmmaking. In his interview he details the process
by which he moved from aeronautical engineering to photography. It is
amazing to realize that he pioneered the development of light meters in
the fifties and then had to fight for their acceptance by the professionals
who were afraid that machinery would take over their jobs. He instead
indicates that the light meter was actually a liberating force which elim-
inated the guesswork involved in lighting. He also worked as a color
consultant, again attempting to solve the technical problems which would
leave the cinematographer free to make artistic decisions. But as this idea
never gained the kind of acceptance in Europe that it did in the United
States where Technicolor technicians were a virtual requirement, he moved
more and more closely into the actual *prises de vues*, the filming. His
first feature effort is a tour de force of the cameraman's art, *Le Procès*,
done for one of the most demanding directors in existence, Orson Welles,
who must also be one of the most exciting to work with, as both Kurant
and Richard indicate.

These man were interviewed in the spring of 1973 in Paris. They
represent remarkably similar attitudes toward their work and toward a
theoretical concept of their role in a film. They all reject the attitude of
self-promotion, the immediate identification of a specific, identifiable style,
which is associated with the traditional Hollywood cameraman. They
counter the imposition of a single style with an attitude of accommoda-
tion, of collaboration with the director. Thus the interviews would almost
seem to run counter to the aims of the study. But, of course, it has long
been the job of the analyst, the critic, as opposed to the creator, to eval-
uate and interpret the statements of the artist. Actually the very rejection

of a style as an approach is a valuable clue to the stylistic development of these men. The interviews also present insights into their working methods. Unlike the more rigid Hollywood union structure with its army-like chain of command (the director of cinematography deals with the camera operator who deals with the focus puller who relays the command to the clapper-loader) in France the cinematographer is freer to participate in as much or as little of the actual filming process as he wishes. In the interviews each man delineates his role, the extent to which he actually operates the camera, participates in the framing of the scene, or occupies himself exclusively with the lighting of a shot. As this participation varies from man to man, on a practical level it was necessary to limit stylistic analysis to the one area which they all controlled—the lighting of the shot.

Semiotics and Lighting

While the interviews indicate that the lighting of the shot is the one constant for the French cinematographer, the necessity for isolating this one aspect of the visual style of the film supersedes mere practicality. One of the major problems in what might be termed traditional film criticism has been to find ways of applying the classical aesthetic of the artist as creator to the essentially collaborative nature of the feature film—to validate film studies by reinserting them into accepted critical modes. Auteur studies were a means of demonstrating to the world that the cinema has its creative geniuses, its artists. However, aside from the fact that every auteurist film critic is constantly confronted with the problem of collaboration presenting her/him with a set of variables which must be juggled with a dexterity usually confined to the circus, the literary model which had been adopted was itself defective. English literary criticism, which had only recently escaped from the "lives of the poets" approach of the late nineteenth century and had just passed through the cleansing asceticism of the new critics which reintroduced notions of style, had not yet developed the critical tools for dealing stylistically with concepts of authorship. The isolation and identification of recurring thematic structures became the major tool of the scholar of English literature, and this approach was quickly adapted to cinema studies by scholars who had often received their training in literature departments. While these thematic approaches certainly validate claims for the cinema as a serious area for study and are necessary for an understanding of the artist, they cannot provide solutions for certain aesthetic problems.

 While many film theoreticians have concerned themselves with the nature of the medium itself, the *how* rather than the *what* of film com-

munication, it is only recently that attempts have been made to deal with this area systematically. But even those semiotic studies which treat most directly the nature of film as a communication system concentrate on the narrative. Because the original model for semiotics is language itself, it is only natural that film semiotics deal with the narrative, that which is communicated, or the form of the communication—the relationship between sender, receiver, and message.

In this absorption with narrative structures, the very means of transmission of these structures is often neglected. The image becomes secondary to its organization into narrative. Of course the subordination of image to diegesis is one of the identifying traits of the classical (i.e., Hollywood) cinema where nothing is allowed to intrude on the onward motion of the film. Perhaps it was the very recognition of this problem that led to the mannered work of certain Hollywood cinematographers on one hand and to the development of the "studio look" of certain films on the other. What emerged was not a true style—an interaction between form and content—but a set of stylistic quirks which could be applied to any situation. Aside from these impositions of "stylistic" qualities on the image, its very unobtrusive quality, its "invisibility," aided in its dismissal from early semiotic analysis. Christian Metz's Bazinian, realistic bias has often been noted, and Metz retained the attitude that the image as a reproduction of reality has no connotational import. It was only with the work of Umberto Eco that the image in general began to have some significance for semiotics.

There has been no concerted effort in the field of semiotics to take into account the actual creation of the image. An analysis of the complex set of variables which transform the profilmic into filmic leads to an understanding of the primary role that lighting plays in the transmission of all filmic codes. However, such an analysis can also lead to the isolation of those elements of the projected image which can be considered from the stylistic perspective. The creation of a semiotic model points out the previously denied areas where lighting can be considered on a denotative as well as connotative level—that is, at the level at which style is generally considered to operate. Such a model also provides the direction necessary for the isolation of certain style markers which can then form the basis of a stylistic analysis along lines suggested by the application of stylolinguistics to literary criticism.

Summary

This study originally started with the rather innocent idea that since so many critics refer directly to the work of the cinematographer and to

her/his style, the role of the image and its stylistic import in the work as a whole should be assessed. A certain initial familiarity with the modern French cinema provided the focus for these investigations. The first blow to my innocence came with the discovery that words such as 'style' and 'stylistic analysis' were, as far as film went, terms without substance. As my discussion of these terms indicates, it was only after an exploration of the treatment of this terminology in other fields and finally in stylolinguistics that I was able to find a method of investigation which would deal directly with the image as a visual communication rather than as a transport for the diegesis. The evidence accumulated from the interviews with the cinematographers helped isolate those aspects of the creation of the image over which they, and only they, always had complete control. Before I could apply stylolinguistic principles to lighting, however, I had to discover a signifying structure in the lighting process which would open it to systematic analysis.

I felt that the only area of film studies which would provide the direction was the relatively unexplored application of principles of semiotics to this field. Once I had analyzed lighting and placed it within this context I then returned to the application of stylolinguistic techniques, the isolation of style markers. While those markers which are eventually isolated might actually have been found through direct observation, it was only through the application of techniques suggested in the Nils Enkvist study that I was able to deal systematically with what had been up to that point mere personal observation.

As the conclusions reached in my study indicate, the stylistic analysis supports the original contentions of the cinematographers as presented in their interviews: the conscious affectations of style are absent in their work. But this absence is itself a presence. Their work is a part of a larger revolt against the established norms. Even when viewed from the short historical perspective of the seventies, the major trends of the period are clear. While critics associated with the New Wave provided a context and a justification for the revolt, its actual effects spread beyond the confines of their aesthetic. One of the major stylistic forces in the extension of this reaction against established norms to directors outside the original *Cahiers du Cinéma* group was the work of the cinematographers. As these men moved from work with the New Wave to other films, the visual style associated with the New Wave moved with them. Of course, it is not easy to determine the original reasons for their selection by other directors. Financial as well as aesthetic criteria may have provided the initial motivation. Nevertheless, by the end of the sixties the effects of their stylistic innovations could be seen as far away as Hollywood—the object of the original revolt—where they were being assimi-

lated into the style of the "new" Hollywood. As a result of this assimilation, it is only by returning to the perspective of the classical Hollywood tradition (the thirties, forties, and fifties) that the extent of the transformation they have caused can be measured. While films are still being made in the classical mode, the atmosphere created by the work of these men has at the very least validated experimentation with lighting. Ultimately the true value of their accomplishments does not lie in a kind of "measurable influence" on present techniques, but rather in the real achievements of the films that they have made and continue to make, and most of all in those great collaborative efforts where they join their talents to those of great directors to create lasting works of art.

2

Lighting and Style:
The Tradition Re-evaluated, The Present Explored

The true picture of the past flits by. The past can be seized only as an image which flashes up at the instant when it can be recognized and is never seen again. "The truth will not run away from us"; in the historical outlook of historicism these words of Gottfried Keller mark the exact point where historical materialism cuts through historicism. For every image of the past that is not recognized by the present as one of its own concerns threatens to disappear irretrievably.

Walter Benjamin, "Theses on the Philosophy of History"

The Past: Theoretical Approaches to Lighting

Light forms the image; light transports it to the camera, and to the screen, which reflects it back to the audience. But the very properties of light often remove it from the world of the critic to that of the physicist. While scientists have dealt with its physical properties, in film at least, critics have seldom dealt with its aesthetics. Too often problems of lighting are left either to the technicians who must deal with them practically, or to the historians who chronicle the changing relationship between advances in technology and their general acceptance in the classical cinema of Hollywood and its imitators. There are no critical schools supporting opposing approaches to light; no high-key versus low-key advocates.

Perhaps one of the reasons for the absence of a theoretical investigation of changing patterns of lighting is that these alterations have an ironically low "visibility" when compared with such radical transformations as that from the silent picture to the talkies. Even such processes as color and wide screen did not alter the industry as completely as did the advent of sound technology. One of the major reasons for the immediate impact of sound is its importance to the narrative, the overriding concern of what has been called the dominant cinema, the classical cinema. Color and wide screen processes become more and more "visible" when they directly affect the diegesis (the color red in *Marnie*, the deliberate use of black and white in *The Last Picture Show*, the relationship between the epic and the wide screen). It is at this point that they also attract theoretical attention. Color becomes the provenance of the filmmaker-theoretician, while wide screen becomes part of the debate between montage and long take.

Laszlo Moholy-Nagy, an artist and still photographer, has summarized some of the basic problems which must be dealt with if one is to discuss problems of light. Many of his questions properly belong in the fields of the physical sciences such as optics, but they do indicate the kinds of questions that can be asked once light becomes the subject of an inquiry no longer subordinate to the narrative.

> Minimum demands of knowledge in field of optical expression
> What is the nature of light and shade?
> of brightness—darkness?
> What are light values?
> What are time and proportion?
> New methods of registering the intensity of light

the notion of light?
what are refractions of light?
what is colour (pigment)?
the chemical nature of colour and effective light?
is form conditional on colour? on its position in space?
on the extent of its surface area?
biological functions?
physiological functions?
statics and dynamics of composition?
Spraying devices, photo and film cameras, screens?
the technique of colour application?
the technique of projection?
Specific problems of manual and machine work?[1]

While some of these questions relate directly to Moholy-Nagy's interests and while many remain unanswerable, they still indicate the wide range of investigation necessary before all of the functions of light can be understood. Moholy-Nagy's first few questions deal with physical properties (physics), but he is also concerned with perception (psychology, communication theory) and interaction between artist and machine (philosophy, aesthetics).

Sergei Eisenstein was one of the first to relate the theoretical implications of light directly to film. He was aware of the effect of light in the formation of the image but was really only concerned with it as an adjunct to other means of structuring the image. The relationship between light and shadow became one means of ordering the visual impact of the frame. Within the conflict which formed the basis of montage he saw conflicts of volumes and conflicts of masses, which are defined as volumes filled with various intensities of light. Eisenstein categorized the light/shadow conflict among those "requiring only one further impulse of intensification before flying into antagonistic pairs of pieces," and called them "pieces of darkness and pieces of lightness."[2] He wanted to assimilate lighting into a general theory of montage that would cover all aspects of cinematic expression.

One of his most direct statements about light suggests a possible dichotomy as clear as that between montage and long-take:

> And similarly with the theory of lighting. To sense this as a collison between a stream of light and an obstacle, like the impact of a stream from a firehouse striking a concrete object, or of the wind buffeting a human figure, must result in a usage of light entirely different in comprehension from that employed in playing with various combinations of "gauzes" and "spots."[3]

This statement seems to suggest an opposition between a harsh realistic approach and the beautification and softening seen in Hollywood. But

Eisenstein was more interested in the action of light masses within the frame than in the creation of an aesthetic for light which would control all cinematic expression. In practice, he advocates the use of either method to achieve the desired results. In his description of the cream separator sequence in *Old and New* he shows how a nonrealistic lighting supports the cutting and adds to the tension. "Furthermore, this is sharply emphasized by light-illumination in no wise conforming to actual light conditions. This brings a distinct strengthening of the tension."[4]

Aside from a few "how to" books such as *Painting with Light* by John Alton or the expansion of Eisenstein's ideas in *The Cinema as a Graphic Art* by Vladimir Nilsen, there are few other texts that deal directly with lighting problems. Joseph von Sternberg does devote a chapter of *Fun in a Chinese Laundry* to this problem. As might be expected, his style, tone, and concepts are diametrically opposed to those of Eisenstein. Eisenstein's involvement is with the theoretical process; Sternberg approaches these considerations from the point of view of the artist. While Eisenstein attempted to reconcile his Marxism with his art, Sternberg believed in the dominance of art over all factors in film. Essential to his conception of art was the role of lighting.

> The proper use of light can embellish and dramatize every object—and that carries us into the province of the artist. The artist's duty and function is to imprison not so much that which he can perceive but that which his skill and imagination can endow with force and power, no matter what the nature of the subject may be. The artist who uses film as his medium must learn to behold and to create, not with the camera but with the eye.[5]

Light for Sternberg was as essential an aspect of the creation of the artistic vision as pigment was to a painter.

Two examinations of lighting in *Screen* by Patrick Ogle and Peter Baxter[6] have done much to illuminate the historical development of certain lighting techniques. This kind of perspective forms an important part of the context for the evaluation of developments in a given period. But as with the earlier theoretical explorations they do not provide a clear direction for any theoretical or aesthetic assessment of the role of light in the general style of a film or of an individual style in a body of films.

Of course, the introduction of the term "style" poses even larger questions for film study. If there seems to be a dearth of information about lighting, this absence extends even more broadly to all considerations of style in the cinema. In the extremely specific field of lighting style, only one work, that of Vladimir Nilsen, approaches this topic.

The Past: Some General Approaches to Style

There are endless critical works that attempt to define style. Everyone seems to agree that this quality exists, but there is little agreement on how to define it or how to isolate it from other qualities in a work. The collaborative nature of most feature film production further complicates this already involved subject. The controversy over the true authorship of *Citizen Kane* is a debate about style: Orson Welles versus Herman Mankiewicz. Most film scholars who deal with style see it as a collection of recurring themes or motifs, an approach which is not helpful in dealing with lighting where style must be divorced from certain kinds of meaning if the contribution of the cinematographer is to be evaluated. A survey of critical approaches to the general problem of style can serve to isolate those areas where closer examination might prove fruitful, but few of these critics actually provide a methodology for the application of their principles. For the actual methodology, other means of stylistic inquiry must be employed.

In a brief essay (omitted from the revised edition of *Signs and Meanings in the Cinema*) Peter Wollen outlines some of the problems in dealing with the term style. Wollen sets up what he considers to be "a very elementary typology of styles." He divides these into four main categories.

> There are those which are individual and those which are collective, on the one hand, and, on the other hand, those which are conscious and those which are unconscious. Of course, none of the four possible combinations can exist in a pure form; this typology is only designed to clarify somewhat the ways in which people talk about style.[7]

One of the most important points to be derived from this series of possible oppositions and combinations is the possibility of a collective as well as an individual style. Its most obvious application would be in the study of such concepts as the "MGM style" or the "classical style"—that is, an examination of historically recognized composite entities. Such a term can also serve to suggest that certain constants exist in the work of people defined as a group such as modern French cinematographers. The conscious versus unconscious distinction can also clarify the difference between the active decision to maintain a certain kind of style within a studio such as MGM, and the unconscious selection of similar working procedures which may actually produce a similar effect. In *Principles of Art History*, Heinrich Wolfflin suggests an important adjunct to the idea of a collective style. "That is to say: to the personal style must be added *the style of the school, the country, the race*."[8] While Wolfflin certainly

recognizes that individual differences exist, he indicates the need for also describing the kind of context within which the artist operates.

So far these definitions have been purely descriptive. However, some critics feel that style should be evaluated—that distinctions should be made between good and bad styles. The major problem in using Vladimir Nilsen's work as the starting point for any discussion of lighting style is its prescriptive nature.

> An aggregate of methods emerges as an independent style and forms an integral system wherever the unity of compositional principles is combined with the unity of the functional treatment of the shot, wherever formal and technical method is recognized as a means of effecting ideological influence, and finally, wherever there is successive logical development and transition of the film composition as a generalising element into the compositional forms of the various shots. The formal methods of 'graphicality' or 'pictorality' are only essential marks of style when they express a peculiarity and distinctive character in the perception of the world, when they are the product of a definite emotional and intellectual treatment of life. Only under such conditions do we get an organic artistic production, with expressive resources organised as a unity in treatment of the content through a definite style.[9]

While Nilsen is still dealing with individual style, his definition requires the integration of fully expressed (conscious) ideology. He also expresses an idea common to many critics—that of the value of organic unity.

The form/content relationship suggested by Nilsen often forms the basis of a judgmental attitude toward style—the only good style is a unified style. In her essay "On Style," Susan Sontag argues for the indivisibility of form and content. But these divisions are not essential for a definition of the term.

Roland Barthes in *Writing Degree Zero* sets up a tripartite relationship in which style is part of the individual unconscious. "A language is therefore on the hither side of literature. Style is almost beyond it: imagery, delivery, vocabulary spring from the body and the past of the writer and gradually become the very reflexes of his art."[10] Language establishes the limitations or parameter within which the individual must operate. As such, language becomes part of the historical, but not part of the unconscious. Barthes calls these areas in which choice exists *écriture*, "writing." Writing is a moral form, "a choice of that social area within which the writer elects to situate the nature of his language."[11] As it too partakes of the historical, this definition amplifies Wolfflin's concept of school, country, or race. While school may be an option like 'writing,' race or country are closer to the given of language. In some ways, Barthes's presentation of language functions like light in the work of the cinematographer. Light is the "given," the set of parameters within which one must operate. Choice lies within these parameters but not beyond them.

All of these theoretical explorations of style help to define the term, and help to establish those approaches which might be of most use in the examination of the more specialized problem of lighting and style. The relationship between the individual and group, between individual and social and political context, the necessary de-emphasis of usual uses of content, the connections between conscious and unconscious traits, must all be considered in applying this term to lighting. Most suggestive, though, is the possible comparison between language and lighting. Recent work in stylolinguistics suggests a possible means of furthering this analogy.

The Present: An Introduction to Stylolinguistics

In his essay "On Defining Style"[12] and his book *Linguistics and Stylistics*[13] Nils Enkvist establishes a basic approach to stylolinguistics. In the essay he proposes a basic definition which is then amplified in the book. He begins with an analysis of classical approaches to style. This analysis is important because it not only exposes the weaknesses inherent in certain systems, but also because it deals directly with problems of methodology which enables Enkvist to propose his own system as a solution to the inadequacies of the other methodologies. Enkvist is, of course, dealing with a stylistic analysis of literature, and literature is part of the larger communication system of language. But once lighting is placed in a similar communication system (semiotics), his basic methodology can be applied.

Enkvist begins his essay by classifying style in two general ways. The first is based on the various stages of the communication process: the sender, the message, and the receiver. The sender is the writer; this category would include all definitions of style made by the writer (sender). The writings of Eisenstein, Nilsen, and Sternberg, as well as interviews by cinematographers, would all be a part of this category. Those approaches which deal with the message attempt to objectify and identify stylistic features in the text. Meanwhile, those which are presented from the point of view of the reader (receiver) are largely subjective, based on the insights that the reader brings to the text. As Enkvist indicates, these approaches do not usually exist in isolation.

Enkvist then points out that another major distinction that can be made is between those approaches to style which are based on objective evidence within the text, and those which are based on subjective impressions taken from the text. From his point of view subjective transformations are not useful. One of the aims of his work is to aid the foreign language teacher, and it is easier for a student to deal with objectively verifiable criteria. In a sense lighting can be compared to a foreign lan-

guage. Most people must learn how to really see the differences, and the establishing of objective criteria helps in the achieving of quantitative results. Enkvist begins to build his own definition of style on evaluation of six descriptions of the term:

[1] style as a shell surrounding a pre-existing core of thought or expression; [2] as the choice between alternative expressions; [3] as a set of individual characteristics; [4] as deviations from a norm; [5] as a set of collective characteristics; [6] and as those relations among linguistic entities that are statable in terms of wider spans of the text than the sentence.[14]

As Enkvist indicates, the first two descriptions, style as addition and style as choice, allow for the possibility of a styleless text, the existence of "prelinguistic thought or prestylistic expression."[15] If style is considered as addition, there is the added difficulty of the possibility of the form/content split. With style as choice the problem becomes the definition of the area in which the choice exists. Selection can be broken down into three areas, according to Enkvist: grammatical, nonstylistic, and stylistic. The grammatical choice is easy to distinguish because it is the difference between the possible and the impossible. But as both nonstylistic and stylistic choices depend on optional selections it is harder to differentiate between them. This difficulty can be seen in the examples he presents. In the choice for x in x *loves Mary*, the substitution of *to eat* for x is not a possible grammatical choice. But the choice in the substitution of *John* or *Peter* for x must be resolved on the basis of nonstylistic considerations rather than grammatical ones. Such choices are based on truths beyond the linguistic framework of the utterance. But there are areas in which it is difficult to distinguish between a stylistic and nonstylistic entity, differences which involve meaning and context. In the example cited from Professor Hockett, *Sir, I have the honor to inform you* and *Jeez, boss, get a load of dis*, on one level the information carried by the statements is the same. But the contexts suggested by the two utterances are entirely different. Therefore, it is difficult to define stylistic and nonstylistic in this context without reference to meaning.

Enkvist's next three descriptions all deal with ways of categorizing stylistic features in relation to the text. The first of these is an attitude which deals with individual characteristics exclusively—the style is the man. He feels that one should not deny the individual characteristics in a style, but that an approach which is based entirely on this attitude encounters certain problems. First, many times what is considered an individual style may actually contain many attributes of a shared style. With a writer of great originality it is possible to identify through fre-

quency counts, etc., his individual characteristics. This is often a basic, intuitive approach to style. This type of analysis resides in the *parole* level of the Saussurian divisions. Thus, as Enkvist points out, there is no room for shared characteristics on the *parole* level. His second objection again deals with the problems inherent in establishing a norm against which the individual style can be compared. One must compare *la linguistique de la parole* with *la linguistique de la langue*. He summarizes his argument against individual characteristics by saying:

> In brief: individual modes of expression form a category too special to give us a general basis for an ideally powerful style definition. The identification of style with the individual element of the language tacitly presupposes the setting up of norms of comparison.[16]

The definition which expresses style as deviations from the norm encounters similar problems. Again one must define the norm in order to establish the deviations. If the norm is defined in stylistic terms, a certain circularity occurs. But if the norm is defined to include the language *(langue)* as a whole, the task becomes impractical and can even become ludicrous. Enkvist's extreme example of the comparison of a poetic text with an engineering book indicates where this might lead. Certain boundaries must be established in relation to the norm. Enkvist argues for a definition of the norm which is contextually meaningful in relation to the subject. Contextually meaningful criteria embrace a wider range of considerations than those used when the norm is defined in stylistic terms. It is in this area that Enkvist sees the possibilities for frequency counts and statistical analysis. Once the norm is established in contextual terms problems in relation to group characteristics are also solved as they obviously will be a part of the norm. (The last part of Enkvist's definition of style concerns the broadening of elements of the norm to linguistic entities larger than the sentence and deals with specific linguistic problems that have no corollary in lighting.)

Enkvist finally arrives at his definition of style:

> The style of a text is a function of the aggregate of the ratio between the frequencies of the phonological, grammatical, and lexical items, and the frequencies of corresponding items in a contextually related norm.[17]

He then turns to the question of probabilities and expectations established through linguistic experience. It is through contextual frequencies experienced in the past that a set of contextual probabilities or expectations is established which the text either fulfills or disappoints. He moves on

to a further definition of style as, "The style of a text is the aggregate of the contextual probabilities of its linguistic items."[18]

The definition of context is not limited to a single level in Enkvist's system. He suggests the categories of history, dialect, field mode, and tenor of discourse. In a stylistic study the texts to be examined should have "a number of intersecting contextual relationships."[19] The context provides the parameters for the stylistic analysis. Enkvist's use of the term 'context' is determined by the intended application. For an application to film the definition needs to be broadened. As film is a communication system, context can still be considered in terms of intention of communication, meaning of text, and possibilities of interpretation by recipient.[20] But concepts of history and dialect (which can be determined by sociological and regional factors) might be interpreted more broadly than would be usual in a purely linguistic study. Enkvist sees a certain reversibility in the determination of context and style. Style can be defined as a "set of linguistic forms with the aid of the contexts in which they occur," or contexts can be defined "with the aid of linguistic forms that occur in them."[21] Thus a style can be determined either by the high frequency of certain types of linguistic forms that occur in a given context, or the very existence of a large number of linguistic features would indicate the presence of a specific context.

Enkvist called these linguistic features 'style markers.' "Style markers are contextually bound linguistic elements. Elements that are not style markers are stylistically neutral."[22] In order to determine these markers the text must be screened at a number of levels to eliminate nonstylistic elements. First there must be a grammatical screening and then a stylistic one. Although he never clearly defines them in quite this way it would seem that style markers are the linguistic forms which pass through a grammatical screening and also a pragmatic screening in terms of meaning. Style markers would then be further defined by concepts of high frequency and predictability of occurrence within a given context (probability patterns). To return to the simple example of *x loves Mary*: the category of substitution is determined grammatically; the actual selection of either *John* or *Peter* for *x* is pragmatic. But the form of that substitution, *Pete* instead of *Peter* may or may not be stylistically significant, depending on the context. In a hypothetical situation one might be able to say that in a given text the author uses diminutives for male names with a much greater frequency than for female names. In such a case *Pete* would be a style marker.

In an analysis of film similar types of screening might take place. When dealing with lighting, the choice of a day scene or a night scene is determined pragmatically. But the contrast ratio that exists in a given day

scene or night scene may or may not be stylistically significant. The identification of a high contrast ratio as a style marker would depend on the relationship between this feature and other similar features within a given context and on a grammatical screening within the same context. However, before Enkvist's principles can be applied to lighting it is necessary to establish a concept of grammaticality which will allow for the identification of style markers. It would also seem that the nature of filmic communication as opposed to linguistic communication would suggest a certain enlarging of Enkvist's definition of context. First, a stylistic study would have to include a series of texts with intersecting authorships; in terms of lighting, a conjunction of films where the cinematographer remains constant and the director is the variable. Second, social and economic factors may play a more important role in film than language. In a literary study the financial condition of the author would generally have little effect on the resulting work. In film, certain factors often have to be eliminated as stylistic considerations because of the economics of the production. The use of color may be an economic choice or a stylistic one. But before attempting to apply 'context' to lighting it is necessary to explore the possibilities of the existence of a significant structure upon which a stylolinguistic analysis can be based—film semiotics.

3

Semiotic and Lighting Codes:
The Search for Significant Structures

A photograph acquires something of the
dignity which it ordinarily lacks when
it ceases to be a reproduction of reality
and shows us things that no longer exist.

Marcel Proust, *Within a Budding Grove*

The Problem of the Real

One of the major theoretical problems facing the film critic is the realism of the photographic image. As Erwin Panofsky said, "The problem is to manipulate and shoot unstylized reality in such a way that the result has style."[1] And of course Walter Benjamin states it perfectly in the title of his essay, "The Work of Art in the Age of Mechanical Reproduction."[2] Critics were faced with having to deal for the first time with a visual art which seemed to be a mere mechanical reproduction of reality, at least as far as the images were concerned. This relationship with the real world has led to an emphasis in critical theory on theme or plot development on one hand or on editing (the manipulation of reality) on the other. The images themselves, except perhaps for their structuring in terms of framing, point of view, size of object portrayed (choices usually made by the director), were seen as mere reproductions of the object photographed. This concept is reinforced by the egalitarian nature of photography. From the beginning, still photography attracted the amateur. It was a popular art form, easily mastered by the public (much in the same way that eighteenth-century young ladies learned the techniques of sketching). And even in the area of the moving picture there was a general amateur invasion in 16mm, 8mm, and then super 8. As the creation of art is usually considered an elitist activity, this attitude has led to two opposing developments. In the area of still photography it has taken years for excellence to be recognized, and even now it is difficult for the still photographer to sell a print because it is one of many, rather than a unique creation. In the moving picture industry only that which is expensive is considered art. Since amateurs can't afford to work in the larger formats (35mm, 70mm, etc.) these are considered the realm of the professional, with the corresponding attitude that anything done in 8mm is the work of an amateur.

Early work in semiotics, one of the most recent approaches to film theory, has continued the traditional attitudes toward the photographic image as a direct representation of reality. Christian Metz sees the great difference between still and moving pictures to be the fact that the film is composed of many pictures.

> One must not indeed forget that, from the semiological point of view, the cinema is very different from still photography whence its technique is derived. In photography, as Roland Barthes has clearly shown, the denoted meaning is secured entirely

through the automatic process of photochemical reproduction: denotation is a visual transfer, which is not codified and has no inherent organization. Human intervention, which carries some elements of a proper semiotics, affects only the level of connotation (lighting, camera angle, "photographic effects," and so on) . . . In the cinema, on the other hand, a whole semiotics of denotation is possible and necessary for a film is composed of *many* photographs (the concept of montage with its myriad consequences)—photographs that give us mostly only partial views of the diegetic referent.[3]

Here Metz finds denotation only in the relationship between images, an opinion which he alters in other essays. Metz is often criticized for the fact that he is only interested in fiction films. In fact, however, if the basic nature of the means of reproducing the image is reduced to mere mechanization, the only hope for finding valid codes must lie in the diegesis.

There are several basic problems in Metz's approach to the cinematic image. They all affect his brief attempts to deal with lighting in relation to the image. The first and most important stems from the nature of iconicity, the extent to which the image is a recreation of the reality of the object. In this area, recent work by Umberto Eco on the nature of the image has greatly influenced Metz and caused him to review some of his earlier statements. Eco cites Metz in "Semiology of Visual Images."[4]

An image is not the indication of something other than itself, but the pseudopresence of the thing it contains . . . The expressiveness of the world (of the landscape or face) and the expressiveness of art (the melancholy sound of the Wagnerian oboe) are ruled essentially by the same semiological mechanism: "Meaning" is naturally derived from the signifier as a whole, without resorting to a code.[5]

Eco studies the act of perception and first comes to the conclusion that,

I work with the given of experience furnished by the design in the same way that I work with the given of experience furnished by sensation. I select and structure them according to a system of expectations and assumptions acquired by preceding experience and therefore by learned techniques, that is to say, by codes.[6]

He then comes to the important realization that,

Iconic signs do not "possess the properties of the represented object" but reproduce certain conditions of common perception on the basis of normal perceptual codes and in selecting from them—other stimuli being eliminated—I am able to construct a perceptual structure which possesses—by rapport with acquired codes of experience— the same signification as the real experience denoted by the iconic sign.[7]

He amplifies the concept of "reproduction of certain conditions of common experience" through the examples offered by drawing on the pro-

duction of graphic design from the real experience. These statements tend to distance the iconic sign even further from its position as an expression of the natural world into an arbitrary sign. The major importance of the essay is the break that it creates with more traditional views of the nature of the image. Eco separates the image from its origins in reality. Recognition of the image is a response related to the original through convention and conditional expectation. He also opens the whole problem of denotation in relation to the image; the denotative level of the image does possess codes and is an organized construction rather than a "visual transfer."

Eco breaks down the codes which concern the image into 10 categories; only a few of these codes relate to lighting and film. Transmission codes "construct the conditions which permit the sensation useful to a perception determined by the images."[8] These codes are scientific, but they establish the "retransmission of sensation not prefabricated perception."[9] Eco acknowledges the influence of these codes on the aesthetics of the message, its tone and style. Tonal codes connote intonations. He sees these as conventional, optional codes, intonations of particular signs or of a system of connotation that is already stylized. Iconic codes which are established through codes of recognition deal with what is most commonly attributed to the image. Transmission codes precede iconic codes. Iconic codes exist on the denotative level, and the codes which follow are all concerned with connotation. The boundaries between these connotative codes often seem to overlap. The codes of recognition, transmission, and tonality transform the real into the image. The iconic codes enable one to understand this transformation. The connotative codes which follow relate the image to the world. There are codes of taste and sensibility, images which connote grace or beauty. Rhetorical codes "are born from the conventionalization of unpublished iconic solutions, then assimilated by society to become models or norms of communication."[10] Finally, there are stylistic codes and codes of the unconscious. By stylistic codes Eco seems to be suggesting what might be termed stylization rather than genuine stylistic analysis.

> *Stylistic codes*: original solutions determined or codified by rhetoric, or after having been realized one time, remaining to connote (when they are cited) a type of stylistic success, the mark of an auteur (for example, "a man who turns away on a road at the end of a film—Chaplin") or also a typical realization of an emotive situation . . . or also a typical realization of an aesthetic ideal.[11]

This breakdown into codes deals with the image as perceived, recognized, transmitted, and understood. But the entire process is weighted toward

the receiver of the message without consideration of the sender. Though various aspects of lighting may be considered under Eco's arrangement such as tone, taste, etc., this approach unnecessarily fragments a process which should be considered as a unity. Eco also repeats (although not quite to the same extent) Metz's attitude toward the transmission of the image. The image is no longer a pseudo presence, but the conversion of the profilmic into the filmic becomes an area for science rather than semiotics. He does not attack the mechanical reproduction of the image (its transmission), but our perception of it.

The Problem of Light and Filmic Communication

The problem stems from the fact that the relationship of light to both the object and its photographic realization is unique and unlike that found in any of the other arts. The mechanics of perception are the same. Yet the physics of light governs not only the transmission, but also the process which transforms the profilmic into the filmic. In the plastic arts, light transmits images, colors, etc., to the artist, who then translates these messages through the medium of his choice into a new message, which is then perceived by the receiver again through the medium of light. Yet only in the photographic processes is light a direct participant in the creation of the message that it transmits. It transmits an image of the object to the film, interacts with the film in the recording of the image, bears the message to its means of retransmission, either in the creation of a finished photograph where it is part of the printing process or in the projection of the image on the screen, (in television the process is no longer projection but an additional transmission is still part of the message chain), and then transmits the finished product to the receiver.

The usual communication models are too simple to accommodate such a complex transaction. If an elementary communication model is examined,

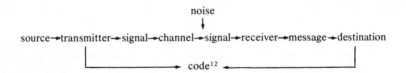

light would participate in all aspects of the communication from the transmission through the reception. Light is the transmitter, the signal, the channel, the signal, and the message. The pervasiveness of light is further complicated by the transformations that can occur in the signal during the

transmission process—the possible variables. The usual division into discrete units does not allow for the participation of light in the communication. Of course, the major reason that the problem of transmission in this case is usually ignored is the assumption that the transmission of an image is a mechanical process of reproduction. Thus, most efforts are directed toward the nature of the sender, the message or the receiver, while the means of transmission is passed off as being a part of the laws of physics. There is in most filmic communication the added problem of the sound track which usually accompanies the image, and (even in mechanical terms) its transmission by both sound and light (the optical track).

At the same time, the differences between the human eye and the camera in their reaction to the stimulus of light add to the complexities. Unlike devices for recording and transmitting sound which have now been perfected to the point that there is almost no perceivable difference, given the right equipment, between the recorded event and the real event for most people (witness the TV commercials for cassettes where recorded sound shatters glass or where knowledgeable musicians can't distinguish the real Ella from the tape). In the present state of technology, the photograph can always be distinguished from the reality that it represents. (Holograms are, of course, another matter. But, again, those TV commercials where we are asked to decide which is the real Henry Fonda and which is the GAF photograph only work because both images are being transmitted another time.) A photograph is never a mere record of reality, not only for the reasons that Eco proposes, but also because those aspects of the original subject that we accept as part of the photographic image must be *created during the process of the recording of the image*. One obvious exception to this statement might be the scratch film which is an acknowledged adaptation of methods used in painting. But after production the complex transmission of the message remains the same.

The importance of the transmission of light has always been recognized by the more theoretical of experimental filmmakers. The various experiments with flicker films are all comments on the complexity of the communicative process in film. In Anthony McCall's recent work he deals directly with the relationship between projected light and image. He calls *Line Describing a Cone* a solid light film because, "It is dealing with the projected light-beam itself, rather than treating the light-beam as a mere carrier of coded information, which is decoded when it strikes a flat surface (the screen)."[13] As this film actually exists in the space between the projector and the surface onto which it is projected, it represents a kind of midway point between film and sculpture with light. It obviously presents some interesting theoretical problems and even brings into question the concept of the basic two-dimensional nature of film. It also fore-

grounds the whole transmission process in filmic communication. As McCall also claims that the film contains no illusion since it exists in real time and space, he accentuates the transformation of reality that occurs in the photographic image.

Moholy-Nagy was also concerned with the transformation of reality that occurs because of the difference between camera and eye. However, he saw the distortions in so-called faulty photographs as closer to objective reality than is possible with human perception.

> The secret of their effect is that the photographic camera reproduces the purely optical image and therefore shows the optically true distortions, deformations, foreshortenings, etc., whereas the eye together with our intellectual experience, supplements perceived optical phenomena by means of association and formally and spatially creates a *conceptual image*. Thus in the photographic camera we have the most reliable aid to a beginning of objective vision.[14]

While for Moholy-Nagy the faulty photograph is an avenue toward objective perception divorced from the distortions of human perception, Marxist critics attack the images created by the camera because the camera is itself a bourgeois invention and therefore reconstructs a bourgeois notion of reality. The cinema as a capitalist enterprise has developed along lines which encourage that view of reality according to traditional laws of perspective which have dominated Western art since the Renaissance. Yet both of these positions confirm the basic technological fact that the mechanism of reproduction changes a three-dimensional world into a two-dimensional image. One of the primary differences between the human eye and the camera is the perception of dimension and depth. We perceive objects in their three-dimensionality, and we can focus at an infinite number of objects in our view. The camera is limited, except for occasional experiments in 3-D, to a presentation of a two-dimensional world and to a focusing system which is controlled by the capabilities of its lenses and the amount of available light. But it is not only in these areas that the camera differs from the human eye. The camera and the human eye differ greatly in their reactions to the physical properties of light.

In his chapter on light in *Art and Visual Perception*, Rudolph Arnheim discusses the differences between human perception of light and the actual physical properties of the medium. What we see is the result of the physical properties of light, but it is also the result of the reaction of our nervous system, our ability to constantly adapt to new situations, and our acquired responses which are derived from experience. The eye constantly adjusts to changing light conditions. A dim room does not seem dark once we have adjusted to it. Brightness is usually a property of the object, rather than a reflection of the light falling on that object

from a source. Many of Arnheim's concerns relate directly to painting, but often the limitations imposed by that medium correspond to those found in film. The contrast range in film is much less than that of the eye, and the cinematographer must realize that a balance has to be achieved between extremes of tonality and an accurate portrayal of mid-range tones. If black or white is emphasized, gradations in gray may disappear. We often fail to notice the varying reflective capabilities of surfaces and textures. Objects vary greatly in their ability to reflect light. When we see a shiny object we seldom consider the effect as the result of the reflection of light. But the cinematographer must constantly deal with the light-reflecting capacities, the luminance of objects.

In the two-dimensional world of painting and photography, light also creates space. Both the artist and the cinematographer use shading to create the illusion of volume and mass. With this use of light to create the illusion of a three-dimensional world, dark objects cannot be distinguished from shadows.

> In order to avoid the confusion between brightness produced by illumination and brightness due to the coloring of the object itself, the spatial distribution of light in the setting must be understandable to the eyes of the viewer.[15]

Shadows present complex problems in both film and painting. Under most illumination conditions, we perceive shadows but do not really think about them. Shadows are not necessary for our depth perception so we generally ignore their presence, except in those low or extreme lighting situations where they are clearly evident. In film where shadows become one of the means of our reconstructing an image which conforms to our expectation of reality, all shadows suddenly become important and sometimes even intrusive. The shadow cast by a nose on the rest of the face is often annoying and ugly. A shadow cast by an object outside of the frame becomes puzzling. Arnheim expresses an interesting point when he observes that an artist's use of shadows does not always derive from nature. "But the use of shading does not necessarily originate from the observation of nature, and certainly is not always used in accordance with the rules of illumination."[16] Even in the creation of an impression of reality, reality must be distorted. The transfer of the real world into a two-dimensional medium is extremely complex. The photographic image as it is perceived is a result of a constant interplay of tensions between the technical demands of the system, the perceptions of the human eye, and the physical properties of light.

Mechanical reproduction itself is not a simple process. Even with the simplest of equipment the amateur photographer must learn certain

skills. As the amateur progresses, both acquired skills and equipment become more complex. Any semiological approach to the image must take these factors into account.

A Model for the Semiotics of Lighting

When Metz deals with the image and more specifically with lighting, he takes for granted Barthes's attitude toward the automatic recording process which has no organization (the previously cited statement, "the denoted meaning is secured entirely through the automatic process of photochemical reproduction"). This attitude creates great problems for him when he attempts to situate lighting in a system of denotation and connotation. In his first statement (he is dealing mainly with connotation, and lighting is merely part of the example) the connoted effect (in this case hardness and anxiety) is produced through the convergence of the signifier of denotation, the manner of filming (including lighting effects) and the signified of denotation, the scene represented.[17] In a subsequent essay Metz revises this approach in his modification of his entire attitude toward connotation. He believes that a division should be made between those codes which precede and are responsible for the iconicity of the image (the visual analogy) and those which come after. These two divisions would correspond roughly to denotation and connotation. It is the relationship between these divisions which presents the problems. On rereading Louis Hjelmslev, Metz saw that the signifier of connotation could not be a mere addition of the signifier and signified of denotation.

> This manner of filming given as the signifier of denotation can not contribute to the establishment of a signified of connotation if one has in effect—and fraudulently—already integrated it in schemes of connotation as, for example, the "symbolic" value of different types of lighting in different genres.[18]

As Metz recognizes, if "the manner of filming" is part of the signifier of connotation it cannot have the same function in the denotation. But if he then turns to the denoted state as being that of mere mechanical reproduction, there is no way to achieve a connoted state. In his view of iconicity, one is then thrown back to the original image. He then returns to Hjelmslev for a reinterpretation of the connotative process which will make possible this leap from denotation to connotation. The basis of his dilemma lies in the fact that he originally wanted to present an analogy between connotation in film and literature, in order to insure the evaluation of cinema as art.

The study of connotation brings us closer to the notion of the cinema as an art. . . . the art of the film is located on the same semiological "plane" as literary art: the properly aesthetic ordering and constraints— . . . in the first case; framing, camera movements and light "effects" in the second—serve as the connoted instance, which is superimposed over the denoted meaning.[19]

The difficulty in the analogy as he presents it is that not only, on a more general level, does cinema have no *langue* according to Metz but, in this case, there is no *parole* to compare with the ordinary speech which is then aesthetically ordered in literature. He defines the denoted level in literature as "the purely linguistic signification, which is linked, in the employed idiom to the units used by the author."[20] The analogous state in the cinema "is represented by the literal (that is, perceptual) meaning of the spectacle reproduced by the image, or of the sounds duplicated by the sound-track."[21] However, looked at closely the analogy is not accurate, given Metz's attitude toward photographic reproduction. Essentially, literature aesthetically orders the *parole* of language through the use of poetic and rhetorical devices, concepts of style, etc. But for Metz, cinema, as he considers it, is *parole* which he wants considered as an art.

Photographic reproduction is, in fact, governed by rules, by choices and limitations which would seem to place it closer to an analogy with *langue* in the Saussurian sense or *competence* as Noam Chomsky would define it. It is true that these rules come from various sources—optics, physics, mechanics—and that they are organized by perceptual codes, cultural conditioning, and the limitations of technological development. Technical advances alter the range of possible expression but not the rules governing the act itself. A faster film may allow one to shoot in low light conditions, but the speed of the film does not alter the rules governing the relationship between the lens opening and the amount of light needed to activate the film. In those situations usually associated with amateur photography where many of the functions of mechanical reproduction are pre-set, the limitations of the system have been internalized into the camera, but they exist just the same. Because of its mechanical nature the camera has been seen as just another recording device like a seismograph or an electrocardiogram. But a photograph is always to some extent an interpretation of reality governed by a combination of codes. The individual response to these codes is a learned process which would then result in a level of *parole* or *performance*. This analogy should not, however, be carried too far into minute comparisons of photographic and linguistic organization. Any discussion of lighting style, however, must take into account the amount of codification and organization inherent in the reproductive process. Style is not the creation of order out of chaos, but it works in a manner analogous to that of style in literature. And the attitude

toward the denotative level of the image must be expanded to include these concepts.

By applying semiotic analysis to the nature of the sign, and concepts of denotation and connotation to lighting, an organization can be formulated which will allow the application of Enkvist's presentation of style markers in a contextually related norm to a specific set of texts. Metz's narrow definition of the denotative level of the image can be abandoned as well as its corresponding insistence that style exists only on the connotative level.

> In this new perspective a cinematographic style—since "styles" are among connotations—can be defined as a bifacial entity of connotation provided with proper signifieds: possibilities of evocation, diverse resonances, ideological implications, etc.) and with proper signifiers: choice of certain types of film and focal lengths, certain angles, certain schemes of montage, certain camera movements, etc.[22]

If the image as it exists (denotative level) is the result of the workings of codes governing its reproduction, style extends over both the denotation and connotation of the image because intervention is possible on both levels. On the denotative level an image may represent a street at night. On the connotative level it may indicate anxiety or tranquility. But stylistically the image can be produced in many different ways, ways which affect both connotation and denotation. The very nature of the sign itself makes it impossible to deny the intervention of style at all levels of signification. To identify style with connotation is in one sense to return to the old form/content division.

If the denotative level of lighting the image is defined as that level of competence which satisfies the technical requirements of the system and produces an acceptable image, the beginning of a stylistic investigation of lighting can be approached. The term 'acceptable' is important as it designates not only the satisfactory reproduction of a recognizable image, but also the production of an image which satisfies the connotative requirements which might be established in the script, as well as the contextual requirements such as a specific studio style. The sign is expressed in terms of the signifier and the signified which form a relationship resulting in a completed signification. The usual definitions of the signifier consider it as expression or mediation of the content which is signified. The signified is the representation. Both signifier (expression level) and signified (content level) can be further broken down into form and substance. The obvious response to this division in terms of lighting codes would be to place the object photographed, that is the profilmic event, in the category of signified and the lighting and other aspects of the filming

process as the signifiers. This is the division adopted by Metz. But the complexity of the communicative process which occurs in filming makes this simple division impossible. The real point of departure must be the definition of the message (the image as it exists recorded on film, that is the object of examination) in its relationship to sender and receiver and to the transmission of light.

Light, as such, exists in relation to the object in the profilmic before the actual act of filming takes place, but, except for natural light situations, it exists solely because of its relation to the filmic. (An actor may wear her/his own clothes in a given scene, but the lighting in that scene exists for the transmission of the image.) Thus the primary aspect of the job of the cinematographer occurs in what might be called a presignifying act which establishes the signified for the act of filming. It is a precommunicative act as it is only understood in the mind of the cinematographer who visualizes the relationship between the lights, the object, and the rest of the image formation process (film stock, film speed, lens camera speed, camera motion, filters—on the first level of reproduction; processing, pushing or flashing of film in the development stage; and print stocks, timing, and filtering in the production of the release print). There is no linguistic analogy for the status of the visual message at this point in the communication process. It is not a thought because it is already the result of a thought process. Yet the object no longer exists as a real thing but rather as the potential image, and it has a temporal existence which precedes the act of filming. The cinematographer must regard the lighting as a bi-facial entity at this point, thinking of light both in regard to the object and its interaction with it (brightness, shadows—those aspects of reproduction discussed in relation to Arnheim) and the reaction of the light with those factors related to the camera and the film. This is the creative moment in the cinematographer's work and it is also the period when the denotative and connotative potentialities of light in the image are established. Thus even though no real sign is produced this is a signifying instant with proper signifiers and signifieds. The signified in this instance is the object as it exists in reality, whether it be a studio set or a real street, and, as such, can be considered like the semiotic signified described by Barthes.[23] The signifier is the lighting system as established by the cinematographer illuminating the object, including not only light but also reflectors, screens, gobos, etc., which may alter or modify the direction or intensity of the light, the lighting ratios, and the relative harshness or softness of the image. The substance of the signifier is the actual (and measurable) amount of light which is reflected from the object. The form of the signifier is the substance manifesting itself according to those sets of rules which govern the optical, physical properties of light

which set the boundaries within which individual choice may be exercised. The signifier and signified form a union which is transmitted by light to the camera.

The next stage of this process is the actual exposure of the film to light, the actualization of the potential image. The process of actualization is not a staggered system, as that exemplified by the connotative/denotative relationship, but an overlay which adds new signifiers and signifieds to the potential image. Much of what occurs at the moment of filming constitutes new signifying systems which, although transmitted by light and recorded through the interaction of film and light, can be considered quite apart from it. Thus film speed, camera motion, framing, and camera angles have their own signifiers and signifieds which are, of course, contained within the final projected image. The projection of the image is the moment of its transmission to the receiver. At this point the image no longer exists as a single unit. It is part of an image chain and is usually accompanied by a soundtrack. If it is a part of a fiction film it has also been subjected to an editing process which establishes its narrative line or, in the case of other types of film, an editing process which is part of their formal organization. Each image can still be considered a sign, but at this point it must also be considered in its relationship with the other signs that surround it. The relation of light to the image has also altered, once the image is recorded and processed. The signified is the image as projected, its substance being the representation of those profilmic objects which appear on the screen (representational or nonrepresentational) and its form being that pattern of light which allows the image to be identified in terms of a representational image or allows for the creation of shapes and patterns in the case of nonrepresentation. The signifier is the light as reproduced. Light is the substance of the signifer whose form is manifested in the film in the arrangement of particles (silver halides and dyes) and governed by those sets of rules which regulate its interaction with film in the photographic reproduction process. Thus in an image depicting a street at night the signified is street/night formed by those patterns of light and shadow which shape the image. The signifier is the relative absence of light (low light level) whose form is established through such factors as fast film, low f. stop, lens filters, less light in the scene, timing the exposure in the laboratory. This conjunction of signifiers and signified describes the image in its denoted state.

Connotation is generally established over a series of images. As Barthes indicates, several denoted signs may combine to form one connotator.

> . . . the units of the connoted systems do not necessarily have the same size as those of the denoted system: large fragments of the denoted discourse can constitute a

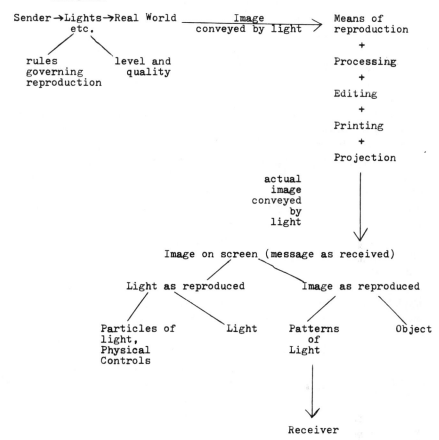

single unit of the connoted system (this is the case, for instance, with the tone of a text, which is made up of numerous words, but which nevertheless refers to a single signified).[24]

The image in the cinema should be considered as a combination of several denoted signs which may then form the connotator of a connotative system. Low-key lighting may connote or evoke a sense of anxiety, but this anxiety may be reinforced through editing, which quickens the pace of the film, and framing, which controls vision or upsets a sense of balance or distorts the expected angle of vision. Dialogue, acting, and/or music may also be a part of the connotator. Thus the simultaneity of the connotative and denotative systems as suggested by Metz must also be called into question. The two systems are unified, but it is at the moment of projection and not of filming as he suggests. Of course, since a film is a

series of images rather than a single image, and since there is usually a shooting script of some type which directs the content of the images at a certain level, connotation can control the denotative level. There can be a simultaneity of creation on both levels. Once the connotation is established it can be seen in the individual image, and at the same time, connotation can occur within the single image. The low-key lighting which is used in conjunction with the portrayal of Michael in *The Godfather II* could at first be interpreted merely as a realistic image of the setting, but its continued presence builds up the connotations which can be read in various ways: his imprisonment in his own character and past, the darkness/evil of his character and actions, etc. Once the connotation is established, each image reinforces it and is an individual example of it. In *Bigger Than Life*, when the father, under the influence of cortisone, has turned into a monster and is forcing his son to study his shadow, as reflected on the wall, he is gigantic in comparison to the actual size of the mother standing in the doorway, unable to overcome his tyranny. In this instance the lighting in a single image connotes the power relationship in the sequence. On the connotative level, light in all of its relationships with the object portrayed becomes the signifier or connotator and the signifieds of connotation are all of those larger issues—ideological, cultural, subjective, etc.—which can be signified through the lighting of the object.

In a return to Enkvist's approach to style, it can be seen that the probabilities and expectations which are used to analyze a literary text are similar to those expectations gained through experience, which Eco indicates as part of our ability to recognize the relationship between the object and its image. There are no exact equivalents for Enkvist's linguistic elements (phonological, grammatical, lexical) within the lighting of the image (nor for that matter should such analogies be attempted). But the signifying models that have been established can be applied to specific aspects of lighting and to assessing their frequency within a set of texts, such as those defined by the term modern French cinema. These findings can then be related to the work of individuals who share similar contextual relationships. Through this approach, message can be equated with the image as projected—a definition which results from the semiotic description of the photo-reproductive process.

4

Style Markers and Lighting: Problems in Identification

Sometimes I think I'd gladly be locked up
in a dungeon ten fathoms below ground,
if in return I could find out one thing: what
is light?

Bertolt Brecht, *Life of Galileo*

The Literary Analogy

Even in literature the identification of style markers is not yet a precisely developed science. A specific approach may begin with the isolation of a context and the recognition of significant structures, and continue through close observation to the isolation of certain repeated traits which may ultimately become identified as style markers. As Enkvist has indicated (see Chapter 2), in literature style markers can be grammatical, lexical, and phonological items which become significant through a screening process which relates the frequency of their appearance to corresponding items in a norm which has been related contextually. Of course, any literary analysis is based on a certain understanding of the structure of the language used in the construction of the literature—an understanding which enables the critic to screen for significant features. For example, a grammatical style marker in a given text might be the frequent use of verbal contractions. These contractions are also part of the grammar of the language, but when their frequency in a given text exceeds their expected frequency or appearance in other related texts (modern American short stories, perhaps), then these forms become style markers as well as grammatical items.

In the preceding chapter, I have suggested how lighting operates in the creation of the cinematic image. The identification of a signifying structure which organizes the lighting process makes possible the search for style markers in the cinematic image in a similar manner to their isolation in the literary text. The literary analogy cannot, however, be carried too far. First, it has been shown that there can be stylistic intervention in the image on the level of denotation, a level not generally considered in the literary text. Second, it is important to remember that there should be no expectations of direct analogies to linguistic items as style markers (grammatical, lexical, phonological items) in the search for markers in the cinematic image.

Style Markers: The Cinematic Image

The process of assimilating a literary text is an acquired skill—you have to learn how to read. But most people do not consider the fact that in order to fully understand a visual text it is just as necessary to learn how to see. This problem is especially true with the photographic image. The art historian has not had as great a problem in retraining or training visual

perception because it has always been understood that the painting is not an exact duplicate of reality, and therefore that it is the structuring of reality on the canvas that is the legitimate area of study. The identification of the photographic image with the reality it represents has hampered this kind of approach in film studies.

It is only in instructional texts—"how-to" books—that there is any serious consideration of lighting, different approaches to problems, which suggest, through the element of choice, stylistic possiblities. The basic difficulty with these texts, including the best of them, Gerald Millerson's *The Technique of Lighting for Television and Motion Pictures*,[1] is that the point of departure is the creation of the image rather than the actual analysis of the projected image—the potential rather than the actual. The other problem that all these texts share is a bias toward what might be described as the "well-made" film, the film which is in the main line of traditional feature filmmaking. Any descriptions of style tend to be judgmental. In a sense these texts tend to identify the Hollywood film with a kind of competence—while all other approaches become incompetent by comparison—when actually what they are describing is a particular style which can just as easily be countered with another style—the kind of exploration of the potentials of the image which takes place in many independent films, for instance.

The starting point for any discovery of style markers must reverse the process of the usual lighting text and begin with the image as projected—the result of the creative process rather than its inception. In the model developed in Chapter 3, the image as projected was shown to be the accumulation of all the decisions which enter into its creation and reproduction. The statements of the various cameramen in Chapter 7 indicate exactly where their control lies, thus defining their areas of influence and their attitudes toward the creation of the image. But ultimately any analysis of the image must reside in the image itself—the projected image.

The basic quality of the projected (or photographic) image is the interplay of light and dark areas—the juxtaposition that defines shapes which may be either representational or nonrepresentational. The basis for this contrast exists in the reality which has been photographed. In the three-dimensional real world, shadows or the interplay of light and dark areas are secondary signifiers which often are unnoticed because it is not necessary to acknowledge these relationships during the ordinary daily functioning of visual perception. (Except, perhaps, if one tells time through the use of a sundial.) In the two-dimensional world of the image, the light/dark relationship is a primary signifier. Millerson lists seven func-

tions of lighting in his book, and all of these are manifested in the juxtaposition of light and shadow within the frame.

1. To direct attention to specific areas, giving prominence to particular features, subduing others.
2. To reveal shape and form, giving an illusion of volume, contour, size and proportion.
3. To establish environment, displaying subjects' surroundings, spatial relationships, scale perspective.
4. To characterise the subject and its surroundings, establishing mood, atmosphere, time.
5. To develop compositional relationships, developing and unifying tonal proportions.
6. To maintain visual continuity of the above factors.
7. To satisfy the technical requirements of the system, its brightness and contrast limits.[2]

Millerson is, of course, discussing conventional cinema, but even within more experimental modes the presence or absence of shadows is equally important. In Stan Brakhage's *Text of Light* the absence of true shadows is an indication of the abstract quality of the image. This absence is comparable to the movement in modern art away from representational forms and is accompanied by a similar disruption of the usual means of recognition—an emphasis on the two-dimensional nature of the work and a rejection of the illusion of depth. In Michael Snow's *La Région centrale* the relationship between shadow and object, where the object (the camera apparatus taking the pictures) and its shadow are disassociated visually at the same time that they are still connected (the object is never shown, only its shadow), is similar to treatments of the relationship between shadow and object in modern art. The shadow no longer denotes depth or volume or mood or atmosphere; instead it becomes the primary signifier of the means of production of the specific visual effects of the film. At the same time its presence or absence during a particular swing of the camera is the major iconic indication of the position of the apparatus during that particular movement. The deliberate suppression of shadows in Hollis Frampton's *Autumnal Equinox* can be directly related to a similar suppression in the work of Francis Bacon. With both of these artists the absence of shadows significantly alters any representational quality in their work, shifting the emphasis from identification of image to a study of form.

In the model in Chapter 3 the image as projected is composed of a signifier—light as reproduced (whose form is determined by the arrangement of particles and whose substance is light) and a signified—the image as projected (whose form is the pattern of light which allows the viewing of the image and whose substance is the visual representation). This struc-

ture can easily be used to identify style markers in the manner suggested by Enkvist's work. When viewed in terms of the final meaning of a text, Enkvist seems to suggest that style markers are the variable signifiers which can produce the same signified. When the substitution of a different signifier changes the signified's meaning in the text, the signifier is no longer a style marker. As long as either "Pete" or "Peter" denotes the same person, the selection of either term is a stylistic intervention. But if the two terms denoted two different individuals the choice would be nonstylistic. This same concept would of course apply to grammatical and phonological items as well.

The light/dark relationship is not unlike the universality of linguistic items in a written text. (If it were not for the hapax nature of the image one might almost make an argument for the phonemic nature of this relationship which, when combined according to rules of photographic reproduction, can produce a recognizable image, but when combined contrary to rules produces unrecognizable images somewhat akin to gibberish or in extreme cases, no image at all). Light as the signifier in the image reproduced becomes the item which must be examined as a style marker. In general terms, if there is a change on the expression level without a corresponding change on the content level then the signifier may be considered a style marker. Shadows or the relationship of shadow to light can then become, within a given context, style markers, while other relationships of light and dark can remain stylistically neutral.

There are four major attributes of light which may be considered style markers in the photographically reproduced image. These may occur together or in isolation and may function both denotatively and connotatively. Underlying these attributes is the basic interaction of light and source which is responsible for the creation of light and dark areas in the colored image or the gradations of gray which become colors in the black-and-white image. While these attributes are defined in terms of the creation of the image (relationships between light and source) they are all manifested qualitatively in the image as projected. The *intensity* of the light as it emerges from the source (or sources, more usually) is expressed in terms of the opposition of hard to soft, covering both the extremes and the range between. A hard source results in a brightly lit subject with sharply defined dark shadows. With a soft source the shadows will appear softer and less clearly defined. The *contrast ratio* is closely related to the intensity of the source. This term refers to the amount of light rather than to its intensity. The ratio is expressed in terms of shadows as: high-key—fewer shadows; low-key—more area covered by shadow. Both sets of terms can exist together in multiple combinations—high-key, hard light, low-key soft, high-key soft, etc.

The next two terms also form a kind of pairing. Both relate to the positioning of shadows in the image. The first, *direction*, deals with the position of the shadow in relation to the source. Traditionally this has been described with terms referring to the dominant direction of the source: front light, back light, side light. The direction of the source as it is manifested in the shadow is very significant for stylistic studies. The dominance of a particular direction may be an indication of personal preference by the cameraman. As Lee Garmes indicates in his interview in *Hollywood Cameramen*, "I've always used his [Rembrandt's] technique of north light—of having, my main source of light on a set always coming from the north."[3] In a stylistic analysis the actual presence or absence of the possible source in the image is another factor to be considered. Some cameramen prefer to have the possible source (often aided by hidden sources) visible in the picture. The presence of such sources does not necessarily connote a "realistic" style; similarly their absence does not indicate the contrary. The continuity maintained between a long shot and a close-up with regard to light direction is another stylistic feature of this aspect. Often continuity of light direction is sacrificed to the need to beautify a star in a close-up (the same is true of the intensity of light—hard light may suddenly change to soft in a close-up). The concern (or lack of it) for these continuities when repeated with a certain frequency indicates general attitudes toward lighting within a given context, as well as individual approaches to these problems.

The second term in this pairing deals with the *location* of the shadow—its spatial existence relative to the objects with which it is associated. Location in the broadest sense also refers to the presence or absence of shadows in certain specific instances. In the first and most general use of the term, both Millerson and Arnheim present approaches to this type of shadow. Millerson deals with it under the heading "coverage of light" and distinguishes three types of shadow: primary—present on the subject and caused by the subject's own surface contours; secondary—present on adjacent surfaces and caused by the subject; tertiary—present on the subject and caused by other objects (usually distorted as they fall over subject).[4] Millerson's categories are relationships between the source of the shadow and the area over which it extends, as distinguished from the light source which creates the shadow. Arnheim divides all shadows into two categories: attached shadows—part of the subject and usually defining volume; cast shadows—including any shadow from one object onto another (or from one part of the subject onto another part). His most interesting analysis relates to the perceptual differences in these divisions.

The attached shadow is an integral part of the object, so much so that in practical experience it is generally not noted but simply serves to define volume. A cast shadow, on the other hand, is an imposition by one object upon another, an interference with the recipient's integrity.[5]

He collapses Millerson's categories by treating all cast shadows equally, ignoring the distinction between the primary subject and other objects in the image. The concept of interference with integrity—the imposition of other shadows on the subject—relates closely to much Hollywood lighting where, in classical lighting situations, great effort is taken to avoid cast shadows on principals, especially in medium and close-up shots. That this convention is not observed in the modern French cinema where tnere is little concern for the integrity of the principals indicates one immediate area of stylistic difference between the two.

In discussing their attributes, shadows as style markers have been divided into four major areas: intensity, contrast ratio, direction, location. But, as has been suggested, these attributes do not exist in isolation in the image. It is rather the pattern of combinations which create both general (contextual) and specific (individual) lighting styles. There are also certain aspects of the use of shadows which to a certain extent may lie outside stylistic considerations. The use of a shadow to mark passage of time, to indicate day or night, are not stylistic decisions in themselves, but, as in literature, it is the means by which these effects are created which become legitimate areas for stylistic analysis. It is the selection of one method among many on both denotational and connotational levels which must be the focus for stylistic study. Generally in a literary study the mention of a certain context immediately suggests a broad stylistic approach, a set of expectations, which the specific analysis will either confirm or reject. (A study of Harold Pinter in the context of modern British drama will give rise to a different set of stylistic expectations than a study of John Webster in the context of Jacobean drama.) As there has been little stylistic analysis of lighting in film, a presentation of context must include broader areas than those usually covered in a literary study.

The Problem of Color: An Aside

All statements or conclusions which relate to shadows are valid for both black-and-white and color films. The specific stylistic problems relating to color have been omitted for several reasons. In an initial study such as this, shadows and related style markers are present in all films and as such are a good basis for an initial theory. A thorough discussion of color would involve a history of color film and color printing processes which

could itself be the subject of a long study. Color is also often related to cultural connotations and is often related to decisions made by the director and the art director and not the cameraman. Thus the cinematographer's use of color can really only be judged where there is direct evidence to support her/his role in its creation.

Another kind of serious difficulty relates to a more general problem in film scholarship—the quality of the prints available for study. Ghislain Cloquet refers directly to this problem in his interview. In general, the scholar must deal with 16mm prints. These can be of excellent quality, such as the newly printed Technicolor prints available from such distributors as Films Incorporated. But many prints made with more recent color processes retain little of their original color—those magenta films which we have all seen at some point. At the same time, even in 35mm, processing can vary from country to country, and the print which arrives in the United States may be subtly different from the original made in France. There may even be national preferences in color shadings which are not respected when new prints are made in a different country. All of these problems suggest yet another one—the subjective nature of the perception of color. Qualitative differences in color are more subtle than the more objectively verifiable criteria suggested for dealing with the light/shadow relationship. Important uses of color may be suggested in a discussion of a particular cinematographer, but uses of color must remain subjective impressions while such qualities as location or direction of shadow can be subjected to frequency counts or other objective methods of examination.

5

The Identification of Context: Modern French Cinema Versus the Hollywood Tradition

... that sense of a cameraman being perhaps what Coutard and Decae might be in France is not true in the United States. Again the question of constant employment is very seldom related to the director. It is related to the studio, and to the establishment of continuity. . . . In France, Decae and Coutard and Ghislain Cloquet work with a limited number of people. . . . That is not true in the United States. Cameramen are somewhat more interchangeable, but the level of technical norms set—about what goes into the camera and what comes out of the lab—is based on interchangeability. It's not based on individuality. . . . It's a rather ironic and bitter fact, but it is a fact of an industry, as against an individual artistic effort that one might say is characteristic of the French cinema.

Arthur Penn, "Interview," *Movie*

The context of this study has been broadly labeled 'the modern French cinema' or the postwar French cinema. Within this context six cameramen were chosen for deeper stylistic examination. These men are both individualistic in their approaches to lighting and representative of the approaches of others in the same context. As Enkvist suggests, stylistic studies are also studies of context, and an understanding of one will lead to an understanding of the other. The context defines the area in which the style will be explored. It must be understood and presented in such a way that it is limited enough for valid analysis and at the same time broad enough to give adequate range to such analysis. The problem of context becomes even more critical in a discussion of lighting stylistics because of the collaborative nature of the relationship between cinematographer and director. The cameramen selected for study have, within the pattern of their careers, established relationships with directors which makes analysis more feasible. They have worked with a variety of personalities both within and outside the historical limits of that context. But this context as a function of economics extends beyond the confines of the postwar French cinema. Orson Welles, Luis Buñuel, and even Arthur Penn in *Mickey One* can be placed closer to the economic and critical context of the French cinema than its Hollywood counterpart. Thus an exploration of the economic and aesthetic context of the period is an essential prelude to a stylistic analysis of these cameramen.

The Economic Context

Both World Wars were the causes of great changes in French life, changes which greatly affected the film industry. During the First World War France lost the preeminence gained in the years leading up to war and fell from a position of leadership in the worldwide film industry which would never be regained. It was this fall which was, in part, responsible for the rise of Hollywood, at the same time that it created the kind of shaky financial structure which has been both the blessing and the curse of the French film industry to this day. The ruptures caused by both wars meant that France could never establish the kind of secure studio system locked into banking concerns which marked the industry in the United States. It was this very openness of the industry which made possible the various experiments of the French avant-garde in the twenties and thirties and encouraged the movement from experimentation to commercial film-making, as exemplified by the work of such directors as Jean Renoir and

René Clair. But the general economic crisis of the thirties added to the instability of the industry. During this period certain directors became established who were later associated with the tradition of quality exemplified by an adherence to literary texts and a kind of psychological realism which became the mainstay of the industry in the fifties.

The Second World War and the Occupation further disrupted the industry. Most of the major filmmakers of the thirties left France either before or during the Occupation. The only major filmmaker of the thirties to remain was Marcel Carné. Two important directors did begin their careers during this period: Robert Bresson and Jacques Becker. In the immediate postwar period France had difficulty reestablishing an industry which had been controlled to a great extent by German capital. Exhibition had also been dominated by German products as the only new foreign films shown in the occupied zones, aside from certain Italian productions, were German. In addition to the major problems of rebuilding an industry disrupted by the war, the French cinema was hampered by import agreements made with the United States as a part of the larger financial program of the Marshall Plan.

Hollywood had a large stockpile of film just waiting to be imported since American films had not been allowed into France during the war. And the quota system for the importation of dubbed films which had been instituted in the thirties to encourage French production was not restored. The amount of program time available for French films was limited because of the influx of films from other countries at the same time that there was no large export market for French films except for certain art theaters in London or New York. The Blum-Byrnes agreement worked out in the early summer of 1946 did nothing to alleviate this situation. This agreement did away with the prewar quota on the importation of dubbed American films set at 120 films per year which, in practice, had meant that about 70 percent of the films shown in France were of French origin. The new agreement limited or set aside 16 weeks of the year for the exclusive showing of French products in French theaters, throwing the rest of the programming open to films of other countries. The remaining 36 weeks were, in fact, block-booked for the showing of American films. The film industry was, in practice, limited to the production of about 48 films a year if they were to make back their money in the 16 weeks open to them. Only about 30 percent of the films shown in France could be indigenous productions as opposed to the prewar standards.[1]

Thus the French film industry, which had reached a certain stability of output before the war of about 120 films annually—an output which had of course dropped radically during the Occupation and risen dramatically after the Liberation—was restricted in the number of films it was

financially feasible to produce. There was great unemployment in the industry, and, in the fall of 1948, the prewar quota system was reinstated,[2] With the industry in this state no one was willing to take risks with any innovative subject matter or technique. The new quota system also raised the number of weeks per year reserved for French films. In addition to the renegotiation of the Blum-Byrnes agreement, the government passed a financial aid law (July 30, 1948) which administered temporary aid to the film industry. A tax was placed on admission to theaters which was to be used to produce new films. But the new law did not really change the perpetual crisis which seemed to be the basis of the French industry.

Producers continued to follow the old formulas for financing films in which the amount of credit was based on the size of the production, the number of stars, and its adherence to established patterns which had been proved to be money makers in the past, the super productions and co-productions. Like their American counterparts, but with even more precarious financial backing, the failure of one of these superproductions could throw the entire industry into chaos. Additional laws attempted to help the industry, but it was not until the late fifties that new methods developed by such pioneers of the smaller production as Jean-Pierre Melville and Robert Bresson became generally acceptable through the financial success of the early "New Wave" films. These films demonstrated the fact that financial success was not necessarily dependent on the size of the initial budget. Experimentation became just as economically feasible as imitation of Hollywood. (Hollywood was at this time in the midst of the battle to counter the economic threat of television with larger and larger productions.)

Additional changes in the law made in 1955 also encouraged the possibilities of smaller, less expensive productions. A commission was established which advanced money for certain films based on a "premium of quality" offered to producers and then paid back to the government if the film was a commercial success. The often-cited example of a film which benefited from this law is Bresson's *Un Condamné à mort s'est échappé* (1956) which could not be completed for lack of funds. It was given a 50,000 (OF) grant and was a great commercial success. These changes in the aid laws also encouraged the production of short films which required a smaller initial outlay of funds than a feature. This financial assistance enabled many people who wanted to start making films to experiment and, in a sense, "learn the trade" by stimulating the production of shorts. Many of the directors who seemed to "burst on the scene" in the late fifties and early sixties such as François Truffaut, Alain Resnais, Georges Franju, Chris Marker, Jacques Demy, and Louis Malle

actually began their careers in this manner. Further refinements of the laws in 1958 and 1959 stimulated production in favor of new directors.

The economic problems of the French industry in the forties and fifties would not seem to attract new cinematographers, especially since these crises meant that many were out of work rather than that the hiring of new people was taking place. At the same time the kind of apprenticeship usually required before a person could obtain the necessary experience to become a director of cinematography on a feature might discourage all but the most dedicated. During this period, along with the adherence to established formulas, there was a general rejection of technical innovation as well. The older directors who returned to work in the French cinema preferred known cinematographers, men who had been working in the industry before the war. But gradually certain people interested in innovation, willing to work in less than perfect situations and sympathetic to directors exploring new ideas, began to emerge. Whether they appeared in response to changes in the industry or whether their availability and experience enabled the industry to develop is not a question that can easily be answered. In their interviews, these cinematographers, unique in themselves and in their experiences, are also representative of trends which all came together at a time when change was possible.

The Aesthetic Context

In conjunction with the changes in the industry there were comparable changes in the critical climate of the time. The early fifties was the era of the rise of *Cahiers du Cinéma*, which proposed new ways of looking at film due, in part, to those very films that created the financial crisis in the first place—the products of Hollywood. But the critical climate reflected in *Cahiers* articles and reviews also indicated an interest in the Italian neo-realist movement which, among other things, suggested ways of making interesting films on small budgets without stars and still achieving box office success. The early fifties also saw the rise of the European auteur such as Ingmar Bergman, and new works by Max Ophuls, Becker, Melville, and Bresson. The future filmmakers who were developing in France during this period had an awareness of the history of the cinema, what had been done in the past, and what was possible for the future. The criticism written at this time became a means of developing ideas which would be tested in the films that they would begin making at the end of the decade.

The pages of *Cahiers du Cinéma* were the experimental territory for that group of filmmakers which is associated with the term "New Wave",

financially feasible to produce. There was great unemployment in the industry, and, in the fall of 1948, the prewar quota system was reinstated,[2] With the industry in this state no one was willing to take risks with any innovative subject matter or technique. The new quota system also raised the number of weeks per year reserved for French films. In addition to the renegotiation of the Blum-Byrnes agreement, the government passed a financial aid law (July 30, 1948) which administered temporary aid to the film industry. A tax was placed on admission to theaters which was to be used to produce new films. But the new law did not really change the perpetual crisis which seemed to be the basis of the French industry.

Producers continued to follow the old formulas for financing films in which the amount of credit was based on the size of the production, the number of stars, and its adherence to established patterns which had been proved to be money makers in the past, the super productions and co-productions. Like their American counterparts, but with even more precarious financial backing, the failure of one of these superproductions could throw the entire industry into chaos. Additional laws attempted to help the industry, but it was not until the late fifties that new methods developed by such pioneers of the smaller production as Jean-Pierre Melville and Robert Bresson became generally acceptable through the financial success of the early "New Wave" films. These films demonstrated the fact that financial success was not necessarily dependent on the size of the initial budget. Experimentation became just as economically feasible as imitation of Hollywood. (Hollywood was at this time in the midst of the battle to counter the economic threat of television with larger and larger productions.)

Additional changes in the law made in 1955 also encouraged the possibilities of smaller, less expensive productions. A commission was established which advanced money for certain films based on a "premium of quality" offered to producers and then paid back to the government if the film was a commercial success. The often-cited example of a film which benefited from this law is Bresson's *Un Condamné à mort s'est échappé* (1956) which could not be completed for lack of funds. It was given a 50,000 (OF) grant and was a great commercial success. These changes in the aid laws also encouraged the production of short films which required a smaller initial outlay of funds than a feature. This financial assistance enabled many people who wanted to start making films to experiment and, in a sense, "learn the trade" by stimulating the production of shorts. Many of the directors who seemed to "burst on the scene" in the late fifties and early sixties such as François Truffaut, Alain Resnais, Georges Franju, Chris Marker, Jacques Demy, and Louis Malle

actually began their careers in this manner. Further refinements of the laws in 1958 and 1959 stimulated production in favor of new directors.

The economic problems of the French industry in the forties and fifties would not seem to attract new cinematographers, especially since these crises meant that many were out of work rather than that the hiring of new people was taking place. At the same time the kind of apprenticeship usually required before a person could obtain the necessary experience to become a director of cinematography on a feature might discourage all but the most dedicated. During this period, along with the adherence to established formulas, there was a general rejection of technical innovation as well. The older directors who returned to work in the French cinema preferred known cinematographers, men who had been working in the industry before the war. But gradually certain people interested in innovation, willing to work in less than perfect situations and sympathetic to directors exploring new ideas, began to emerge. Whether they appeared in response to changes in the industry or whether their availability and experience enabled the industry to develop is not a question that can easily be answered. In their interviews, these cinematographers, unique in themselves and in their experiences, are also representative of trends which all came together at a time when change was possible.

The Aesthetic Context

In conjunction with the changes in the industry there were comparable changes in the critical climate of the time. The early fifties was the era of the rise of *Cahiers du Cinéma*, which proposed new ways of looking at film due, in part, to those very films that created the financial crisis in the first place—the products of Hollywood. But the critical climate reflected in *Cahiers* articles and reviews also indicated an interest in the Italian neo-realist movement which, among other things, suggested ways of making interesting films on small budgets without stars and still achieving box office success. The early fifties also saw the rise of the European auteur such as Ingmar Bergman, and new works by Max Ophuls, Becker, Melville, and Bresson. The future filmmakers who were developing in France during this period had an awareness of the history of the cinema, what had been done in the past, and what was possible for the future. The criticism written at this time became a means of developing ideas which would be tested in the films that they would begin making at the end of the decade.

The pages of *Cahiers du Cinéma* were the experimental territory for that group of filmmakers which is associated with the term "New Wave",

including: Eric Rohmer, Jean-Luc Godard, Truffaut, Jacques Rivette, Claude Chabrol, Jacques Doniol-Valcroze, and, somewhat apart from these, Pierre Kast, Alexandre Astruc, and Roger Leenhardt. The general critical tone was one of appreciation for the American cinema, especially that of certain directors elevated to positions of prominence through the workings of *la politique des auteurs*. In addition to the American cinema they greatly admired the work of the Italian neo-realists, most specifically that of Roberto Rossellini, of certain established directors (Renoir and Ophuls), and of such relative newcomers as Melville, Bresson, and Bergman. The overriding emphasis in the evaluation of a director's work seemed to reside in a championing of a certain kind of realism leading to insights particular to film as opposed to other media. There were disagreements as to the importance of the long-take over montage, and the value of deep focus, but there was a unified impulse toward a cinema freed from ties to literature and theater (the prevailing mode of most French cinema of that period being a form of adaptation). The search was for a kind of pure cinema, democratic in nature (an understandable reaction to the totalitarianism of the Occupation), which would explore to the limits the specific potentialities of the medium. This interest in the cinematic as opposed to the literary as the basis for filmic expression led to theoretical approaches which concentrated on the techniques of the medium, the way that a film is made, the way it is edited, the way it is seen, in opposition to a concern with the way a film is written. These theoretical formulations were based on an understanding of technique, and their evaluations of this technique were based in a relationship to the real, to a kind of art which became art through its transparency. In all of their criticism these critics were, of course, supremely influenced by André Bazin, and much of the *Cahiers* writing of this period becomes either an extension of, or a reaction to, his ideas about the nature of film.

These critics recognized the importance of the role of the cinematographer in the creation of the visual style of the film. This kind of appreciation began with their admiration for Orson Welles's *Citizen Kane* and Gregg Toland's role in the development of deep-focus cinematography. But they understood the value of lesser known (to the public) cinematographers as well. The very title of Charles Bitsch's review of *The Big Combo*, directed by Joseph H. Lewis, indicates his approach, *"Rendons à John Alton."*[3] Alton was, of course, the cinematographer. Truffaut's review of *River of No Return* mentions specifically the contribution of Joseph LaShelle to the development of cinematography in cinemascope.

To the name of Preminger it is always fitting to associate that of his favorite operator, the great Joseph LaShelle, who is in a certain manner called upon to take a place in

the history of the American cinema as important as that of Toland or Maté. Faithful to their style of shooting with a crane—before them it was scarcely used except to accompany descents and ascents on stairs (or when it was rough)—Preminger and LaShelle have shot the first moving cinemascope, and this dazzling technique takes on here an extraordinary breath. When Marilyn sings at the right of the screen—framed in a medium shot—and when the camera turns around to her to the point that she (Marilyn) is found at the extreme left, one will never be able, from now on, to confuse—like certain swimmers—this movement with a banal pan.[4]

It is easy to associate this interest in cinemascope with Truffaut's later work, but what is more important is to understand the value that the use of the camera and the selection of the right cinematographer has for the finished film.

For Bazin and the *Cahiers* critics who followed him, the Italian neo-realists represented both a liberation from certain formal tendencies and a confirmation that the true development of the cinema was toward a realism which extended in the sound film from *Citizen Kane* to this post-war movement. For Bazin, Welles and Rossellini use different means to arrive at the same "aesthetic of realism." They are both concerned with the integration of character and milieu—the difference being in the means used to accomplish this end. Welles used all of the artifice of the studio, while Rossellini and the other neo-realists took their camera into the streets. Bazin recognized but oversimplified the effect that the camera movement of the studios had on film lighting. Regarding the neo-realists, he wrote,

> As for photography, the lighting plays only a minor expressive role. First, because lighting calls for a studio, and the greater part of the filming is done on exteriors or in real-life settings. Second, because documentary camera work is identified in our minds with the grey tones of newsreels. It would be a contradiction to take any great pains with or to touch up excessively the plastic quality of the style.[5]

The change is not merely to an absence of technique, but rather to a different attitude toward technique. The American cinema was also in certain cases moving toward a greater use of real exteriors, as in Elia Kazan's films *Boomerang!* and *Panic in the Streets*. Yet this movement did not radically affect Hollywood lighting styles. The innovation was rather that the union of subject and setting led to a critical appreciation of a kind of lighting quality for the fiction film which had only been acceptable in the documentary. This simplification of the lighting process did not mean that exteriors were not carefully chosen, that filming was not done at a time of day which gave the most favorable lighting conditions. And, in fact, some of the realism that Bazin attributes to the actors is part of a lighting scheme which refuses the usual glamorous close-up

to flatter the star. Rivette in his *"Lettre sur Rossellini"* clarifies and syn-
thesizes the contribution of the neo-realists to the theoretical preoccu-
pations of the *Cahiers* critics. In Rossellini, Rivette finds the radical
simplicity which he feels to be the true sign of modernism. He is, of
course, addressing himself to the Rossellini of the fifties, while Bazin had
concentrated on the early work of the neo-realists. Rivette found that
Viaggio in Italia "opened a breach and that complete totality of cinema
must pass through it under pain of death."[6] He explains the modernity
of Rossellini through a comparison with Matisse and the similarity in their
approaches to the depiction of objects—a simplicity which is ultimately
a complexity because it is only achieved through a refinement to essentials.

> Realist, Matisse is one also, in my opinion: the efficiency of a flexible material, the
> attraction of a blank page loaded with a single sign, of the virgin beach inviting the
> invention of the exact line, all of this seems to me to be a realism of a better quality
> than the overloading, the grimaces, the pseudo-Russian conventionalism of *Miracolo
> a Milano*; all of that far from being a disservice to the intentions of the cinéaste, gives
> him a new accent, present day, that touches the modern man in us and already serves
> as a witness to the period as precisely as the story does; all of that deals with the
> honest man of 1953 or 4: that's the real subject.[7]

Rossellini was the one neo-realist director who most clearly carried into
the fifties the promise inherent in the movement in the forties. He was
also the example of the farthest development of that realist aesthetic, that
conception of the cinema as truth, which was one of the few ideas upon
which all of the *Cahiers* group would agree.

If the *Cahiers* group can be distinguished by an aesthetic based on
a knowledge and appreciation of cinema, the other directors who began
working in France during this period can best be identified by their in-
terests outside of the world of film. Both those directors known as the
"left bank" group and those identified with cinéma vérité, or direct cin-
ema, came to film as a means of dealing with interests which they ulti-
mately felt could not be expressed through other media. It is a sign of the
continuous importance of film in French cultural life that avant-garde
movements have always seen it as a viable means of expression, as a
medium which should be explored. At the same time those who were
associated with early expressions of the vérité movement originally turned
to film as a more accurate method of recording anthropological concerns.

The "left bank" directors are usually considered to include Alain
Resnais, Agnès Varda, Chris Marker, Alain Robbe-Grillet, Marguerite
Duras, Jean Cayrol, Henri Colpi, and Armand Gatti. They are all gen-
erally older than the *Cahiers* group, and many of them were already
established in other fields before turning to film. Their concerns are both

more political and more intellectual than the *Cahiers* people. In terms of influence on the visual aspects of their films, it is important to note that both Varda and Marker were professional still photographers before turning to film. Resnais had a long interest in comic strips which would influence not only the editing of the image but also its construction. At the same time the literary interests of Duras and Robbe-Grillet are part of the movement known as *le nouveau roman*, which was a revolt against the traditional French novel not unlike the *Cahiers* revolt against the traditional French film. Thus even though this group did not share the *Cahiers* concern with film history, and even though their stylistic interests are more closely related to problems of time and narrative structure than the *Cahiers* critics, they did share with this group a revolt against traditional forms and a search for new means of expression which led them to look for cinematographers who could help them express these interests.

Although Jean Rouch usually photographs his own films he is also a part of the critical climate of France during this period. His use of film for his ethnographic work led to his later experiments with combining fiction and fact and the use of fact in cinéma vérité. His work not only indicated certain kinds of subject matter, real peoples' lives, but also an approach to the use of the camera. He demonstrated the effects that could be had with the use of small, portable, lightweight equipment without lights, in direct sunlight. Rouch pointed the way toward a kind of realism not unlike that of Rossellini, even though Rouch started with a recording of facts and moved toward narrative, while Rossellini moved from fiction toward the inclusion of more and more fact.

The attitudes represented by both directors and critics during the forties and fifties in France grew out of the two major influences—the presence of the American cinema and the rise of Italian neo-realism. The criticism engendered by the interest in the American cinema led to the formulation of theoretical positions which favored a move toward what was considered to be an increased realism of representation on the screen. This move toward the realistic image was reinforced by the neo-realist movement and encouraged by such early uses of direct cinema as Rouch's *Les Maitres fous* (1954–55). But the emphasis on both the American and Italian cinemas led to conflicting approaches to lighting.

The Lighting Heritage

Ever since World War I, when its production surpassed that of the French industry, Hollywood's very existence has been an element in the development of every other nation's attitude toward film. Whether it is to be

imitated, adored, or rejected, the American cinema is always a factor in any stylistic consideration of film. The French industry and its technicians went through all of these attitudes during the period after the Second World War in an attempt to develop a national character of their own. It has been mainly in the area of technical expertise, the quality of the image (as well as sound, of course), that Hollywood has established standards of competence—that "Hollywood gloss"—which anyone making films must acknowledge, consciously or unconsciously, as an influence. Direct imitation has always been difficult because there are few countries that have had industries as large and stable (and free from destruction through war) as has been the American one over such a long period of time. The admiration of the young French critics was shared by those who were training for the technical side of film creation as well. They were, for the most part, people who did not drift into film the way the early masters did, beginning in the silent period and growing with the art. Instead, these people were aware that cinematography could be a career and that it had a past as well as a future. Among those interviewed, the majority went to technical schools specifically to become cinematographers. Even those who were not formally trained as cameramen demonstrate an understanding of the traditions of their craft which is quite different from the responses of the Hollywood cameramen.

In France there was, of course, a prewar tradition of quality photography not unlike that which existed in Hollywood, an attempt to make the French product look as technically perfect as its American counterpart. But the cameramen who came into the industry after the war were just as eager to rebel against conventions as were the young directors. Many got training in those same shorts which provided experience for the directors. They became aware of the same critical climate which was influencing those people with whom they would soon work on larger feature films. They could not, however, use Hollywood as an expression of their rebellion against the establishment, since the aim in the French industry was to approximate the established American standards. (It could only be an approximation since there was never enough equipment on most productions for the "full treatment.") For them the stylization of *film noir* lighting was just an extension of certain traditional concepts, such as an insistence on the bizarre and the unnatural. But these changes really only emphasized the rejection of realism for which Hollywood was famous. In *film noir* lighting there is no attempt to associate the light and its source. There is a sequence in Jacques Tourneur's *Out of the Past*, photographed by Nicholas Muscuraca, where a character is seated next to a lamp, but it is the side of his face next to this source which is in

shadow while light from some unidentified source illuminates the other side of his face. Perhaps the only possible influence of *noir* would be the absence of special close-up soft lighting for female stars, which did represent a break with tradition that was continued in the later French cinema.[8]

The real revolution in lighting in the late forties took place in Italy. In an article in *Film Culture*, Nestor Almendros details the extent of this revolution and the Hollywood situation which preceded it:

> For 25 years cinematography, especially that of interiors, had been chained to a series of rules and precepts that Berlin had created and Hollywood imposed: every scene should be lighted with four basic sources: 1) Key Light, which modeled the subject; 2) Filling Light, to fill the excessively harsh shadows produced by the key light in the subject; 3) Back Light, the light that comes almost in opposite direction of the camera and that creates a halo around the head or the body to detach it from the background; 4) Background Light to emphasize the sets.[9]

He continues by explaining that even when the great cinematographers like "Shufftan, Périnal or Toland tried to transcend these rules, they . . . usually fell into artificiality and false virtuosity."[10] He extends his criticism even to the deep-focus lense developed by Toland, where everything was in focus from three inches to infinity. "As you see there is nothing further from human vision than this monstrous mechanical eye with such an optical precision."[11] Because the postwar Italian cinema was rejecting everything represented by the prewar "white telephone" attitude toward film, realism became of supreme importance for the cameraman as well. Almendros details the career of G. R. Aldo, who often worked for Luchino Visconti until his death in an automobile accident during the filming of *Senso*. Aldo had no previous experience as a cinematographer when Visconti asked him to work on *La Terra trema*; he had been a still photographer for film and theater. Perhaps because he was not indoctrinated in the existing traditions, Aldo was able to avoid them.

> Some fashionable techniques to today were included in this film: exposing for the shadow; high-key lighting; general low exposure getting insuperable richness and density of tones; shooting under very poor lighting conditions considered tabu in the past. The lighting of the actual interiors started from natural light that was coming through the windows and doors, helped by the artificial light, but always through veils or bounced against walls or boards making it much more similar to real daylight, and avoiding the clean-cut glamorous aspect of studio lights.[12]

But it was not only the glamorous quality, or the lack of reality, which French cinematographers found objectionable in the Hollywood "look," it was also the rigidity with which this "look" was applied. They

objected to the very attitude which many Hollywood cinematographers find the best thing about their work—the recognizable signature.

> My signature became established as high-contrast: they'd always say 'use more light,' but I liked shadows. A lot of fellows could recognize my works straight away, no matter who was directing.
>
> —Leon Shamroy[13]

> You can follow my style like a thread through many director's films. Ever since I began Rembrandt has been my favorite artist. I've always used his technique of north light—of having my main source of light on a set always coming from the north. He used to have a great window in his studio ceiling or at the end of the room which always caught that particular light. And of course I've always followed Rembrandt in my fondness for low key. You look at his paintings, you'll see an awful lot of blacks. No strong highlights. You'll see faces and you'll see hands and portions of clothing he specifically wants you to notice, but he'll leave other details to your imagination. Of course, film is transparent material, unlike canvas, and sometimes too much light gets through it, and you are apt to see things I might not want you to see. But I like to highlight significant detail, and I have been able to do this in spite of a great variety of directors.
>
> —Lee Garmes[14]

> I guess in that picture I really 'got' my style of having shadows hard and very bright highlights indeed, with the furniture heavily oiled.
>
> —Arthur Miller[15]

Of course, not every Hollywood cinematographer is obsessed with signature and personal style. But often even an approach which seems to reject a certain kind of artificiality for a more naturalistic attitude develops into a rigidity where that, too, becomes the only way to photograph a film.

> I have a basic approach that goes on from film to film: to make all the sources of light absolutely naturalistic.
>
> —James Wong Howe[16]

No matter what the attitudes expressed, these remarks by Hollywood cameramen really stem from one source—a lack of respect for the work of the director. These cinematographers were all working in "pre-auteur" Hollywood, where the great majority of directors were considered hacks, and where the prestige picture was the quality adaptation of a great literary work. When the role of the director becomes unimportant, the obvious response is to develop a personal style which will transcend it—produce great pictures by working around the director rather than with her or him. The French situation was radically different. In the first place, the absence of a strong studio system meant that an individual had

greater mobility. The cinematographer who is not under contract, assigned to pictures, can choose (within economic limits) appealing work. At the same time the director can also select the personnel that she or he prefers. Each project ideally becomes the result of mutual consent and mutual trust. And second, and most important, in the late fifties the younger cinematographers understood and agreed with the aims of the new directors. They were a part of the same aesthetic revolution, although they may have slightly reversed its order. Rather than using the American cinema to attack the French, they rejected the Hollywood visual style precisely because it had set the standards which determined French lighting as well. In their interviews, the concept of a single style which is always applied is rejected. And instead the collaboration between director and cinematographer, the adaptation of style to film, becomes a constant of their aesthetics.

6

An Investigation of Style:
The Application of Style Markers to Text

In a flash I understand
how poems are unlike photographs

(the one says *This could be*
the other *This was*

The image
isn't responsible

for our uses of it
It is intentionless

Adrienne Rich, "The Photography of the
Unmade Bed"

A Brief View of the Classic Style

There is a wonderful scene in Vincente Minnelli's *Undercurrent*, an argument between Robert Mitchum and Robert Taylor. It takes place in a stable during a storm and is lit (apparently) by a single lantern which swings back and forth in the wind creating strange shadows on the walls. With each swing the changing patterns of light and shadow on the faces of the two men indicate the fluctuations in their conversation. Elaborately lit by Karl Freund, this scene is a deliberate abstraction of a natural effect. Freund has taken elements which exist in nature, lights which could exist in the "real world" and refined them, so that the shadows exist simultaneously and obviously as signifiers on the denotative and connotative planes. A primary characteristic of "classical" Hollywood lighting at its best is the creation of a connotative atmosphere whose signification is readily understood, the heightening and refining of a real situation so that it adds to the appreciation of the scene. In the same way, the deliberate harshness and ugliness of *film noir* lighting has an immediate existence on the connotative plane in the presentation of the world of the film. But it is not just the recognizable level of connotative lighting (which, of course, does not necessarily exist in every sequence or every scene of a film) which is an indication of Hollywood style, and by extension what might be called more generally the classical lighting style.

On the denotative level as well, the image presents certain distinctive characteristics. In fact, "classical" becomes the perfect term to describe a style of photography in which the characters, especially in medium shots and close-ups, bear close resemblances to Greek and Roman statues known in the art world as classical. The careful molding of features which is the result of an extreme modulation of light and shadow represents a similar attitude toward the recreation of reality as that exhibited by not only sculptors but also painters up to the nineteenth century—the use of light and shadow to convey volume, the creation of a modeled rounded image. In the Hollywood film this style meant that facial contours could be emphasized at the same time that facial blemishes could be minimized. In the case of close-ups of stars, this glamorization was often taken to extremes. Even the increased angularity of the *film noir* and the ensuing rise in a kind of ugliness in the close-up meant that while there was often no attempt made to beautify the face (there are often deliberate cast shadows from the nose onto the side of the face which would have been unacceptable a few years earlier), the image still retains its sculptured

quality. There has not, as yet, been a definitive study of the "classical" Hollywood product, but a certain number of its attributes can be suggested. There is, perhaps, one basic and overriding principle which governs not only the image but also the story told through that image—the classic Hollywood film attempts to recreate, to reproduce, to provide the illusion of a kind of reality, of life as it might be. The concept of the studio film is, then, not that different from the concept of studio art—both idealize perceptions, eliminate blemishes (or exaggerate them). In this regard it is important to recall the overwhelming influence of German Expressionist film in setting the visual style of Hollywood. The following statement by Alfred Barr, Jr. might well apply to the classical film as well as German art.

> German art is, as a rule, not pure art. It is significant that German painters do not concern themselves over-much with still-life, nature *morte*, and that German sculptors are usually not satisfied with torsos. They frequently confuse art and life. Impressionism implies subservience to nature; expressionism implies subservience to the human imagination.[1]

In terms of the style markers presented in Chapter 4 the classical style is neither predominantly high-key nor low-key—although at times one or the other of these aspects of contrast ratio have been associated with it (the high-key quality of the MGM musical, the low-key atmosphere of *film noir*). The intensity of the light tends to be soft rather than hard, especially in the close-up. Lighting direction, except in the previously noted case of *film noir*, tends to follow the traditional three point system—a triangular arrangement of key and fill lights. The general softness of the lighting results in soft shadows which emphasize the contours of the face blending together to create a rounded image, rather than an angular one even in the most dramatic shot.

The first major break with this approach to lighting (discounting early silent films) occurred, as has been noted, with the Italian neo-realists. Ingrid Bergman's confrontation with the statues on her trip through the museum in Rossellini's *Viaggio in Italia* is not just a meeting of past and present; it is the juxtaposition of the old and the new in film lighting as well. This opposition is again made visible in two films by Godard. Within the self-reflexive context of *Le Mépris*, the classical statues serve as a commentary on the inadequacies of the real performers, the distance between myth and reality, in the same way that their stone faces, sculptured bodies and painted eyes are contrasted with the sensual softness of Brigitte Bardot. Fritz Lang will never finish his film because that kind of cinema no longer exists, just as it would be impossible for the technicolor

technicians to dominate Raoul Coutard. In *A bout de souffle* the changed attitude toward lighting is made visible at the moment Jean Seberg places her head next to that of the Renoir portrait of a young girl—a revolution in photography and art.

The constant references to art history do not suggest that there is a one-to-one relationship between painting and film (or that one should adopt that art historian approach of comparing specific paintings and stills), but it is evident that there are certain similarities in the visual style of the modern French cinema and that of the French Impressionists. Both share the respect for the natural world, that "subservience to nature," which is manifested in an attempt to capture the moment rather than recreate it in the studio. Both approaches also represent a break with traditional modes of working with their subjects. Auguste Renoir's belief in the importance of nature, "An artist under pain of oblivion must have confidence in himself, and listen only to his real master: Nature,"[2] is certainly reflected in the statements of many modern French cinematographers. Rabier cites as one of the most important lessons he learned of an old French director: ". . . he told me not to spoil the light that exists in nature."[3] The director also must understand nature: "I'd like to say that if you don't know light, if you don't love light, if you don't love painting, if you don't vibrate with light, it can't be helped."[4] Raoul Coutard states in an article,

> And a film cameraman ought never to let himself forget that the eye of the spectator is naturally tuned to full daylight. Daylight has an inhuman faculty for always being perfect, whatever the time of day. Daylight captures the real living texture of the face or the look of a man. And the man who looks is used to daylight.[5]

These statements provide a sharp contrast to the attitudes toward the natural world implied in some of the remarks made by Hollywood cameramen cited in the preceding chapter. But a presentation of the French attitude does not, of course, suggest that a more traditional attitude toward lighting is ignorant of the light that exists in nature. What is suggested in the two approaches, and what is confirmed throughout the interviews with the French cameramen, is a basic difference in attitude toward their work. The Hollywood cameraman claims intervention at all levels of the creative process, while the French cinematographer works with the director at the same time that he constantly attempts not to control or alter, but rather to reveal what is already present.

In Hollywood, recent attempts to assimilate the French, and by extension modern European, style have meant the introduction of Europeans into the Hollywood system as was done earlier with the German

invasion. In addition to the six cameramen under consideration (of the six, five have worked with American directors), Jean Boffety was brought to the United States to film Robert Altman's *Thieves Like Us* (Willy Kurant was also considered for the job), and Raoul Coutard has filmed such American productions as *The Southern Star* (directed by Sidney Hayers, a British, French, American co-production) and *The Jerusalem File* (directed by John Flynn). Even the traditional Hollywood cameraman has responded to this changing style in words, if not in actual lighting practice.

> I'm very sympathetic with all the cinematic changes that have taken place in Europe in the last ten years or so. We try to be too perfectionist here, and that makes everything look too manufactured. I've always followed the 'European' look. I was 'New Wave' long before it came along![6]
>
> —Lee Garmes

Although it may be hard to find any evidence of Lee Garmes's claims in his work, such cinematographers as Haskell Wexler, Vilmos Zsigmond, and Laszlo Kovacs are attempting to break with many of the conventions of the past. In some of Zsigmond's statements there is a curious blend of the attitudes exhibited by the French cinematographers who have been interviewed, and of the published views of the Hollywood cameramen.

> But the most important thing is how you work with your director. The cameraman has to be a partner with his director. It's a partnership. It's my picture and his picture together and it's one film. I mean, you want to create a certain style together. The cameraman shouldn't have his own style because with it he might kill the story, he can kill the director's concept. Together they should create a style for that particular film. And that's why I think a good cameraman should be able to make his films look different—every single time.[7]

He affirms the joint possession of the film with the director at the same time that he affirms that adaptability of style which is part of the expressed attitude of the French cinematographers who have been interviewed.

A General Description of Modern French Lighting Style

The new French approaches to lighting represent both a revolution and an evolution—evolutionary in development and revolutionary in scope. This approach evolved through the fifties, finding its first expression in feature films in the early work of young directors such as Malle, Godard, et al., and the more recent work of older directors such as Melville, Bresson, Welles, and Buñuel. Its evolution can be seen in the development of Decae, whose early work with Melville on *Les Enfants terribles* is quite traditional by present standards, and the distance traveled can be mea-

sured in the difference between this film and *Le Samourai*, a more recent collaboration of the two men. The distance between the two films can be suggested by a comparison with the accepted Hollywood standards in the later film as opposed to their presence in the earlier one: a relative absence of dramatic shadowing and a rejection of the modeled sculptured "look", resulting in an increasingly flattened or angular image. In contrast to Hollywood's rather erratic attitude toward the depiction of the source for the light, French cinematographers regularly include either the possible source itself or a suggestion of it in the frame. There even seems to be a certain preference for a consistent approach to the direction of the light— frontal and above when possible, and a relative absence of back lighting. This directional preference is linked to a refusal of the kind of glamor generally associated with the photographing of a star, and generally the lighting does not change from a long shot to a close-up. All of these stylistic devices are present to a greater or lesser extent in the work of the six men under consideration, and form the individual traits of what can be considered in a general way as components of a context.

Each trait must be discussed individually as a part of the application of style markers which should result in a definition of this style—a definition which can then be further refined in certain cases as a test of the individual style or idiolect within the larger group context, when such an idiolect demonstrates a significant development of the collective style. At the same time it should be recalled that Enkvist's definition of style deals in probabilities and ratios rather than in absolutes:

> The style of a text is a function of the aggregate of the ratios between the frequencies of the phonological, grammatical, and lexical items, and the frequencies of the corresponding items in a contextually related norm.[8]

In this case context has two meanings. The first is the way that it has been used to define the specific context of this study, the modern French cinema, but in a more general sense the classical Hollywood cinema as it has been presented forms yet another, larger context which intersects with this more recent and more specific one. Of course both of these contexts can be seen as part of an even larger context—the commercial feature film as opposed to the industrial or educational film, for example. The presentation of the kinds of stylistic expectations generated by the classical approach serves to delineate those areas where style markers are found and the way in which a shift in style establishes a new norm with a new set of probabilities—a kind of opposition of markers found in one context with those absent in the other context and vice versa. This is another way of arriving at Enkvist's proposition that, "The style of a

text is the aggregate of the contextual probabilities of its linguistic items."[9] The primary text is the classical Hollywood film which establishes those traits which may or may not be present in the secondary one of the modern French cinema. This secondary text can further be defined as the collective work of the six cinematographers under consideration both as individuals and as representatives of a larger movement. The description of the collective style is based on the frequency of the occurrence of these style markers within the collective context. As these style markers appear in every frame of every film under consideration, and as the actual availability of film for this kind of study differs greatly from the kind of availability of a text for a literary stylistic analysis, and as this is in actuality a preliminary study suggesting theoretical possibilities for general stylistic analysis where none existed before, actual numerical frequency counts are beyond its scope and can only be suggested in general terms. In any case, numerical counts should be the result of the detailed study of a single film rather than the aim of a more general study of a body of work.

Intensity of Light—Hard or Soft

As has been stated before, this pair of terms refers to the quality of light as it emerges from the source. In the resulting picture (the image as projected, as opposed to the image as filmed) softer light produces softer shadows (the reverse is, of course, also true). With all of the cinematographers in this study there is a genuine preference for soft light, especially in the lighting of actors. But this preference is maintained only when it is valid in relation to the source of the light. Natural sources such as light coming in through a window provide a soft light for the center of the room as can be seen in the daytime scenes in *Les Cousins, Peau d'âne, La Gueule ouverte, La Rupture*. But the natural action of light is also maintained. If a character moves closer to a window with bright sunlight (a harder source), the resulting shadows are also harder (*La Gueule ouverte*, scene between mother and son); or, if the character passes through areas where the sunlight varies, the shadows change as well (the streetcar ride in *La Rupture*). As the light becomes softer the farther the subject is from the source, when artificial lights are the suggested source (lamps, for example) the intensity will vary with the subject's movement. In the interior of the palace in *Chimes at Midnight* the source is strong sunlight which enters from the windows, but as the king moves, the light varies from hard to soft. When characters move about the casino in *La Baie des anges* the light is harder when they approach the lamps that illuminate the gambling tables and softer as they move away from these sources.

And in *Les Amants* when a character turns off a strong overhead source the shadows become softer.

In exterior sequences the softer light associated with the overcast day and the absence of hard shadows is also preferred when possible. Hard shadows then become a specific indication of a region known for its sunlight or for a time of day when the sun is strongest. The shift between Newfoundland and the Barbados in *L'Histoire d'Adèle H.* is mainly indicated through the transition from soft to hard shadows. This transition, which is also maintained with harder shadows in the Guernsey sequence, is of particular importance in this film because there is a concurrent attempt not to emphasize the bright colors which would normally be associated with the Barbados. Such a color shift would have disturbed the mood of the film at this point (too much brightness would create too large a discrepancy between Adele's degenerating condition and the happiness usually suggested by bright sunlight).

Although the hard or soft image occurs as a response to the intensity of the light source as it would exist in the real world, the general preference for soft light must be the result of practical considerations as well. Since soft light causes soft shadows there is less chance of strong shadows affecting the image. With the time and budgetary conditions of most French cinema, the cinematographer cannot eliminate unwanted shadows through the careful and often tedious means of balancing many different lights, as is done in the classical cinema. But while economic necessity may have occasioned this response in the late fifties, by now it has become part of the aesthetic of the French cameraman, and even in those situations where Hollywood lighting is possible it is not chosen. Another reason for the use of soft light is related to the problems generated by the directorial aesthetic of the long-take or the shot with much camera movement. In films where these factors are present, soft light allows a freedom of movement without elaborate lighting set-ups. (In the classical Hollywood situation such lighting could be accomplished with complicated use of multiple lights whose intensity might be varied during the take.) As the soft light is not used specifically to create glamorous close-ups but rather as a part of a practical and functional approach to lighting, even the softest lighting may also be accompanied by hot spots, areas where the light is reflected in shiny spots, especially on actors' faces. There is also no greater frequency of hot spots when the light is hard rather than soft.

In respect to the intensity of light there is considerable unanimity in the approaches of all of the cinematographers with little deviation into idiolect. The sole exception is the early work of Henri Decae, where he employs a harder light in conjunction with a more modeled classical approach to lighting generally. But even in a film like *Les Enfants terribles*,

where this tendency is rather pronounced, there is a certain softening which occurs toward the end of the film suggesting his later development. And this softening occurs in night sequences when there is no specific source indicated, rather than in the majority of sequences which are lit by what would, in any case, be considered hard sources. Yet even the soft light in *Les Enfants terribles* retains that sculptured look which is absent from his later work, even those films such as *The Only Game in Town*, which were made within a classical feature framework. In a comparison of Decae's and Rabier's work with Chabrol, Decae does seem to avoid hot spots with greater frequency than Rabier, one aspect of differences between them which can be ascribed to individual choice.

Contrast Ratio—High-key or Low-key

There is no single tendency toward one extreme or the other which can really characterize the French approach to these alternatives. As with the intensity of light, high-key or low-key lighting occurs as a response to a specific situation rather than as a standard attitude. Because of the general concern for an adherence to light as it would occur in the real world, interiors are often rather low-key. When the sources are lamps the light is brightest at the source, with a rapid fall-off as the distance from the source increases. At the same time, when large windows are considered sources, or when overcast exteriors are used, the overall effect is more high-key. In any case the extremes associated with either *film noir* (low-key) or musicals (high-key) do not generally exist. There also seems to be no attempt to make the connotative associations—of high-key: happiness or comedy; low-key: seriousness or mystery—which is often made with the classical cinema. Individual films by individual cinematographers may be considered as high-key or low-key, but this is a function of setting (a film that uses a lot of night sequences like *Masculin-féminine*). While most films move in and out of these extremes (*Le Charme discret de la bourgeoisie, Trans-Europ Express, Mouchette*, etc.), even among the individual cinematographers there is so little difference in approach that there is no suggestion of idiolects in this area. Thus the contrast between high-key and low-key is not a style marker because of the dominance of one approach over another, but rather because of the very lack of this dominance, the adaptability exhibited as a response to the natural situation.

Direction and Coverage of Shadows—Front Light, Side Light (left and right), Three-quarter Light, Back Light

The direction and coverage of shadows is again the result of the relationship between the object and the source. The general preference with the

cinematographers in this study is for either a frontal light which is also above the subject or a side light (right or left) where half of the face in a medium shot or close-up is in shadow. There is almost no use of lighting where the top half of the face (or the bottom) is in light and the rest in shadow. One of the rare instances is a conversation between Jacqueline and the delivery boy in *Les Bonnes Femmes*, where this effect is the result of the particular arrangement of doors where they talk. Less rare, but still relatively infrequent, is a three-quarter lit shot or a shot where the face is in three-quarter shadow. Some instances of both of these approaches can also be seen in *Les Bonnes Femmes*, and some examples of three-quarter light on a face in *Ophelia* and three-quarter shadow in *L'Histoire d'Adèle H.* and *Chimes at Midnight*, but these are still relatively few in number compared with the frequency of the other two approaches. There is also an almost complete absence of conventional backlighting. One reason for this absence is the fact that side light often lessens the need for backlight (light which distinguishes the object from its background) because the spill from side light already helps to separate the subject from the background.

Contre-jour techniques (when the light which illuminates the subject is opposite to the side from which it is viewed) are used when they would naturally occur. In *Le Feu follet* characters are filmed in front of windows, and in *Le Genou de Claire* characters are almost silhouetted by the sunlight behind them. Some of the shots on the beach in *La Baie des anges* make the same use of sunlight. But even *contre-jour* effects as a variant of backlighting seem to grow out of a character's movement into a particular relationship to sunlight, rather than as a kind of dramatic point which was specifically chosen for its visual impact—another aspect of the general avoidance of shocking or startling effects unless they grow naturally out of the decor.

The preference for frontal or side positions is another example of simple, practical solutions to the problems posed by the shooting situation. Both of these directions lend themselves to quick, uncomplicated lighting setups with a minimum of obtrusive facial shadows. When the frontal light is slightly above the subject, contours can be indicated while the resulting shadows are cast downwards. A similar effect is achieved with side lighting which seldom reaches extremes of contrast, but instead results in a soft shadow over one side of the subject. Certain differences do emerge between some of the cinematographers in a preference for either frontal, side right, or side left. Almendros uses both frontal and side right (source on left, shadow on right) with equal frequency but seems to avoid side left when possible (when not dictated by specific sources). Rabier seems to prefer frontal light, often from a central source,

when his choice is not dictated by a visible source in interior shots. In shots lit from the side there seems to be a slight preference for shadows on the left side. In many of his films Decae prefers side light, with the shadow on the right and less directly frontal light than Rabier. Cloquet would also seem to prefer shadows on the right, especially in *Le Feu follet*.

Location of Shadows—Object on Self, Object on Others, Others on Object, Not Connected to Primary Object

The location of the shadow is directly related to its direction and coverage, on the one hand, and to its source on the other. As has been noted, a source which is above and in front of the object will result in shadows which are cast downward. While the intensity of the source dictates the hardness or sharpness of the shadow—whether it will be a soft blur or a clearly defined shape—proximity to the source also influences the quality of the shadow. Even a relatively soft light may create a distinct shadow if the object is closer to the source.

In general, these cinematographers seem to be less concerned about cast shadows and especially those cast by the subject on itself than do their classical counterparts. While frontal light eliminates certain shadows it creates others, especially cast shadows from hair, eyelashes and other features, onto the face and body. There is little evidence of any attempt to avoid these shadows. They often occur, even with soft light, but in such direct sunlight situations as the beach in *La Baie des anges* they are particularly pronounced. In many scenes in *L'Histoire d'Adèle H.*, Adèle sits close to a source, resulting in frequent cast shadows on her neck and other parts of her body. Both Almendros in this film and Cloquet in *Love and Death* make no attempt to eliminate the shadows cast on the face by glasses worn by characters. As has been suggested, side lighting which is soft with one-half of the face in shadow often eliminates specific facial shadows. This is especially true of nose shadows (shadows cast from the nose onto the rest of the face), which are difficult to handle in a lighting setup and which can be very distracting for the viewer. While general soft lighting eliminates this problem there is often no attempt made to hide it through the creation of the traditional triangle of light (a triangle formed with the nose shadow blending into the side of the face and a small triangle of light formed by this blending together under the eye) in hard light situations. In *L'Histoire d'Adèle H.*, where several instances of this problem occur as Adèle sits next to a lamp while writing her journal, Almendros allows the nose shadow to show, but he controls it by making certain that there is only a single shadow which remains consistent with

the source—another example of the fidelity to reality rather than the idealization of it found in the classical cinema.

As with the shadows cast by the object on itself, the modern French cameraman makes no great effort to avoid the shadows cast by the object on others. In classical lighting, especially in close-ups and medium shots, an effort is usually made to avoid having one character cast shadows on the other. Of course, many times these shadows are unavoidable, and examples can be found in the classical approach. Among the six selected cinematographers there are no real stylistic distinctions. The major stylistic differences which can be cited between their use of this kind of shadow and the classic use of it relate to those previously indicated distinctions between the soft and hard shadows.

There is, however, a secondary aspect to the shadow cast by the subject, and that is the shadow cast, not on another character, but on a surface. Often in classical lighting this type of shadow is part of the diegesis or is integrated thematically (the "x" in *Scarface*, the shadow of the vampire in *Nosferatu*). There are only rare instances of diegetic cast shadows in the modern French cinema. In *Leda* the shadows cast by the characters in the exterior sequences serve as time indicators in a film which takes place in one day. In *La Rupture* the shadow is directly connected to the dialogue. As the balloon man passes Helene he casts a long shadow at the same time that he tells her, "I see you have lost your shadow." The appearance of shadows in a non-diegetic sense is extremely common. The frequent use of frontal light would, in any case, increase those shadows cast behind characters, and in cases where there are multiple sources for the light there are multiple shadows. There is seldom any attempt to eliminate multiple shadows if these would occur normally. (In the classic cinema, multiple shadows are consciously avoided.) Because of the relative absence of backlight or light from more than one source, cast shadows of this type appear in the work of all six men. Rabier's preference for frontal light does increase the number of these shadows in his films. Among the other cinematographers there is no significant difference in this aspect of style. The relative absence of diegetic shadows may be the result of their general agreement that they in no way interfere with the director's telling of the story.

But in the area of shadows cast either on the subject or on adjacent surfaces by other objects there are important stylistic differences. In Decae's work there are frequent examples of decorative or non-diegetic shadows cast by objects onto walls. Bannisters, especially those on stairways, cast shadows on the walls in *Leda*, and in *Les Cousins* the railings on the sun deck cast shadows on Paul and Charles. When Leda and Henri go for a walk, the leaves create patterns on their faces. In Leda's house the

pattern of the Japanese doors is reproduced on the walls. Such patterns are much less frequent in the work of the other cinematographers where, if they do appear, they seem related to the diegesis. In *Adèle H.* they are functional, indicating through lighting the difference between earlier settings and the Barbados. In the Barbados sequence, the hard light creates distinct patterns of leaves on the walls as Adèle walks through the city. In *Le Procès* there are many extreme examples of dramatic cast shadows of all types, but as these do not appear in other work by Richard and are obviously related to Welles's earlier work with *noir* type lighting, they should not be included in a discussion of Richard. What is important is that even in a film which is so heavily influenced by Welles's previous work, the dominant distinction of an absence of modeling which characterizes the French approach is still evident. The more "decorative" use of the cast shadow which appears in Decae's work indicates an aspect of his idiolect which is absent from the work of the other men.

Relationship of Source to Image—In Frame, Suggested, Not Suggested, Source Betrayed

In the context of the modern French cinema the cinematographer's relationship with the source is, perhaps, the most important indication of style. Since all of the people in this study express, in their interviews, a concern for natural lighting and a respect for sunlight as a source, it is important to trace the extent to which their expressed aims are fulfilled in their work. Some of the aspects of this relationship have already been suggested as all of lighting is essentially concerned with the nature of the source of the light. It is also in this area that the testimony of the individuals as to their actual practice is important. Although all profess a respect for natural light, some believe in giving nature more of a helping hand than others. Rabier states that there is always some form of lighting (reflectors, if not actual lights) in all of his exteriors (except for long, panoramic shots), while Kurant seldom uses additional light for exteriors and, at times, does not even use it for interiors. These differences have an obvious effect on the way in which the source is perceived in the frame. Distinctions must also be made between practices followed in interior as opposed to exterior lighting; one can usually assume a certain amount of artificial light in an interior (except in those cases where a window is the suggested or visible source), and then the problem is to distinguish between the supposed source and the actual source.

In exteriors when sunlight is the source it is obviously not necessary to have the sun in every frame. What is important is the faithfulness with which the natural interactions of sunlight and subject are portrayed. It

should, of course, be noted that exteriors (and the majority of the interiors as well) are shot on location, as the French say, *en décor naturel*, and that both the director and the cinematographer expect that the real light of the region be reflected in the final image. (In some cases the locale was simulated as in *The Only Game in Town*, but there was still an effort to approximate the local lighting situations.) In daytime scenes great care is taken to preserve the illusion of sunlight as the source. When the characters cast long shadows it is consistent with the time of day when this would occur. When no specific time is indicated the cinematographer prefers an overhead light (noonday sun) and an absence of cast shadows. Unless a specific location dictates the quality of the light (the hard light on the Riviera, for example), the softer light of a slightly overcast or cloudy sky predominates. Consistency in the sunlight source is maintained when characters ride in cars or carriages or are temporarily sheltered by beach umbrellas, the overhanging roofs of outside market stalls, or cafes. Street lamps serve as sources in nighttime sequences, and they usually appear in the frame at some point during the sequence. When characters ride in cars at night, the lighting always reflects the dual source of passing cars and street lamps. In costume pictures set in periods before the advent of electricity, Almendros takes great care to indicate the sources of light, and they are always shown at some point in the sequence. Of course, in almost all of the nighttime sequences additional light (more than indicated by the source) would have been used to obtain the proper exposure (especially with color film). But whether or not the suggested source is sufficient is not as important as the fact that the source is shown, and its direction and quality of light is respected.

The lighting of interiors is a much more complex situation, and it is here that individual differences most clearly emerge. All of the cameramen attempt to give the illusion of recreated reality, but it is the extent to which that illusion is maintained upon close inspection that separates them. In all cases there are generally understood sources which may or may not be actually shown during a sequence. In the work of Decae and Richard there seems to be more unidentified source lighting than in the work of the others. But even with these two men, when a source is available it is indicated. Cloquet prefers windows as interior sources when possible. As he sets his exposure for the interior, especially in *Le Feu follet*, these windows are almost overexposed and bleached out. When windows are positioned at the back of the frame, this results in a kind of back lighting which is, in part, responsible for the richly textured appearance of fabrics and faces in his films. While Rabier often includes a suggested source in the frame, generally a window, the actual lighting sources are more centrally located, particularly if characters (more than

two) are seated in a circular arrangement for conversations or meals. Both Almendros and Kurant show the suggested source in the frame more frequently than the others, but even with them there are times when the scene is lit by an undetermined source or the actual lighting in the scene comes from a source other than the one indicated.

The term "source betrayed" is, perhaps, too strongly stated to really apply to the modern French cinema. What is really meant can be broken down into two related concepts: the light necessary for the correct exposure would have to be stronger than that given off by the source (practicals—a stronger light than a fixture would have in reality—would also be included here as they are stronger than the indicated source); the light in the room comes from more sources (as indicated by shadows) than those suggested. In neither case does this indicate that there is a strong, observable difference between the light suggested by the source and that reproduced on the film in either quality or direction. In Rabier's work some medium and long shots reveal more shadows than could be cast by the suggested sources, but as ceilings are seldom revealed, additional real sources outside of the frame are not beyond the range of possibility. In closer shots he still maintains the direction and quality of light suggested by the source rather than the additional, unseen light. In cases where a source has been established, a two-shot direction is maintained in subsequent alternating close-ups. (Although at times the light might seem softer on the woman than the man, this is actually due to makeup rather than lighting.) In certain instances (scenes lit by nonelectrical source, daylight scenes lit by windows, etc.) the source may not actually provide the light for the scene, but low lighting levels consistent with the actual amount of light that would be available are retained (in the Almendros films already mentioned, several early morning shots in *Le Feu follet, Les Cousins, Juste avant la nuit*). There are also times when the absence of a source or the presence of an additional source may actually be due to the fact that the source has been established in a previous scene and its continued existence is assumed. This previously established source may often take the form of a light from other rooms which spills into the room where the action occurs (the bedroom in *The Only Game in Town*, the main room in the inn in *Chimes at Midnight*, the bathroom in *La Baie des anges*). In scenes where there is much character movment, direction from the original source is maintained even though additional lighting may be there precisely because the larger space which must be lit for extensive character movement requires additional lighting.

General Conclusions

In a broad sense the modern French style can be characterized by an adherence to an approach which attempts to recreate the image as it

would appear in reality. However, this adherence to reality is a concept which goes beyond mere imitation. The aim is not any reality, but a reality which is consistent with certain attitudes toward the natural world and the exigencies of the filmmaking situation. It should not be assumed that this approach is necessarily qualitatively better than a more classical means of dealing with the problems of lighting. As it is, in any case, impossible to capture a three-dimensional world in a two-dimensional format, what is being described is a different attitude toward the representation of that world. And a description of a style is not a judgment. When the classical style has been invoked, it has been for the purposes of comparison, so that quantitative differences could be measured. And of course the same is true of the differences among the six cinematographers. More and less are always meant as quantitative rather than qualitative terms.

Bearing these qualifications in mind, certain distinctions can be made. The collective style of these six cinematographers is marked by a simplified approach to lighting problems resulting in a flatter, less rounded image with the light generally above the subject, and either frontal or lateral in direction. Great attention is placed on the source of the light and its relation to the subject. Sources are generally indicated when possible, and direction and quality of light are maintained throughout a sequence. Less attention is paid to cast shadows. There are relatively few deliberate non-diegetic or decorative shadows, but many shadows are cast onto the object or adjacent surfaces.

Individual differences are again quantitative rather than qualitative. With Decae's work, which spans a longer time period than that of the others, there is a certain progression from a more classic approach in his earlier work to a style consistent with that of the others. All of the individuals exhibit a great deal of flexibility, and idiolects emerge as preferences. These preferences can be expressed either as the presence or the absence of certain characteristics. The continued presence of decorative shadows in Decae's work is a part of his idiolect, while its absence (relative) in the work of Rabier becomes an expression of his idiolect as well. Almendros, whose use of the decorative shadow lies somewhere between the two, exhibits a quantitative difference in his idiolect. Thus the identification and examination of style markers leads to the isolation of certain characteristics which form a general style. Within that general style there are quantitative differences which become expressions of individual styles or idiolects.

Yet on the individual as well as the more general level the whole is greater than the sum of its parts. The totality of the modern French approaches, as well as that of the six cinematographers, resides on the connotative as well as the denotative level. For the moment that concepts of relation to the real are introduced, certain connotations are also im-

plied. But these connotative implications still reside on the more general level of the body of work as a whole rather than on a specific film. A detailed study of the work of a single cinematographer would ultimately have to deal with the relationship between connotation and denotation in each film—a study of constants and variables. But even in this more general survey it is important to note that with these six cameramen and with the modern French cinema in general, it is the very absence of stylistic "ticks" and the presence instead of certain preferences which can be adapted to the needs of the situation which constitutes a style. Transparency is in itself an attitude and a stylistic approach. And within the already stated constructs of a general attitude toward the reproduction of the natural world, this transparency becomes one of the most important, unifying factors in identifying the individual and context. This is ultimately the stylistic summation of the viewpoints presented in the interviews, the constant rejection of a single approach, the denial of style. For these six men style is fluctuation, once a certain attitude toward reproduction of the real is established, and fluctuation becomes transparency.

7

Their Own Testimony:
Conversations with Cameramen

Les langues imparfaites en cela que plu-
sieurs, manque la suprême: penser étant
écrire sans accessoires ni chuchotement
mais tacite encore l'immortelle parole, la
diversité, sur terre, des idiomes empêche
personne de proférer les mots qui, sinon se
trouveraient, par une frappe unique, elle-
même matériellement la vérité.

The imperfection of languages consists in
their plurality, the supreme one is lacking:
thinking is wrong without accessories or
even whispering, the immortal word still
remains silent; the diversity of idioms
on earth prevents everybody from uttering
the words which otherwise, at one single
stroke, would materialize as truth.

Mallarmé

Setting the Scene

The following interviews were conducted in Paris, France, during the month of March in 1973. I wrote a series of letters to French cinematographers before the trip and had done a certain amount of research about their work, including reading any previous interviews, before talking with them. I formulated a series of set questions about their work and their attitudes toward camera work in general. When it was possible I followed these questions, but I also allowed each person to develop those things which seemed to interest him the most. Four of the interviews were conducted in a small café near my hotel. The interview with Henri Decae was conducted in his house, a beautiful home near the Bois de Boulogne which once belonged to André Gide. I met with Jean Rabier in his *pied-à-terre* in Neuilly. Four of the interviews were conducted in French. As both Almendros and Kurant spoke English, I chose to conduct those interviews in English largely because I thought it would be easier to have English interviews transcribed.

I have tried to retain the verbal style of the individuals as much as possible, and for this reason have retained the repetitions and hesitations which are part of normal speech patterns. I have followed Almendros's request to correct some of his more flagrant violations of English grammar and syntax. At moments there were short stretches of the tape that were unintelligible because of the background noises in the café. As these breaks were very short, they have not been indicated in the final version.

I have included checklists of films made by these men following each interview. These lists are, except in one instance, complete and approved by these men up to the period of the interview; some of them even supplied me with lists at the interview. In the intervening years I have attempted to update each list, but I can only safely say that I have included all films reported either in the English language press or in those foreign journals that make their way to the United States. There are, for example, no listings of the commercials made by Kurant. I asked Edmond Richard which films he wished to have included on his list, and the list here reflects his wishes, omitting the films he made in Yugoslavia. Where possible, in all lists I have indicated the director and year of the film, whether the film is in color (*) or black-and-white, and in a wide-screen process (+) in those cases where this information was available.

Some Notes on Terminology

"Cameraman" or "cinematographer" is the general term for the person in charge of the entire crew, the others being, in order of importance and responsibility, an operator (in charge of the camera), a focus puller, a clapper-loader, and a dolly pusher. The cinematographer's main responsibility is the lighting rather than the actual operation of the camera. In the United States this credit usually reads "Director of Cinematography" or "Director of Photography;" in France most people prefer the simpler credit of *Images* or *Chef Opérateur*. In the interviews, *Opérateur* can refer either, in the general sense, to the cinematographer, or in a specific sense, to the actual operator of the camera, a division of labor standard in the United States but often combined in a single job in France when the cinematographer prefers to run the camera.

In the checklists certain abbreviations have been used: "d." stands for director. Co-photographers are indicated by "co-ph." The abbreviation "ep." stands for a specific episode from a larger film, usually a film composed of several parts directed by different men.

Interview with Nestor Almendros, March 31, 1973

NA: Well, my background . . . I started by seeing movies.
SR: Well, this is the thing that interests me out of . . . just from other things I've read. You seem to be of a generation that's bringing a historical knowledge of the movies even into your work as a cameraman.
NA: Yes, probably, yes, I think so . . . because most cameramen haven't seen old movies, I think. Directors, yes. The reason is because I wasn't a cameraman to begin with.
SR: Right.
NA: I wanted to be a director. I first liked movies. I used to go a lot to the movies when I was a kid. My grandfather used to take me to the movies almost three times a week. He loved them too. My mother did, my uncle did. The whole family was crazy about movies in Barcelona. It was one of the cheapest entertainments. We were very poor then. And from there I really collected movie magazines and pictures of Marlene Dietrich, who was my favorite. I had a whole album with Marlene Dietrich pasted, you know, just top to bottom. And then from there I bought movie magazines and read some articles by a movie critic called Angel Zuniga, who by the way lives in New York now and has written the best movie history I think that exists in the world, called *A History of Cinema*, not *The History of Cinema* but *Una His-*

toria del Cine. And it was a fantastic book, and he used to be a reviewer.

SR: In Spanish?

NA: In Spanish. It's never been translated, and it's completely out of print. I mean it sold for 50 years.

SR: Yes.

NA: But you can find it in any book library, in any film library. And then I started realizing that cinema was an art form, not only entertainment, seeing movies in another, from another point of view. And I started going at 14 or 15 to a film club society that Zuniga had, where they showed silent movies which were already old then because they were silent movies and that was in 1945, '46. And so I saw all the German films: Murnau, Fritz Lang, Robert Wiene, all the classics. Some French films, too, silent. I was crazy about silent movies. I loved them but they were so much more exciting than the sound ones. For me they were the past also. And at the same time I went to commercial movies, any movie I could see. And then from there I decided that I should make movies.

SR: So how did you end up in Cuba?

NA: Well, because my family, my father was a Loyalist and he had to flee from Spain. And he chose Cuba as many other people chose Mexico, and others chose Argentina, or some chose the Soviet Union and so on, you know. He went to Cuba. It would be long to explain why. And then we followed him after awhile. Because we couldn't live with him and then we established ourselves in Cuba. That's why. And then we all become Cubans. We took Cuban citizenship. So my first films were made in Cuba, 8 millimeter, with friends from the high school and university. Those were my first films as both director and cameraman.

SR: Did you get any professional training?

NA: No, nothing. There were no schools there. We just saw movies. What we did is that. I remembered the film club society from Barcelona and I created, with two or three Cuban friends, the first film club society in Havana. That was in 1949. And then we got films. Cuba was an extremely good country for seeing foreign movies because it was an open market. They used to receive about 600 feature films a year from Mexico, Spain, USA, France, Soviet Union, every country. You could even see Philippino movies in Cuba, which is very strange. Indian movies, some . . . you know, they came from everywhere. So just by going through the renting companies, you know, it would be like in America or in England. There was not this intellectual feeling about movies.

SR: Yes.

NA: They were just entertainment, but there was no selection. I mean we got, I think we started with *La Bête humaine* by Renoir, our film program, then we got *Alexander Nevsky*, all this rented from just regular companies in Havana. Then we followed with Marc Donskoi. We loved at this time Soviet movies and French movies. They were our favorites. Still American cinema, I did like it, but the other people in the club, they didn't because they were Cubans, I mean Americans, you know.

SR: Yes.

NA: I mean in the continental sense of Americans.

SR: Yes, yes.

NA: So Europe shines more . . .

SR: Yes, it's always that way.

NA: They couldn't see that a good Western could be as good as an intellectual French movie.

SR: It's always that way.

NA: I finally got them to show *You Can't Take It With You*, a good American comedy. I had to fight with them because they didn't accept it. Later on they did. But at that moment they didn't. And, well, that's how it was. And we started doing these 8 millimeter movies. Then from there I went to the USA where I taught for awhile. That coincided with the dictatorship of Batista and I was exiled for the second time. And then I bought with my savings a 16 millimeter camera and I started making films again.

SR: Which kind?

NA: A hand-held reportage in the style of the Maysles brothers, although I did not know the Maysles brothers then.

SR: This was when?

NA: That was in 1956.

SR: That was just when cinéma vérité was just barely beginning.

NA: Just barely beginning, yes. And I met the Mekas brothers and especially a lady who I owe a lot to, who I love, who, of course, is Maya Deren. Maya Deren came to Vassar College twice to give a lecture, and I got her invited to the film club, the Student Film Society. She was a marvelous person. Not as much as an artist, but as a person. As someone, who, I think, America owes a lot to her, the underground movement, because she was like a sort of *éminence grise*. She was behind everything. She has so much enthusiasm. And she gave me some of this enthusiasm, you know. And her ideas were very correct. I think her ideas were better than her movies. You see what I mean. The things she said about the movie arts were really fantastic. And so

I started doing 16mm movies with a sound track then, not silent like in Cuba. I knew a little more. Oh, I forgot something. In between this time, I'd gone to Italy. And I started attending Centro Sperimentale di Cinematogrâfia, which I thought was a very bad school; so I left. I didn't finish the diploma. I just got one year. And also in New York city I took some evening courses at the Institute of Film Techniques with Hans Richter. It was very interesting, but very short. They had very little money. But it did help me a little, you know. So then from the USA there was the victory of the Cuban Revolution. I was full of enthusiasm. And I came back to Cuba. The few films I had done in New York, these underground films, allowed me to get a job in the Cuban Film Institute, ICAIC. And we did some films, instruction films for adults like boiling water for peasants and agricultural things and how to grow tomatoes. Not very interesting films, but that gave me some training. Of course, it was a state monopoly, and you had to accept what they offered you. You could not do what you wanted to do. And because I had the habit of protesting, of questioning everything, I very soon got into trouble again. And the director of this state monopoly did not like my attitude, did not like the fact that I wanted to do something else besides propaganda. And he started to be rough with me. He lowered my salary; he gave me bad jobs; he gave me the worst films, things that nobody wanted to do like this growing tomatoes and so on; he wouldn't give me any feature films; he wouldn't give me anything. So I realized, you know, as long as it was a state monopoly I could do nothing there. That's why I decided to leave, and I came to France. And I re-started my career in France.

SR: How did you become a cameraman once you moved here?

NA: Well, I went in and started doing this film with a director. There were no cameramen in Cuba. I mean none that I really liked. And also not only a question of liking, I couldn't take it. So I had to learn to handle a camera and to shoot my own films and since I was doing documentaries.

SR: This is still 16mm?

NA: Yes. Once I was doing 8mm and 16mm. I did 35mm very late in Paris, practically no 35mm in Cuba. And, you know, 35mm is easier than 16mm. So if you are good in 16mm, you can be much better in 35mm.

SR: Really?

NA: Oh yes, much easier. Everything looks beautiful in 35mm. In 70 mm anybody can make a great movie.

SR: Well, that's the way I feel about color. I feel that to do a good movie in black-and-white is a real art.

NA: It is much more difficult.

SR: Yes. Color hides a lot, I mean as long as you get your . . .

NA: 70mm in color, can't miss—always beautiful.

SR: So that's why I admire certain black-and-white stocks. Sorry black-and-white is . . . Nobody is really shooting in black-and-white anymore.

NA: Yes, I don't know. I used to be favorable to black-and-white, but I like color more and more. There is not enough information in black-and-white. I mean maybe because I'm nearsighted, my sight is decaying, but when I see black-and-white movies I just don't see enough. I think there's something missing, like I don't see if there is a tree in the background or just something, you know, the colors help you to see. People who have bad sight, they really like color.

SR: You shoot everything in Eastman now, right?

NA: Yes, and I regret it. I wish I could get other stocks but actually for *Les Deux Anglaises et le continent* I talked to Truffaut and he said because this is a film out to be sort of old-fashioned film and a little funny, how do you say it in English, funny or dated. We thought it should be a little faded. Like adding white which does not change, *la palette*. Painters have this thing; how do you call that in English?

SR: Palette.

NA: The palette, yes. And because Kodak colors are always the same. And no matter what you do with them you always have the same reds and the same, you know.

SR: Yes.

NA: Just changing the color, like going from water color to something. What to do. We could go to Agfacolor, which I remembered being a system which had defects, a little dirtier, and I like that quality. So I . . . so he said yes, "I like that." But Agfacolor had just discontinued its color film. And they were getting a new one, a better one, according to them. But before selling it in France, I mean Agfa-Gavaert, they wanted to try an underdeveloped country first. And then if it worked, instead of coming out in Paris and then finding out it wasn't good enough.

SR: Yes, yes.

NA: So I suppose that by now it might be good, and I would be very happy to use it. The last two films I've done, they were not suited for that you know. So I didn't want to take this because they were comedies and, you know, I wanted bright colors. I wanted Kodak, but if I do another like *Les Deux Anglaises et le continent* I will certainly look for another system. I think it's better than using filters and shades, or just changing the lights.

SR: Yes, well, with the filters you get into everything . . .

NA: Yes, so. What else?

SR: Well, we could start with when you started as a cameraman in France, you . . .

NA: Yes, when I came to France, none of the films I'd done were really very interesting, besides I didn't have them. They belonged to the Cuban movie industry. I only had two. And to survive, since I had learned the trade of how to make films, because I photographed my own, I decided or I thought it would be easier to make a living to start, to begin with as a cameraman than as a director because no one would trust me. And so I told people I'm a cameraman. Then I started to contact people and finally I met Rohmer who gave me a chance in *Paris vu par*, his sketch.

SR: Did you have trouble with the unions or . . .

NA: Yes, but you know, France has one advantage that there is no big industry here. There are not companies like Carlo Ponti or MGM or like in other countries, even in Spain they have bigger companies than here. It's just . . . you know, movies are made in cafés, *terrace de café*, some people get together and they talk and they say, "Oh, I have some money and maybe we can borrow because of *avance sur recettes*. The government gives money on the reading of a script they consider good. And then they get some money from television with a contract that they would give priority to television. And so a film is made. And since there are no big companies, there are no technicians on payroll. I mean on a yearly basis. People here, they're just "shopkeepers." And so, consequently, unions are not strong enough because there is no work to control. It is too anarchistic, the production here.

SR: Yes.

NA: So you can always get in, you know. Also there are too many movies which are made with no money at all. And unions are interested when there is money involved. But when there is no money involved, no one cares about it, you see. So there are so many pirate movies, I mean, in the sense of movies made with no money, no nothing, just raw material and a camera borrowed by someone. So you can always do movies. And then you don't get paid, of course, but eventually if you're lucky and you've made a good choice you can make movies that are successful. And when it's made, that happened with *La Collectionneuse*. I made *La Collectionneuse*, which was a film made with no money at all. And no one, no one was paid on this film. But the film had a *succès d'estime*, not a big success, but it made money. I mean the company didn't spend anything. And also, it made, it got awards for France in film festivals. In Berlin it got the Silver Bear or something. So it got hard for the unions to refuse work to someone

who had won an award for France, you see. Still they didn't want to give me papers, and I had to make several movies in which people would sign for me. Also, some of the movies I made were actually not French, like *More*, which had a Luxembourg nationality although it was filmed in French. Then the unions could not say anything because it was not a French movie. Then for *My Night at Maud's* it was my assistant cameraman, who did have the papers, who signed for me legally.

SR: You do all your own camera work?

NA: Yes. And then for, finally, Truffaut because he had great interest when he wanted me for *L'Enfant sauvage*, he got me permission to sign for *L'Enfant sauvage*. It was the first film I did sign, you know, but I had done many. And then after three "delegations" . . . I don't know if you know it, you need three permissions to shoot because belonging to Centre National du Cinéma which is something like a guild, then you finally get into the guild. It took me seven years to get into the guild. I mean I can't complain. I know in another country it would have been worse.

SR: No, that's why I wondered . . .

NA: It would have been worse, yes. I'm certain. France is a relatively open country.

SR: Yes.

NA: Because of the fragmentation of the movie industry.

SR: When you worked in black-and-white is there a film stock that you prefer in black-and-white?

NA: No I did not.

SR: I mean were there discussions?

NA: About choosing black-or-white or color?

SR: Yes.

NA: No, you know, Rohmer had decided to do *Ma Nuit chez Maud* in black-and-white and I could not possibly convince him of other things. Besides it was also a problem of budget. It was cheaper that way. For Truffaut, *L'Enfant sauvage*, he made *L'Enfant sauvage* in black-and-white. And it was a decision that was taken before he hired me. No I liked the idea of doing black-and-white.

SR: What did you shoot with? What film stock did you use?

NA: I think Double X. I change according to serious material. But Double X then and some 4x too, for *L'Enfant sauvage*. It was a regular stock.

SR: Yes.

NA: A very fast film, you know, because . . . so we didn't have to light too much.

SR: When you . . . I'd like to try getting to the difficult area of relation-
ships with directors, but I think it's even slightly different when you
do your own camera work then in the relationship . . .

NA: You have a closer relationship.

SR: Yes, because you deal with them on both levels.

NA: Directly, yes, particularly, you know, otherwise you have to go through
your operator. And he talks to the operator and you are left to one
side. Also I light quite quickly. If I didn't do my own operating I would
be bored. What would I do?

SR: Yes, well, you use very little light?

NA Very little light, yes.

SR: Do you sometimes put stronger bulbs in existing fixtures?

NA: Yes, I do that always. Yes, putting stronger lights in existing places.
And sometimes whenever the light is good as it is I just leave it that
way. For instance in doing *Two English Girls* there are three sets which
are like the Black Maria, you know the studio . . .

SR: Yes.

NA: And with, how do you say—

SR: Open?

NA: No, there is glass in—

SR: Glass, yes, glass.

NA: A painter's studio you know, there are beautiful soft lights so you
don't have to put anything, just leave them as they were. There were
three sets like that. Have you seen the film?

SR: Yes.

NA: The studio of Ann, then on the staircase there was, the ceiling on
the staircase was all made of glass. We call that in French *dépoli*. How
do you say that in English? Sand glass?

SR: Probably, yes. [frosted]

NA: You know, that has been scratched so that it doesn't let the light go
through it, just opaque. And there was a photographer's studio that
was a real photographer's studio.

SR: Now a funny thing which bothered me in the movie, maybe I shouldn't
bring it up, but in her studio, that was a set, right?

NA: No, it was a real studio.

SR: Did you really go up the stairs to the studio? Because when you go
outside, you're outside on the ground.

NA: Yes, it's absolutely right. Yes, that's really true. But, you know some-
thing, I'll tell you, I talked about that with Truffaut, but said this is
supposed to be in Montmartre, there are hills and it could be, which
is true. But also, as a matter of fact, this house, it wasn't built like
that.

SR: No, it bothered me in that way.

NA: It did bother you. Yes . . . but it could be in France in Montmartre.

SR: But I notice continuity things like that.

NA: Yes, I agree with you. It disturbs me a lot. But he had it this way in his mind. But the studio is not a set, it's true. It does exist. It is a place. And then the steps where he goes up, he's actually going up to the second floor. But this floor where the studio is, is on the level so we were using the steps in a different way.

SR: Right.

NA: By editing, so it didn't work.

SR: No.

NA: I thought on the editing it might.

SR: Now the people who saw it with me, it didn't bother them.

NA: Not them, only you. You probably have very space, I mean, you have a sense of space.

SR: Yes, I notice continuity lapses.

NA: And now at this moment with *Two English Girls* I'm using basically a one-light system. I mean like I would have one light on the set, only one.

SR: What size?

NA: A big light.

SR: A big light, but not a brute.

NA: No, no, no. I have a soft light, a square box with reflected light. It's not indirect lighting. It's like Vermeer light, you know, just parallel light coming from a big box. Soft. But only one. I would have only one light, placing it in a good place. The question is that. Where to place this one light. Instead of multiplying the light, having a little light here and a little light there.

SR: Well, when you have that you have multiple shadows.

NA: It's not only that. It's that you have the multiple shadows, that's one problem. Also you have a sense of, I think it makes photography very mannerist, you know, the little touches. I'm for realism. I believe it in life, there's only one light and then light that bounces back, like in here. We only have one light.

SR: Yes, do you think some of that comes from your documentary background, before?

NA: Probably, yes. And also from the silent movies in which they lighted less.

SR: Right.

NA: You have seen the silent movies. They were much less refined. I like this rough way of lighting, you know. I think it is very amusing. I have just seen *Casablanca*. I like that. Very amusing, this kind of little light-

ing here and there. But to me it is amusing and I love them as cinema, but I wouldn't want to do it, you know. I would be ashamed.

SR: I just saw Gance's *La Roue*, but that's very lit. I mean the thing that they do always though when they come to a close-up, it never matches.

NA: You mean the silent movies.

SR: Yes.

NA: Yes, they never match.

SR: Yes.

NA: But I like the silents because it's very, I don't know, I like the contrast of the black of the silent movies. Also, they have good and bad in the silent films. They are not all good. I like very much Feuillade movies, Louis Feuillade. I think they have fantastic photography. There were people who had the pictorial training, I'm sure they were probably painters before. They have seen lots of painting. And I'm looking for neo-classicism. I like balance.

SR: Well, that's what I was going to get to. I mean when we talk about the actual frame, is that what you try to look for in the frame, I mean aside from what the director tells you?

NA: Yes, I like balance. I like symmetry. The weights of the frame. I studied that to a point in which I change sometimes the places of things on the set. That I've done with Truffaut, very few people notice that. You change the place of a painting on the wall. It really, you know, people don't see that. It's silly to respect those things. On the contrary, people do feel something uncomfortable if the shapes on the frame are not well balanced. I mean it's unconscious. I hope it's unconscious.

SR: No, no, it's not like Eisenstein where . . .

NA: You can't go too far at the same time because then you go to the extreme of Eisenstein. But I like balancing the frame, having rhythm inside the frame.

SR: Well, do you like the things being contained within the frame? With Godard a lot of times you have the frame cut off people that still exist beyond the frame.

NA: If it's well balanced, I like cutting things in the middle, too, like a person comes in the edge of the frame and things like that. But I have no rules actually, you know. Sometimes I like breaking the rules, things which are . . . but in general, I like classic balance in the frame.

SR: Now, when you worked with Truffaut, I mean how much does he work on the camera in regards to, or does he just give you the directions.

NA: He looks a little less than Rohmer, but he does look, yes. He's a man who thinks in terms of movements of the camera. His camera is always, it's a continuous thing like *caméra-stylo*, writing across from one thing to the other, describing things.

SR: I notice, whether it's good or bad, I notice a great deal of difference in films with different cameramen.

NA: Well, he's a man, Truffaut is a man that gives *carte blanche* to his collaborators, you know. Other directors like Rohmer, they take care of the smallest detail like, for instance, the colors of the costumes, everything, every little detail, you know. Truffaut doesn't. He thinks that a set designer who is a specialist and who's a great set designer knows more than him so why should he tell him what to do. You see? Also, there is another reason. Truffaut is a man who improvises quite a lot on the set. He has no shooting script. Rohmer doesn't either. I mean he does not read a shooting script, but he has it in his mind, you know. Now when . . .

SR: For both of them now the dialogue is pretty much set.

NA: Yes, the dialogue is exact. But there is no camera set. Now, Truffaut likes to have a shock, a visual shock that gives him inspiration at the moment he gets into a new set. He goes to the extreme. I don't know if I can explain that well. He goes to the extreme of refusing to go to scout locations. He doesn't want to. He prefers, it's not out of laziness, he preferred it. His assistants do it.

SR: That's what . . .

NA: They do the set and then when . . .

SR: That's what Rabier told me about Chabrol as well . . .

NA: The set?

SR: Yes, yes.

NA: He likes to go to a set the first day, you know, he's told more or less what he wants, then he doesn't want to see it. He comes to the set and then he sees the place and he gets the ideas. If he knows it by heart he gets no ideas. It's the set, the surprise that excites him, that stimulates him. Now, Rohmer when he has a set, I mean when I say a set I mean even a street, when they're going to shoot a girl coming with a bicycle in *Ma Nuit chez Maud*, he chooses the right place and he's been there twenty times before and seeing exactly where the camera is going to be. And, you know, up to the moment when he knows that every little cobblestone on the street, he is going to shoot, you see. He knows everything by heart. And the two of them are completely opposite.

SR: Now Truffaut tries to vary with each film, right, to get . . .

NA: Also I think that's one of the reasons why he has changed cameramen so many times.

SR: Yes.

NA: He believes that, I mean he hasn't said it to me, but I think he believes that changing camermen can change the style of the film. I

don't agree. I think it's, I mean you change if you want, but not a change of cameramen.

SR: No, but I think a cameraman can change the style.

NA: It can help. Yes, but you can also have other camera doing what you want.

SR: But with Rohmer there seems to be more consistency in what he looks for.

NA: Oh, yes. He wants to do one thing only. Actually, he said on the lot the last time we were together, he actually only made two films. One is *Lion's Sign* and the other one is *Six Contes moraux* which is one film. Now maybe we'll see it because the next film will change probably because *Contes moraux* is finished.

SR: One thing. I don't remember, you've done work in 70 as well as 35?

NA: 70 millimeter?

SR: Yes.

NA: No, unfortunately. I would like to. I've worked in scope, not cinemascope but techniscope, *La Vallée*, with Barbet Schroeder. I liked it. It was exciting.

SR: What do you do, did you find it difficult to deal with as far as . . .

NA: No, no. Amazingly easy. I mean, you know, I thought that it would be . . . You know, it just, I probably think some things were different from what is usually done. People, most cameramen I've noticed, when they do a cinemascope or techniscope I mean, a scope shape, because of the long shape of the frame, they tend to frame in a, on the side, I don't know how to put it. I mean balancing, again symmetry. They try to have no symmetry, symmetrical, because they think that the shape of the frame since it is not symmetrical, because its sides are smaller, and they go on this tendency. But I found surprisingly, I mean because I surprise myself with what I do, too, because I do it unconsciously. Most of the time being symmetric. I mean I would frame people in the middle no matter how much space I had on both sides. But most of the time I was doing it exactly as I would do in 35 regular 1:1.66 ratio. I don't find too much difference. Of course, the problem that, you know, tables are never on the frame and things like that, you have to put them up. But since we were in the jungle with this, maybe if I would shoot a cinemascope movie in an apartment, that would be another thing. But in the jungle there wasn't any problem.

Nestor Alendros: born 1930, Barcelona, Spain

Shorts as director and cameraman:
1960 *Escuelas rurales*
 Ritmo de Cuba

1961 *Gente en la playa*
 La tumba Francesa
1970 *El baston*

Shorts as cameraman:

1960 *El agua* (d. Manuel Octavio Gomez)
 El tomate (d. Fausto Canel)
 Asamblea general (d. Tómas Gutiérrez Alea)
 Carnet de viaje (d. Joris Ivens)
1964 *Nadia à Paris* (d. Eric Rohmer)
 Paris vu par. . . (ep. *St. Germain des Prés*, d. Jean Douchet; ep.
 Place de l'Etoile, d. Eric Rohmer)
1965 *Le Sursistaire* (d. Serge Huet)
1966 *Une Etudiante d'aujourd'hui* (d. Eric Rohmer)
 Pour mon anniversaire (d. Pierre-Richard Bré)
1969 *Des Bleuets dans la tête* (d. Gérard Brach)
 Fermière à Montfaucon (d. Eric Rohmer)
1972 *Dubuffet* (d. Jacques Scandelari)

Features as cameraman:

1966 *La Collectionneuse* (d. Eric Rohmer) *
1967 *Wild Racer* (d. Daniel Haller)
1968 *La Méduse* (d. Jacques Rozier, unfinished)
1969 *Ma Nuit chez Maud* (d. Eric Rohmer)
 More (d. Barbet Schroeder)
 L'Enfant sauvage (d. François Truffaut)
1970 *Domicile conjugal* (d. François Truffaut) *
 Le Genou de Claire (d. Eric Rohmer) *
1971 *Deux Anglaises et le continent* (d. François Truffaut) *
 La Vallée (d. Barbet Schroeder) *+
 L'Amour, l'Après-midi (d. Eric Rohmer) *
1973 *Poil de carotte* (d. Henri Graziani) *
1974 *Pink Floyd* +
 Cockfighter (Born to Kill) (d. Monte Hellman) *
 L'Oiseau rare (d. Jean-Claude Brialy) *
 General Idi Amin Dada (d. Barbet Schroeder) *
 La Gueule ouverte (d. Maurice Pialat) *
1975 *L'Historie d'Adèle H.* (d. François Truffaut) *
1976 *La Marquise d'O* (d. Eric Rohmer) *
 Maîtresse (d. Barbet Schroeder) *

Interview with Ghislain Cloquet, March 19, 1973

SR: What do you think of lighting today?

GC: The Hollywood style has disappeared a little.

SR: Not right now.

GC: Yes, it's a long time since '64.

SR: I would like to start with some usual things . . .

GC: I would like to ask you a question first. Who else have you questioned among the operators?

SR: Well, Henri Decae, Jean Rabier; I tried to talk to Raoul Coutard but he is not in France right now. Also Willy Kurant, and perhaps some of the other operators, but I have tried to talk to people whose films are known at least a little in the United States because I think it's better for my project.

GC: And there are French films that are well-known in the United States?

SR: Oh yes, some. You were in the United States?

GC: Yes, with Penn. In New York.

SR: And in Chicago also?

GC: Yes, New York and Chicago, but nothing more.

SR: Did you like Chicago? Because I live just north of Chicago.

GC: Ah, good, yes, I was interested because that was more interesting than if I had been in New York all of the time, it's a completely American city. Chicago is less cosmopolitan.

SR: Well, I would like to begin with what are the usual questions. How did you begin in your profession, how did you decide to become . . .

GC: Ah yes, that's to say, that began a long time ago. Because I'm not French, but Belgian. I was born in Anvers, and there wasn't any Belgian cinema. And when I was young I didn't especially think about working in the cinema, because it wasn't a plausible idea, and what happened was, the war broke out, and the exodus from the war put us on the road and I went to live in Paris from the time I was 16 years old, under the Occupation. And I began to think in a much freer way because I didn't live anymore in Belgium, and if you wish, the possibilities in France were much vaster. At that point I wanted to be a cameraman but more as a kind of idea that I would later work as a reporter, a journalist, but in reality that kind of career didn't really exist, except after television. Before, the newsreels were all and that wasn't much. And I went to Vaugirard, The School of Paris, IDHEC, the Paris School, and I started with great difficulty, during a period where normal crews for normal films never took beginners. And that explains what happened, which is that our generation which came out of the war found itself confronted with an older generation which was

very competent, how shall I say it, who were very great technicians, but who were very closed, like Hollywood. And we began to work among ourselves with people like Resnais who were beginners, with people like Marker who were beginners, see, we made shorts, and during that period, shorts were very bad, rarely very good. And we began to create a movement, which is also called "the group of thirty," which was a movement for shorts of quality, which demanded means of working in a manner to produce quality.

SR: And these were in 16 or 35?

GC: They were quality shorts, like *Nuit et brouillard, Les Statues meurent aussi*, etc. And they found, effectively, laws which made this kind of work possible. You could make money, not us but the producers, if they had subsidies, you see, for the costs of the film. And we began to have a reputation, because we were always getting prizes, you see. And this achievement meant that instead of being sidetracked toward what might be, let's say, an aspect of the craft which was secondary, that we in particular began to interest some directors of the preceding generation, like Becker for example, who got interested in us. And I, for example, became his cameraman, without previously having been an assistant. I was an assistant very little, you see. To put it another way, we passed very quickly from shorts to features as heads of crews. For example, I had, this didn't happen at all during this period, chief operators didn't exist at this period, and when I made *Le Trou* with Jacques Becker I was 35 years old. Well, that wasn't normal at that time, you see, it happened because of the shorts. For example, today, when I see young people in the schools who say, "we can't do anything, it's impossible to begin," they can do a lot of things faster than we can, because of the habit of entrusting important things to young people. In our time nobody trusted us at all. And it was necessary to have people like Resnais, it was directors like Resnais, who attracted attention, you see, and since we worked together, it was my luck to work with him, for example, and then I worked with other people who had great qualities, when I made film by Nicole Védrès that you have noted here, *Aux frontières de l'homme*, it was very interesting. But that was very little, you understand, it was the quality short. And we began to know each other like that. And later as heads of crews, we made some great films, but for example, I was hardly ever in those old crews, you see. And from this point of view, the schools were very useful because if I hadn't gone to school, I wouldn't have been able to learn my craft, you see.

SR: Did you have any problems with the unions?

GC: None, I didn't have any problems, but I did everything according to the rules in any case, since I had a diploma from all of the schools that existed then, which were Vaugirard and IDHEC.

SR: When you started working in features did you think you had a certain style? Especially in black-and-white, do you try to do something particular?

GC: I am not favorable to the idea of style. I don't think that operators have a style, I think to the contrary, that operators must relate to the style of the directors who hire them. For example, if we have an influence, it's somewhere else, which is in the way we made the short with a lot of quality. For example, if you wish, I am thinking of *Nuit et brouillard* or *Toute la mémoire du monde*, which begins a trajectory which becomes fulfilled much later in the films of Resnais like the celebrated *L'Année dernière à Marienbad*. I think of a certain rapport between exigencies of the small means on one side and the large means on the other. The thing that we brought with us, because I am not alone, there were two or three of us, not many, what we had, what interested the directors, we brought the light techniques of the short film at a time when the cinema was very heavy. And I say that's what happened in France, and Becker, for example, when he made *Le Trou* was interested in these light techniques which were however also very exacting, and that's the same reason that Penn, when he saw *Le Feu follet* wanted me to come, because that related at the same time to a liberation of technique and an exactness, you see, for example, I don't know exactly what you mean to say when you say that's not Hollywoodian. *Mickey One* is certainly not Hollywoodian either. But, if you want, it's exacting all the same. Everything is in real decors, in real places, not in studio decors, and yet the actors do rather complicated things, but the sound is recorded live, and all of this requires a lot of organization, you see.

SR: Was there any difference in the things you could work with in the United States or in France?

GC: No, it was the same, my uneasiness, it was the same, my uneasiness. The way that I work is always the same, because if I had to work with another kind of material I would be very annoyed. For example, when I arrived in Chicago, I found everything that I wanted and when I was working in France, before, during that period, it wasn't usual, to use such things in a big film, but for example I used colortrans and things like that, and at that time, 1964, in Chicago, you only used that in, let's say, industrial or publicity films.

SR: But with lights and everything, you used the same . . .

GC: I worked exactly the same as I did in *Le Feu follet*, the year before, in '63. I made *Le Feu follet* and the next year I made *Mickey One* exactly the same way.

SR: Did you use any more lights, or more brutes, etc.?

GC: Well, that depends on the film, in any case in every film there's a certain amount of heavy material like brutes etc. And in *Mickey One* there were two nights when we used brutes because there was a very large decor, the Marina towers in Chicago, there were six brutes, I think, but that was a rare case. Otherwise, it's always very light material, but in France it's the same, I use very light material. The only thing that I have done for 10 years which is now becoming rather general, is to equip natural decors in a way that you can film in them without having anything on the ground which encumbers everything. You see, everything is suspended. Everything is always suspended. It's therefore essential to have light material, and the problem is to have, how shall I say, time to prepare, time for . . . I don't work, I don't take long during the filming, but, if you want, three or four weeks before the film, I must know everything. Because I can't improvise. I must prepare. And for example, on the level of electricians, it's very important to have electricians who are capable, while I'm shooting, of preparing in the next decor, you see.

SR: Do you keep the same crew?

GC: Inevitably not; in *Mickey One* I had an American crew, which was wonderful, besides. I had wonderful people. As many electricians as grips. But if you want, the problem of technique is not a problem of style. The technical problem is to give to the director the style of image that he wants. And an operator in my opinion is someone who changes style.

SR: Ah yes, but when you shoot in black-and-white, you choose the film and the quality?

GC: Yes that, for example, I like very much the way of working in Europe, because in Europe you choose everything. In America a certain number of things are imposed on you. For example the laboratory work in America is imposed. In France I determine the conditions of the laboratory's work, you see.

SR: Which kind of black-and-white stock do you prefer?

GC: In any case there aren't a lot. For example, *Le Feu follet* was made in Double X; it was the beginning of Double X. *Mickey One* was made in Double X also, but in another older period, Gevaert film was used. For example, *Le Trou* was made with Gevaert 36, and there were operators who worked completely differently because they tried to make it have the maximum possibilities. That's what happens in films like

ones Decae made at that time, *Ascenseur pour l'échafaud* and things like that. But I found it was necessary to try, precisely because it wasn't Becker's style to use this film which gave me so many possibilities, and so many facilities, but with a little more exactness, as if it were a film stock of the period when Becker worked in Plus X, for example. For example, in the films in Gevaert 36 at that time there wasn't a good black. The black wasn't beautiful, you see. And in *Le Trou*, if you have a good print, because it's always a problem to have a good print with good projection, and I, I know what it is to see my own films, in Brussels for example, or in certain theaters in Paris—it's terrible. A good print, with good projection, it's a discovery. Well, for example, if I had a good print of *Le Trou* with good projection there are magnificent blacks, you see. And it was Gavaert 36 that in that period didn't have good blacks, but there was work done at the laboratory according to my instructions, and at that time I got what I wanted.

SR: Well, yes, but even if you feel that you don't have a certain style, I think that in your films you can see more details, more texture in the black-and-white.

GC: Well, if you want, the films that I prefer are *Le Feu follet, Mickey One, Au hasard Balthazar: Au hasard Balthazar* is very interesting.

SR: Oh, yes, that's a great film, one of my favorites.

GC: You know, I'll tell you right away, you can ask me all of the questions that you want to about making a film, but I'll tell you the real problem: that's to be certain of having, after making the film, good prints, and good projection, and that's terrifying. When you see a film that you know well, for example the way that I know mine; then when I see others' films I don't always take this into account. But you would be surprised if I showed you some films that I made in a good projector, you would be surprised to see things that you never saw.

SR: Yes, you never know when you go to a theatre what kind of a print you will see. Sometimes I decided not to go when I've been told that it's a bad print.

GC: Do you think it's better in the United States?

SR: Well, actually, I was thinking of the United States. But here it's worse because you might expect a bad copy of a French film in the United States. And of course it's a terrible problem with color.

GC: Yes, and sometimes there's not enough light or the focus is gone.

SR: And above all when the state of the film is bad.

GC: Yes, yes, and then the density, everything is very serious.

SR: In the United States, unfortunately many films are reduced to 16mm. But if it's not a popular film like *Le Feu follet* which I saw just before

coming here, because it's not too popular, there are still some good prints because it isn't rented too often.

GC: Where did you see that? In a theater or a university?

SR: In a university.

GC: Are there good theaters, good projection?

SR: Sometimes.

GC: I can't say, perhaps it's one of the most beautiful. I like it very much. I also like *Mickey One* very much. *Mickey One* is much stronger, much rougher, but the style, the style isn't mine. Penn's style is very violent, I don't mean to say that he is violent, but his expression. I would very much have liked to shoot again with him. He suggested that I shoot *Bonnie and Clyde* but it was the same time that I was making *Au hasard Balthazar* and I couldn't leave.

SR: Could you talk about your work with Bresson? Is it different than working with other directors?

GC: Yes, yes, since the problem was that when I began, it was for *Au hasard Balthazar*, I saw some of Bresson's films. He spoke to me, he wanted me to continue the photographic style that he liked. Well, I won't say that it's exactly the same as the other operator who worked with him before. But I saw the films, I spoke with Bresson, I made tests for two or three days with Bresson. He told me, this, this, you understand, showing it in the film, it was exactly like that. He was reassured, he was happy. But that wasn't my point of view, it was his. You see. And what's interesting, quite properly, with regard to photography, is exactly to be led. I think there is a difference between the photography of *Mickey One* and *Au hasard Balthazar*. They weren't for the same man, you see. And in color, it's the same, because when I make a film like *Un Soir, un train*, or *Rendez-vous à Bray*, have you seen that?

SR: No, not yet. I have heard things about it.

GC: If you see for example, *Le Rendez-vous à Bray* or if you see *Benjamin*, or if you see *La Maison des Bories* for example, there's no relationship, they don't look alike.

SR: Is Bresson harder to please?

GC: Very hard to please. He wants you to do exactly what he wants. He doesn't want you to look for something new. He wants you to do exactly the same thing as before. If you worked with him two years before, he never says now we're going to change. Only the contrary, he asks you to work with him again, it's to be sure that you'll do the same thing again. It's because of this that he was very uneasy about *Une Femme douce*, because that was the first time that he worked in color and he wasn't at all certain about what was going to happen.

However the second film that he made, Pierre L'Homme photo-graphed, because I was taken, and Bresson liked Pierre L'Homme's work very much. It's a very beautiful film to see, the photography.

SR: I've seen *Une Femme douce*, but *Les Quatre Nuits d'un rêveur* hasn't come to the United States yet.

GC: Good, I think that now, if I did another film with him it would be very interesting because that would be his third film in color and now he's gotten to the point of being very closed.

SR: You like working with people who demand that you do certain things?

GC: Yes, I don't like being left to myself. I'm like an actor who asks if the director has an opinion. I'm not saying that he has to know how to do it, and I think that he has to direct you, he must be certain, that's what's expected from him. And then, that moment, that produces something interesting, because if the *mise-en-scène* and the photogra-phy are one and the same, well, that is a style. Then, if this isn't the case, if you work with a director who does one thing, and then the actors do something else, and then the decorator does a third thing, and then the operator does a fourth thing, there's no result, you under-stand. Besides, in my opinion, the three people who have enormous things to unite, who must work together, are the director, the decorator, and the operator. For example, if I know someone is going to hire a decorator for a film with whom I have absolutely nothing in common, I won't be able to do the photography suitably. Now you understand, what makes certain films so wonderful, like those of Visconti, it's that Visconti's will controls everything. There's not a single face, not a hat, not a table, not a color of a wall, not an hour . . . the hour of the day is chosen to get the effect that the director wants. Well, the operator must, of course, be capable of photographing it, but everything must be in the same direction, you understand.

SR: You are talking of a collaboration. But you have often found this kind of collaboration.

GC: Ah well, I have been very lucky. Because if I complete the list of films that you have, you will see that aside from several very excep-tional films, I have done very little of what you could call commercial films. Almost never. I have always worked with directors [*metteurs en scène*], even on films which can be seen as a kind of failure, which doesn't mean that it was not a great success. For example, *Mickey One* is a failure, but I think it's one of the most beautiful of Penn's films. You understand what I mean? It's a pity that it's a commercial failure.

SR: Yes, I like that film very much.

GC: Yes, I like it too. But, for example, I also like *The Chase*. I like that very much. I liked in black-and-white things like *Le Miracle en Ala-*

bama [*The Miracle Worker*] and like the first one *Le Gaucher* [*The Left-Handed Gun*], all of that. I mean, it's for example I worked with Resnais, I worked with Marker, I worked with Becker, I worked with Malle, I worked with Sautet, Bresson, with Delvaux, with Deville in France, for example, he's a very good director, he does more commercial things, but *Benjamin*, for example, was fun to make. Films like . . . I made even, in fact I find *La Maison des Bories* quite good, it's very successful. Have you seen it?

SR: No, it's not possible to see many films like that in the United States.

GC: I've done things like, for example, I made *Faustine*, that's something that photographically was interesting to do.

SR: And you also worked with Demy?

GC: Yes, of course.

SR: And *Les Demoiselles de Rochefort* was also a kind of failure.

GC: Oh, yes, but that's less understandable, because really, for example, *Les Demoiselles de Rochefort* was very interesting, and it had things that were really sufficiently interesting and attractive for it to go over. Well there were some errors made, but not necessarily all in the film. For example, the publicity that was released was perhaps a little too important, and what happens is that when people hear too much about a film, they expect too much, and it seems to them that there's too little there. If they had spoken about it less, the audience might have been able to appreciate it better, perhaps.

SR: Right now in the United States it's exactly the opposite with Demy's films. Nobody talks about them, and there's more to see than the publicity would suggest. When I saw *The Pied Piper* in the United States there was no publicity at all. Could we go back to more technical things, when you begin to light a film, do you try for a kind of reality?

GC: That depends completely on the director. What I like to do is to work in a way that the film corresponds to the scenario. At that point, when it's a film like *Le Feu follet*, that must be very realistic, but when it's a film like *Un Soir, un train* it's not at all realistic.

SR: But do you like a realistic film better than another one?

GC: I like changing best. Perhaps, if you want, I don't say this, but friends of mine say things like that, I don't say it because I don't completely believe it, but they say I have a greater gift for dramatic films, not for realism, for dramatic films. For example, comedies, uh, it's possible because, it's possible for the simple reason that dramatic films need photography to explain something, and that comic films, certain comic films absolutely don't need photography; on the contrary, it's better to photograph things relatively quickly so that the time and the money can be used by the actors, and the director can focus

the comedy better. Besides photography of comedy is not at the service of photography, it's at the service of the action. But when you make a dramatic film, the director, even if the photography isn't essential, counts on the photography to give it an atmosphere. It's not because it's preferred, it's because it's necessary.

SR: Are there any other operators whose work you like?

GC: Yes, yes. There's often a lot of work that interests me a lot. I like the fact that you are writing about operators, because I find that in articles or reviews of the cinema they talk a lot now about *mise-en-scène*. The question is not exactly to talk about technique, but all the same to point out a certain number of qualities of films. For example, I don't know if you know an operator in films from the East, like Kucera. [Jaroslav Kucera—husband of Vera Chytilova—photographed *Daisies*, among others]. He's a very interesting operator. Have you seen anything of his?

SR: Yes.

GC: And there is, for all that, a very interesting movement with the New Wave. But it was on the whole a movement that simplified photography to the point that, for example, Coutard's films are interesting to the extent that it's Godard who, if you want, needed his techniques, and it's interesting that he brought them to him. But from the point of view of photography it's very simple, If you want to judge Coutard and appreciate his work, you have to think of more elaborate films than those of Godard. In fact certain of Godard's films, for example, still Godard but, *Le . . .* , I think it's *Le Mépris*, huh?

SR: Yes, *Le Mépris*.

GC: Good, *Le Mépris* is superb, and I think he—Coutard—also did *L'Aveu*? Was it him?

SR: Yes, and *Z*.

GC: *Z*, to my eyes, is a very interesting film, but *L'Aveu* interests me even more, from the point of view of the photography. From the point of view of the photography there's a problem today which is that, in effect, there are lots of films where the photography isn't important, and which one must make, like for example *La Salamandre*. That's a film which is wonderful. It's obvious that it was made very cheaply, and it had to be under such conditions that the photography, from the moment that you see the actors and understand the action, it's the main object—the action. But, for example, there are other films that require that the photography be taken up with exactness. And then, there's a kind of, let's say, divorce, that those aren't always the most interesting. For example, there are films that are very, very well photographed, but which aren't very interesting. And then there are films

which are poorly photographed that are very interesting. Then, an operator like myself, if you want, can ask himself if he isn't more interested in making an interesting film even if the photography is done very simply, rather than making a less interesting film and do elaborate photography, you see. For example it's a problem besides, the French cinema which is surrounded—well—by a general movement in the world, they could have, perhaps during the period of the New Wave, they began the movement, but now they've been overtaken; there are Swiss films, Canadian films, New York films, there are probably Chicago films, you understand. And it's this which is alive right now. On the other hand, in opposition to this cinema which is very light, there are the films of Visconti, for an operator of my age and my category. It's obvious that I am exactly between the two. I was lucky to the extent that I work with people like Delvaux, or, from time to time during the year, with very exacting people like Bresson and that I am able, all the same, to have the chance to make films that are interesting for the operator as well. But my conclusion is that I'd still rather make films where the photography isn't important if the film is important, you see?

SR: What do you think of the work of someone like Jean Rabier?

GC: Well, what would you like me to say? That he's a wonderful operator? You understand, it's . . .

SR: Well with that kind of total agreement.

GC: It's that, he works with Chabrol. He has done some very interesting things. You understand it's still the same thing that I said a while ago, everything depends on the director and on the film that you're making. The role that he plays in Chabrol's films is a very precise one and he must fulfill it. Good, but, for example, he played another role when he made *Le Bonheur* with Varda, he played another role when he made *Les Parapluies de Cherbourg* with Demy, you see. His problem is with and for whom he works. And, for example, in Chabrol's films I don't think that the photography is the essential thing. You understand, I think it's very well done, it's very, very good technical work, but all things considered, the photo isn't the essential thing in a film by Chabrol. I'm not saying that it's essential with other directors, but there are other directors where it counts more.

SR: Like whom, for example?

GC: I'll tell you, for example, Bresson, in French films, or Delvaux in Belgian films; there are people who expect more from photography than Chabrol.

SR: With Bresson do you work quickly or slowly?

GC: You work slowly because Bresson needs to work slowly, but . . .

SR: Do you have to wait for the others during the day, to light?

GC: No, you work all the time, all the time. No you don't wait. In a word, if Bresson needs time you give him time, if he needs to go fast you go fast. An operator must go as fast as the director, even faster, because most of the time the director needs time, and for example, if a day has eight hours, the director needs six and the operator only has two, you see.

SR: Well, Bresson's method of working interests me, and that's why I was asking you.

GC: I think that people like Bresson go relatively slowly, and let's say you do photography that ends up a little ahead of him. But, for example, I am going to make another film with Delvaux, and the last one, *Rendez-vous à Bray* was made rather quickly and for not a lot of money. *Rendez-vous à Bray* was made in seven weeks for a very small amount, and the photography is very interesting because the director let me do it, and I went rather quickly because he really needed the time to direct the actors. There is one thing that I do which is a little different, that's that I always run the camera. And I do the lights and the camera. I think that's done less in the United States?

SR: Yes, and even here, Henri Decae told me he never runs the camera.

GC: Yes, it's a question of the film as well. It depends on the films that you make. I didn't run the camera on *Mickey One*.

SR: Was that because it was in the United States?

GC: No, there were times when we used four cameras at once. I couldn't hold four.

SR: But with Bresson you did the camera work as well?

GC: With Bresson, yes. I did *Une Femme douce*, for example, but before that I had a framer who got along very well with Bresson; there was, if you want, an understanding between them, and then for *Une Femme douce* he wasn't free, so I did it.

SR: And with Louis Malle?

GC: *Le Feu follet* I did the camera work, and with Demy also.

SR: And of course you do the framing the way that the director indicates, but do you ever suggest anything?

GC: Yes, but only material things. I always let the director find his ideas, but once he tells me what he wants, the second when he's set the scene, I only suggest corrections, but I don't give him any new opinions. Because I think that it's the job of the operator to enable the director to go as far as he can with his own ideas, not those of the operator.

SR: You work with directors who know what they want.

GC: In general, yes, and when I work with directors who don't know what they want I'm not happy. I don't ask that they know how to do it, I ask that they know exactly what they want. Because if not, I'm the one who is doing the directing and I don't want to do that.

SR: Do you prefer to work in color or black-and-white?

GC: I like not having to do one thing or the other. For a long time I did films in black-and-white that would have been better in color. Now you do color films, and certain films would be better in black-and-white. I think it's a shame that this is done for commercial reasons. The real reason should be that a film is interesting in black-and-white or in color. In particular, I think that black-and-white will come back; for example, this year Marguerite Duras proposed that I make a small cheap film in a short time, and one of the reasons that I accepted was that the subject interested me, but most of all because it was in black-and-white. And because I don't have the opportunity to work in it anymore, I wanted to. Unfortunately the film was very short, it was shot in two weeks, and I really needed two days to put myself back in tune with black-and-white; you're completely displaced, like a musician who changes an instrument. I was glad that I did it, because really, when I saw the results, I said to myself, my God, black-and-white is beautiful, it's really beautiful!

SR: Do you like the wide screen?

GC: Yes, but that's not very important, wide screen or no wide screen. A film . . . a good print, in a good theater, that's what's important.

Ghislain Cloquet: born April 18, 1924, Antwerp, Belgium

Shorts as camerman:

Forties:
> *Pétrole de la Gironde*

Fifties:
> *Hommes des oasis* (co-ph. Robert Arrigon)

1953 *Les Statues meurent aussi* (d. Alain Resnais and Chris Marker)
> *Curare et curarisants de synthèse*
> *Une Ligne sans incident*
> *Soldats d'eau douce*
> *Statues d'épouvante* (d. Robert Hessnes)
> *La Belle Journée*
> *Pantomines*
> *Contes à dormir debout*
> *Le Cubisme*—(d. Robert Hessnes)

Neige (co-ph. Sacha Vierny, Georges Strouve, André Dumaitre)
Deux Bobines et un fil
L'Ecole de Paris
1955 *Nuit et brouillard* (co-ph. Sacha Vierny, d. Alain Resnais)
Roman d'un constructeur
1956 *Saint-Tropez, devoir de vacances* (d. Paul Poviot)
Louis lumière
Aux frontières de l'homme (d. Nicole Védrès)
Toute la mémoire du monde (d. Alain Resnais)
Le Ciel est par-dessus le toit
1957 *Le Mystère de l'atelier* 15 (co-ph. Sacha Vierny, d. Alain Resnais)
1960 *Description d'un combat* (d. Chris Marker)
Le Poulet
Touriste encore
1966 *Vive le tour!*

Features as cameraman:

1957 *Un Amour de poche* (d. Pierre Kast)
1959 *Les Naufrageurs* (d. Charles Brabant)
Classes tous risques (d. Claude Sautet)
Les Honneurs de la guerre (d. Jean Dewever)
1960 *Le Bel Age* (co-ph. Sacha Vierny, d. Pierre Kast)
Le Trou (d. Jacques Becker)
La Belle Américaine (d. Robert Dhery)
1961 *Un nommé la Rocca* (d. Jean Becker)
1962 *Carillons sans joie*
1963 *Le Feu follet* (d. Louis Malle)
1964 *Mickey One* (d. Arthur Penn)
1965 *Pas de caviar pour tante Olga* (d. Jean Becker)
1966 *Au hasard, Balthazar* (d. Robert Bresson)
The Man Who Had His Hair Cut Short (d. André Delvaux)
1967 *Les Demoiselles de Rochefort* (d. Jacques Demy)*
Loin de Viet-nam (collaboration)
Mouchette (d. Robert Bresson)
Un Soir, un train (d. André Delvaux)
1968 *Benjamin, ou les mémoires d'un puceau* (d. Michel Deville)*
1969 *Mazel tov, ou le mariage* (d. Claude Berri)
Une Femme douce (d. Robert Bresson)*
1970 *La Décharge* (d. Jacques Baratier)
1971 *La Maison des Bories* (d. Jacques Doniol-Valcroze)
Peau d'âne (d. Jacques Demy)*

Rendez-vous à Bray (d. André Delvaux)

Quatre Nuits d'un rêveur (gangster sequence only; ph. Pierre L'Homme, d. Robert Bresson)*

1972 *Au rendez-vous de la mort joyeuse* (d. Juan Buñuel)*

Nathalie Granger (d. Marguerite Duras)

Belle (d. André Delvaux)

1974 *Faustine et le bel été* (d. Nina Companeez)

Dites-le avec des fleures (d. Pierre Grimblat)

1975 *Love and Death* (d. Woody Allen)*

Interview with Henri Decae, March 10, 1973

SR: I would like to start by asking the most usual question: how did you begin in your profession?

HD: Listen, I began as an operator when I was very young.

SR: Did you always want to be an operator?

HD: Always, I always wanted to be an operator, even when I was very young. My brother was in love with photography, and I always wanted to be an operator with him. I didn't think that I would be able to be an operator for big films. My big ambition at that time was to be an operator for P.T.T., and I never thought it possible. My family certainly wasn't part of the cinema, and I never thought that I would be able to penetrate this very closed world which was the cinema.

SR: And when you began did you have problems with unions and things like that?

HD: Yes, I began with a Hungarian operator and director (he wasn't really a director), who asked me to make shorts about France. This was scarcely professional; it was in 1935, certainly because 16mm didn't exist then, because if not I think we would have shot in 16mm. But this was a Hungarian traveling in France, and he asked me to make three shorts with him, so I was an operator. I was 16 years old then. I understood that this wasn't enough since I couldn't enter production directly because the unions at that time were very strong. And there wasn't any reason (that I should enter); I didn't know the trade. So I entered the school of cinema on Vaugirard Street. I studied and got my certificate and then at that time I worked, at night I worked with my brother, I passed my exams, and I entered Vaugirard Street. That was how I started.

SR: I understand from my reading that the first film you made was with Melville, that you started with him and his first film.

HD: Le Silence de la mer? We made *Le Silence de la mer* in 1947.

SR: You avoided normal production means?

HD: Yes, normal organization, because, how shall I say, he didn't have money, he didn't have any authorization, and Vercors, who was the author of the book, didn't give him any authorization to release the film unless it pleased him. The film had to be made before Vercors would give the authorization for the filming, which was very risky at this time. In this period Melville filmed very cheaply, film was purchased, negative cutouts were purchased, we never knew what sort of film we had. Finally the film was shot like that; that was in 1947. That was my first big film.

SR: You have made many films by yourself?

HD: Ah, yes, shorts. I made advertising films; I worked a lot with Jean Mineur at the beginning. Right after the Occupation, even during the Occupation, I went to the unoccupied zone. I escaped from the occupied zone and, with a camera that one of my friends lent me, one who came from service in the army, I bought some outdated film, and, always with the help of my brother, who hid me in the Alps, I began to make, then, a small film that I called *Eau vive*; it was a small documentary about the rivers, the mountains, the origin of a stream, the origin of a torrent, the melting of the snow, etc., everything that could be beautiful to see. And obviously once my film ended I had to have it developed. I wasn't able to develop it. I had it developed carefully, thanks to one of my friends who worked in a laboratory. But obviously at that time I didn't have any money to finish it. And I suggested it to Jean Mineur, and Jean Mineur told me, "Well, we'll finish it together." That's how I began to work with Jean Mineur and the collaboration lasted with him many years.

SR: But you also helped other directors with their first films?

HD: Ah, after, at that time, that was the period called the New Wave. I worked a lot with, I made a lot of first films of the people of the New Wave. I made the first film of Truffaut, I made the first film of Chabrol, I made one of the first films of Molinaro, one of the first films of Louis Malle—understand I have an entire period when the young directors liked to work with me very much.

SR: And now?

HD: And now they have evolved in one way or another, and I find myself suited to certain directors, but in a less regular manner.

SR: How do you like their development?

HD: Their development? Ah well, listen, many are a little wiser, you might say, they film things that are a little less . . . how shall I say . . . a little less original, except for Louis Malle, see, in recent years. When we made *Le Voleur* together, he told me, "Listen, we're going

to make a film that pleases us, if the public likes it, so much the better. If they don't, too bad." We made *Le Voleur* like that.

SR: But what do you think are the changes between their early work up to about 1963–1964 and now?

HD: After? There was Godard who changed to a different genre, but that's not the same thing.

SR: Yes, what about Truffaut? Chabrol?

HD: Chabrol, he remains in an area half commercial, half original. He always has extraordinary ideas, subjects which are good for him. And he remains, how shall I say, very fixed in a cinema which is his, which is really his genre.

SR: Yes, and I think that after he began his collaboration with Jean Rabier, they get along well together. He has small subjects, but small subjects which are worked out perfectly.

HD: Yes, but after all it's a genre that he likes. It's the kind of film he makes. It suits his personality perfectly. He knows very well that it is perfectly adapted to his personality.

SR: Yes, but he lacks a certain difficulty, things which must be overcome. [Laughter]

SR: Good, let's go on to more technical things. How do you begin to prepare for shooting?

HD: During the preparation? During the preparation I talk very often with the director about the kind of film he wants to make, as long as the director is willing, because there are directors who don't want anyone to prepare with them, who know exactly what they want to do and who will only allow their word. But most of the time we talk together about the kind of film, if it's a director that I already know. If it's a new director with whom I've never worked, like some American directors who come to me such as George Stevens, Robert Wise, we meet each other, we project films they've made, but that we look at again together, they look at mine and we discuss together, things are said like, "I like this kind of photo, I don't like this kind," etc . . . Then we tackle the subject and determine together the quality, the kind of images that can be made for a film, and we discuss the style, we discuss . . . the atmosphere.

SR: What about more specific things like film stock?

HD: No, because now we shoot in color, it's not the stock but the style to give it.

SR: But before?

HD: Ah, before, when we filmed before, I chose the emulsions according to the style of images that were to be obtained.

SR: And in France are there differences in the color laboratories?

HD: Of course, we have each . . . and the Americans and each operator, has a preference for a certain laboratory. I have my regular laboratory with which I have worked, and I prefer that one to others because I have found they work better with the sense of style of photos that I like.

SR: And in black-and-white, do you prefer a particular film stock?

HD: Black-and-white, I worked for a long time with Gevaert because Gevaert had many emulsions and, at that time, Kodak only had one, and besides it was softer and faster; it was like that that I made the first films of the New Wave, with very little light, using very fast emulsions. It's that that gave those photos their style, a little, how shall I say, unsophisticated, unprepared. Obviously we had few resources. It was necessary to find a way of shooting in spite of everything, in spite of the same resources that we had. When for night scenes I took out some films of X brand. [Kodak Plus X?]

SR: Yes, but with *Les Quatre cents Coups*, it was wide screen.

HD: It was cinemascope. It was shot with a hand-held camera, at that time we used Dialyscope besides, and we shot as well hand-held in the streets of Paris hiding. We almost shot on the run in order to avoid difficulties.

SR: And when you shot a film like that, did you use lights for exteriors?

HD: Always, yes; most of the time I always have fill lights and either reflectors when you can't have regular lights or arcs.

SR: Yes, because it always seems like no lights are used.

HD: Well, that's what's wanted, understand, it shouldn't show. You understand the greatest fault, exactly, it is when the lights are used and many directors [use lights that are obvious].

SR: But in a Hollywood film—you always know.

HD: Yes, but that's not the same style for photos. You understand they don't try for realism; you know it's an operetta, it's a comedy, you know something, and, at that instant, it can be seen; but from the moment that you have the impression of people in a street, etc., if one sees that there are fill lights, that breaks the rhythm, breaks the ambience.

SR: Do you like this style, this realistic style?

HD: Yes, I have always strived throughout my career, you understand, to not have the same style, to always bring to each new film an ambience, another style. I find it deplorable, you understand when you enter a movie theater, and this doesn't exist now, happily, too often, but in the past, there were certain operators who had a certain aura and when you entered the theater you would say, "Oh, this is the operator who filmed it, ah, it's the operator." You understand as I said

just now, it's the operator who must adapt himself to the style of the film, to the type of film and not look to set himself off the best advantage in saying, "I made a beautiful picture of this kind." It's happened that certain directors have asked me to make a dull, flat image, which isn't very flattering for an operator, but which suited perfectly the style of the film.

SR: But Melville has said in an interview in a book in English that even when he doesn't film with you he tells his operators to film the way that you do.

HD: No, well, with Melville, we began together, so to speak, we understood each other very well from the beginning, and we adapted to each other. He adapted himself to me, you understand, he knew that when he asked something of me he would get it. When he works with someone else, if he asks for the same thing, he won't get it. He'll get perhaps a result that's not too bad but which isn't exactly what he wants. Then he's bothered. When you're so used to habitually working together, you understand, it's troubling to change.

SR: Well, he says that when it's necessary he does what you do for him. [Laughter]

HD: That's part of the glory of the director who doesn't want others to have, how shall I say, profit from a film. That's to say that the film is the way it is thanks to anyone but me.

SR: Do you have the same crew?

HD: Generally I always have the same crew. I always have the same cameraman, the same assistant, the same second assistant, the same chief electrician, and when I'm able, the same chief mechanic.

SR: Have you worked a long time with these people?

HD: It must be around 20 years now; a little more than 20 years that it's always the same; not 20 years for the same cameraman, because cameramen change. Many of my old cameramen like Rabier, Alain Derobe, my cameramen or my assistants have become chief operators now. Inevitably I can't hold them down under my thumb when they're capable of flying with their own wings. It's normal that they evolve.

SR: Before the filming do you prepare with the cameraman as well?

HD: Of course, you understand the way that I like best to work, it's when the director, before everything, rehearses with the actors. We look together at the rehearsal, then during rehearsal I try to regulate the lights without disturbing them, and, as much as possible, be ready at the same time that he is. Then there is a rehearsal with the cameraman; the director and the cameraman see what they want together, either through an intermediary or, if they know each other well, directly. It's really the work of all three, the director, the cameraman and me.

SR: Yes, well, whose responsibility is it? I have noticed that, for example, a close-up is different with different crews.

HD: Yes, everything, you understand, depends on the director. There are directors who are absolutely, categorically, sure of what they want. If you work with a René Clément, for example, you know exactly the size of the shot that he wants . . . If you work with Melville, well, he is already a little more, how shall I say, not inattentive, but very often he will tell us, "do what you want, I'm going to the screening room." Often there are no exact indications. Now you have certain directors who are very rigorous from the point of view of indications, and others who leave you a little bit of latitude in framing. But if a director knows you well, at that moment he lets you regulate the framing with the cameraman.

SR: But with the composition of the framing, do you have things that please you and things that you don't like?

HD: Yes, if there's something I don't like I say, "Uh, uh," we try not to do it. You understand, it's an understanding between the framer, the director and me.

SR: Yes, but can you . . .

HD: Intervene, always.

SR: Can you explain the things that please you?

HD: Ah, generally? In principle I like to work in a rather close shot. I very much like rather long takes on a subject treating a face in a close-up. But it is indispensable all the same to have long shots that I very much like to light. Because you can do beautiful lighting in the long shot, and it's in the long shot that the atmosphere is created. Once the atmosphere, the ambience of the scene is created you can move to a close-up on the actors and of the action and that remains in the atmosphere that you have created in the beginning. Obviously the atmosphere must remain the same in the close-ups as in the long shots.

SR: When you film, do you film close-ups in the street?

HD: Close-ups in the street, yes, except if you're working with difficult stars. I've come to the point of not wanting to do exterior close-ups either when we're in the street or in regions like Spain in the last film I shot, where many of the close-ups had to be redone in the studio because the sun was too hard, too direct, and the actors couldn't bear the full light, so we did the close-ups in the studio.

SR: In France, in general, do you, like in Hollywood, have the same kind of work schedule, exteriors at one time, then interiors, etc.?

HD: I work like that. We begin a film, we begin in the studio, then go to the exteriors for eight days, then to real interiors, then return to the studio. All of that depends on certain conveniences, the availability of

the actors. It's that, above all, that guides the work plan. To finish up with the most expensive actors, to keep them the least amount of time, that's what generally organizes the work plan—or then, if we are using a certain season. You understand, it's better to film exteriors in the months of April, May, and June, and film in the studio in January and February; that's what you try to do. That's the reasonable way. Sometimes it's the reverse, but finally when it's reasonable it's like that.

[Laughter]

SR: Generally what do you think of your work?

HD: It's an extremely agreeable profession—when you work with people who understand it well. It's a profession that becomes very difficult from the moment that you work with people who don't know what they want. Then, at that moment, you sometimes have difficulties, but that's rare. Up to now I've always been lucky enough to work with directors who are very precise, who know exactly what they want, and right now work is very easy.

SR: You were in Hollywood?

HD: I went to Hollywood with George Stevens to finish *The Only Game in Town.* I was lucky that he took me there to finish it. For me this was extraordinary for a French operator to shoot in an American studio. This was an exceptional *coup.*

SR: How did you like Hollywood?

HD: I liked it a lot. Besides I had already been there about 20 years ago when I went through a period of instruction in Technicolor, during the period when we began to do color. A French producer sent me there to see what was happening, and I took a course of instruction, but without working, I simply watched. But when I arrived in the middle of the film, I was very well received. Obviously I had an American chief operator who doubled for me but many times he would ask me what I was doing, "If I can do something, tell me, if not, I'll let you alone." Obviously I continued to make the film normally, as if I were continuing to shoot in Paris studios with this aspect of assistants and opportunity which one knows but poorly in French studios from the point of view of machinery, possibilities, perfection, number of people who try to help you, you understand. It was for me sensational. When someone would give us something temporary to try out at night, by the next morning I would be face to face with it, but as if it had been eight days in the making. Well, with odds and ends they constructed solid things.

SR: Like a small child in a candy store.

HD: Yes I was entranced.

SR: You also shot a film with Peter Glenville?

HD: Yes I made two films with Peter Glenville, the last was *The Comedians*.

SR: Did you shoot in England?

HD: No we shot in France and Dahomey.

SR: Not in Hollywood.

HD: No, unfortunately. No, you know many times when I made films with Sydney Pollack, Sydney Pollack told me "We'll film together," and when he made films in Hollywood I know that he tried to find a way to have me, but with the rules it was impossible, because you have to double the crew itself. Right now it's not too costly, obviously, for American operators it doesn't seem expensive; to the American operators it seems unlikely that a French operator would want to keep his crew.

SR: Is it the same for American operators who come here?

HD: No, if an American comes here, he's the only one who has to be doubled. Well, American films are often shot here. They hire American operators, but with another French operator who is paid, obviously, by the company, and it works very well.

SR: No double crew?

HD: No, that's over now. In the past the syndicates imposed a double crew, but now the exchange is freer. In principle right now, there is a free exchange throughout Europe. Even with England and Italy a French operator should be able to make a French film in Paris; a French operator should be able to make an English film in London.

SR: Is it like this because of the Common Market?

HD: Exactly, it's good with the Common Market. In the Common Market there's an exchange of all professionals. But I think it's still a little theoretical, because practically it's not regulated yet. The operator always stays with the nationality which has priority in the production, when it's a co-production. If it's a Franco-Italian co-production, if Italy has the priority, it's an Italian operator; if it's a Franco-English production, if the English co-production is strong, it's an English operator.

SR: But do the directors do the choosing?

HD: In principle, they do the selecting. The director always does the choosing, except when the production says he can't.

SR: And does that happen?

HD: It happens. It happened to me recently with an Italian production where the director wanted me but an Italian operator was assigned by them.

SR: Aside from Melville, are there other directors that you prefer?

HD: Ah, yes, in principle I get along very well with all of the directors I have worked with, whether it's with René Clément, whether Melville,

Gerard Oury, Louis Malle; we've made many films together, I've certainly forgotten someone. Then there are those who I've worked with and we always promise to work again together. When I finished a film with Bob Parrish, we said to each other, "We'll have to work again together"; it's that way with Robert Wise, and others. I hope, if they come back to Europe to film, that I'll film with them. And Sydney Pollack certainly. If Sydney Pollack returns to Europe I would be very happy to work with him.

SR: With directors, who knows the best what he wants?

HD: You know, they all know what they want. But, for example, Clément is, I think, the most of a technician. When you work, on the other hand, as I said a while ago, with someone like Melville, who is also a big technician, but who allows you more liberty of action. Someone like Robert Wise knows exactly what he would like to do, and he does it, but he lets you prepare the shot. He'll say afterwards, "Yes, like that, that's right" or "No, I don't like something," etc. Then after, there is very important collaboration. With Mr. Clément, from the beginning you know what has to be done, and it's not worth the trouble to try to find something else.

SR: But when I saw *A double tour* by Chabrol, I thought that the color was different from the color in other films that you have done.

HD: Yes, we tried to have, above all, a lot of effects . . . and then that house, on one side the house in Aix-en-Provence where that was shot because, it was shot in the real locale where there were those colored tiles. And then there was that Japanese house which was all windows, all glass, which was nice, difficult, but nice to create. We created a special atmosphere.

SR: And you always use lights or something for the exteriors?

HD: Yes, you understand, exteriors always have to be treated. You can't film them just the way they are; you have to interpret them. You interpret them in the style of the film that you want.

SR: I have found with Chabrol there are certain things which seem to come from Hitchcock.

HD: Hitchcock is a very great director who certainly he thinks of as a master.

SR: But you never think of Hitchcock in the films you did for him?

HD: No, or then, it's the director who has it in his ideas who has suggested it to us, who has demanded it, but without specifying what that is, what it must be in a specific film. He has it in his spirit, without even remembering, it's the unconscious which makes the action. No, above all it's the subject, the ambience, that counts for us. It's not

necessary to look, except when someone asks for it, to imitate, or to do something in the same style: you have to recreate.

SR: What do you think about the difference between shooting in 16 and 35?

HD: Well, from the point of view of the amount of money you get back, it's the same. Because you have to blow it up for distribution. When you shoot you spend less, but at the end when you try to show your film, the price is equal for a mediocre quality. Nothing can be done when you've shot the film; even if you have succeeded, the quality is deplorable.

SR: Yes, but there was one film I saw which used a combination of 16 and 35, did you see *L'Amour fou* by Rivette? When you see a film like this the 16 seems like film, but when you move to the 35 it's like it's no longer film, but reality.

HD: Certainly, with certain subjects, in certain cases, I don't say that you shouldn't use 16. But, you understand, 16 is deplorable when as is sometimes done, 16 is used to economize. It's basically bad to want to economize, perhaps seven or eight million on a film that's going to cost hundreds, and which is certain, when it's released, to be of mediocre quality.

SR: Do you like cinemascope?

HD: Yes, certainly, what I like the best is 65mm. Because not only do you have image quality, but also color that is absolutely remarkable. But obviously, I understand that producers hesitate. Because you never know if the film will have the quality necessary for projection in 65. And with the lenses that we have now like panavision etc., which are extremely sharp, extremely well defined, you can have the very good enlargments like *Dr. Zhivago* which was shot in 35 and enlarged in 65 and 70. But what counts, you understand, the big fault, if you shoot in scope, it's not the shots that make the problems, it's the projection. Not all theaters are equipped. If the projection isn't right, all of the quality of the film is lost. With 65 they have to have equipment; in 70 the projection is impeccable. You understand, that then, you can find the quality that you would hope the film would have. The cinema is spectacle; only if you want the cinema to be different from television you have to give to the audience who go to a theater something different from what they get on television. These are two arts that complete each other. One is more intimate, you look at it in a house with two or three people. Good, you look, you stop looking, you go. When you're in a theater the spectator has to see the film from one end to the other; it's necessary, therefore, to give him a quality film that he can endure from one end to the other without getting tired.

SR: But of course there are sometimes problems with the projectionists who just want to make money and who don't care what they do. I don't know if that's a problem here but it certainly is one in the United States.

HD: Yes, and with distributors there's another problem because now no producer can make a film without an arrangement with a distributor. And the distributor himself is nothing more than a merchant who doesn't care what the film is, what's the history of the film; who only sees one thing, that there are stars that will sell in the film. And very often the producer is driven by this to make a film that he doesn't want to make. But he can't do anything else because he's now at the mercy of the distributor.

SR: Also I have seen that in the United States some films fail because they are poorly distributed.

HD: Look, in France the example of *Jeux interdits* of René Clément is very striking. The Clément film, when it was released, didn't do well. It stayed for 15 days and was withdrawn. Two years later it was re-released with a colossal success, because it was released better, people heard talk about it, people went to see it. It was an excellent film. But in the beginning the distributors opened it in little theaters, without talk, etc. When there's no talk about a film no one will go, they don't know what it is. There are films that are very poorly released.

SR: Sometimes it's very difficult to see French film in the United States. It's also difficult to understand why one film will succeed while another fails. And sometimes, especially with shorts, you can't see them at all.

HD: And even though we have agents called Uni-France-Film who are in charge of foreign distribution of all French films and who, in principle, are supposed to get them shown, even if it has to be in theaters for free. They are there to show films.

SR: Of course, there's another problem of films shot in one format that get shown in 16mm, cinemascope into a normal image.

HD: It's happened that sometimes a film that I have made is shown on television, where I know the actors and you can't see everything because the actors were at the edge of the frame. There's nothing in the center and you can hear them talk, but you don't see anything. It's because of that that in France we don't shoot as much in panavision or scope, because of the commercial possibilities of television. Even the Americans, when we shot *The Only Game in Town*, George Stevens said, "No, we're going to shoot in 1.85 or in 1.66 because we're going to sell the film to television later." I gained a little height.

SR: When you first started in large screen formats did composition bother you?

HD: No, it's another way for the director to work also. You understand, instead of certain close-ups, very often you group the actors, and you work more with backgrounds, you have more latitude with the decor. It's a format that I like, and I tell you I return to 65mm because 65mm is a framing that has a little more space in the middle than 1.85, a little narrower than scope and which is wonderful. It has all of the advantages, unfortunately you can't use it.

Henri Decae: born July 31, 1915, Saint-Denis, France

Shorts as cameraman:

Forties:
 Au-delà du visible (also directed)
Fifties:
1950 *Cher Vieux Paris*
 Bertrand, Coeur de Lion (d. Robert Dhery)
1951 *Au coeur de la Casbah* (d. Pierre Cardinal)
 La Course de taureaux (co-ph. Jimmy Berliet, d. Pierre Braunberger)
1952 *Crève coeur* (d. Jacques Dupont)*
 L'Or des pharaons (d. Marc de Gastyne)*+
1954 *Navigation marchande* (d. Georges Franju)
1956 *Israël, terre retrouvée* (co-ph. Jean Rabier, d. Marc de Gastyne)*
 Propre à rien (co-ph. Jean Rabier, d. Marc de Gastyne)*
1957 *Robinson* (co-ph. Jean Rabier, d. Marc de Gastyne)*
1958 *Le Château du passé* (co-ph. Jean Rabier, d. Marc de Gastyne)*

Features as cameraman:

1947 *Le Silence de la mer* (d. Jean-Pierre Melville)
1949 *Les Enfants terribles* (d. Jean-Pierre Melville)
1955 *Bob le flambeur* (d. Jean-Pierre Melville)
1956 *SOS NORONA* (d. Georges Roquier)
1957 *Le désir mène les hommes* (d. Mick Roussell)
 Ascenseur pour l'échafaud (d. Louis Malle)
1958 *Le Beau Serge* (d. Claude Chabrol)
 Les Amants (d. Louis Malle)
 Les Cousins (d. Claude Chabrol)
1959 *La Sentence* (d. Jean Valere)
 Les Quatre cents Coups (d. François Truffaut)+
 Un Témoin dans la ville (d. Eduard Molinaro)

A double tour (d. Claude Chabrol)
Plein Soleil (d. René Clément)*
Les Bonnes Femmes (d. Claude Chabrol)
1960 *Quelle Joie de vivre* (d. René Clément)
1961 *Léon Morin prêtre* (d. Jean-Pierre Melville)
 La Vie privée (d. Louis Malle)
1962 *Le Jour et l'heure* (d. René Clément)
 Eve (d. Joseph Losey; Venice Festival sequence only)
 Cybèle ou les dimanches de Ville-d'Avray (d. Serge Bourguignon)*
1963 *La Porteuse de pain* (d. Maurice Cloche)
 L'Aîné des Ferchaux (d. Jean-Pierre Melville)
 Dragées au poivre (d. Jacques Baratier)
 La Tulipe noire (d. Jacques Christian)
 Les Félins (d. René Clément)
1964 *La Ronde* (d. Roger Vadim)
 Week-end à Zuydcoote (d. Henri Verneuil)*
 Le Corniaud (d. Gerard Oury)*
1965 *Viva Maria* (d. Louis Malle)*
1966 *Hotel Paradiso* (d. Peter Glenville)*
1967 *The Night of the Generals* (d. Anatole Litvak)*
 Le Voleur (d. Louis Malle)*
 The Comedians (d. Peter Glenville)*
 Le Samourai (d. Jean-Pierre Melville)*
 Diaboliquement votre (d. Julien Duvivier)
1969 *Castle Keep* (d. Sydney Pollack)*
 The Only Game in Town (d. George Stevens)*
 Le Clan des siciliens (d. Henri Verneuil)
1970 *Hello and Good-bye* (d. Jean Negulesco)*
 Le Cercle rouge (d. Jean-Pierre Melville)*
1971 *The Light at the Edge of the World* (d. Kevin Billington)*+
 Jo
 La Folie des grandeurs (d. Gérard Oury)*+
 Le Droit d'aimer
1973 *Two People* (d. Robert Wise)*
 Si Don Juan
 Elle lui dirait dans l'île (d. Eric le Hung)*
1974 *The Mad Adventures of Rabbi Jacob* (Gérard Oury)*

Interview with Willy Kurant, March 19, 1973

SR: We'll start with the most normal, ordinary question . . .
WK: Yes, O.K.

SR: Which is, how did you get started, you know, sort of a background of . . .

WK: Well, I started first, I was living in Belgium because I was born in Belgium. And I started very, very young. I had to make up my mind about a choice of work, and I was introduced with a kind of contest. To tell you the truth I had a brother-in-law having—I was living, I was an orphan living with a brother-in-law who had—a still camera. And I was not permitted to touch this still camera. He was always telling me he knew how to handle the still camera. He was always telling me he knew how to handle the still camera and how to make photographs. So at a certain moment, at a given moment, I was thinking about starting a job and I hesitated. It was a kid's idea about being a radio telegraphist, I mean, or a photographer. And then, well, I started to learn photography. And I started to learn it in a kind of institute. This institute was not really a school and it was not really work; it was a research institute. I started in a very little institute with chemists trying to find a new color process. So, I was learning a lot of things in books. I wasn't exactly a worker because I was working with engineers explaining things to me. Then I started in a very strange way in processing things, making tests and things like that. I was 16 years old. So this lasted about two or three years. And then I was always promised to get out of the lab and to work on the film, but it was in Belgium and in Belgium there is no big film production. So I was put as an observer very strangely on a film, on a feature film, and it was not as an assistant cameraman or not assistant sound engineer because it was the only available place, to record reference sound, so I did an uninteresting feature film . . . I got back and I studied more. Then I wanted to work. I was 19 and I had been offered an amount of documentaries in Africa as first assistant cameraman. And I bluffed a bit. I said I was graduated from a school in Paris, and I was not at all. But to tell the truth I knew thoroughly as much as the people who graduated from the film school in Paris. And as a matter of fact, I got a graduation there later, because through very strange circumstances there was an examination for technicians working already in the industry in France to get this graduation. And I got it later on. So I went to the Congo as an assistant cameraman. I made seven documentaries in the jungle. And most important I was 19; I was 20 when I was in the Congo. And I was with a very odd cameraman I will not name. He was very racist. And he was thinking Negroes were too idiotic to carry cameras. So I was the assistant cameraman carrying very heavy cameras through the jungle.

SR: Were they 35 or 16?

WK: 35. Very heavy 35 and at that moment in '53. So I was carrying a very heavy Debrix old camera. And this was the way of the, that moment. He was giving me the f-stop. And then he was hiding with his hands the operator, for me not to know how he was working. So I did those films. I got back. Then I started to make shorts. Myself being, . . . I was a cameraman myself so I put some. . . . with money I had from this . . .

SR: Was this 35 or 16?

WK: 35. Everything was in 35.

SR: Have you only worked in 35?

WK: No. I worked in 16 but very later on. I started mostly in 35, so I bought myself first an old Vinton British camera, war stock camera, and I started to make documentaries in Belgium. That's as a cameraman. I did two or three documentaries. And with the money, I resold my old Vinton and I bought myself an Arriflex. And then I did other documentaries and I started to be known in Belgium because of a film I did called *Clean Cart* with a Belgium film director. This film won a first prize for short films, or something like that. And this was in '56. So I was already director of photography and it was a feature film. It was not a short. But it was very hard for me to earn my life, so I was keeping doing that and also working as an assistant. It was very hard, it was easier to get work as an operator than as an assistant because we were not using assistants in Belgium. I started at the same moment to work as a news stringer for television, the new Belgium television starting. And they were very reluctant to use me because I had a very bad reputation. People said because they were not knowing what I was, that I was a radical. And this was the most terrible thing to say in a conservative country like Belgium. It was not exactly that, but it was very hard for me to work. It was the McCarthy period, you remember, and I was doing once in a week covering meetings with blinders or something like that or some new school opening in the country for television. And I went like that; it was very hard for me to live. Until I obtained, how do you say, through the British consul I obtained permission to learn Vistavision in Great Britain. So this was in '57. And I went to Great Britain to work as an observer, which is the official term for the union, British union, in Pinewood studios. And I worked with Jack Hillyard, Geoffrey Unsworth, and Harry Waxman. And I learned Vistavision. And I never used Vistavision or tried Vistavision after that. It was a very strange thing. We were several assistant cameramen. Among them Johnny Alcock I met last week and he became the cameraman of *Clockwork Orange*, with also Geoffrey Unsworth, the cameraman of *2001*. And well, I got back to Brussels and there

was a World's Fair in Brussels. And then from one day to another day I started to earn a tremendous amount of money because I was the only one who could speak English, Russian, and some foreign languages, because I learned those languages just like that and I was hired. I was really, when I got back from Britain, I had nothing to do with knowing Vistavision, a lot of things, and then I was hired to work in 16mm very shortly, for an intervideo news service sponsored by the Belgium television having to service all televisions of the world during six months. So during those six months I'd been hired at, let's say, $1,200 a month; at this period that was something for me. During six months, plus overtime (and I was always in overtime because I was working for this agency during daytime and nighttime). Fox Movietone and other companies were fighting to use me because they were just short of cameramen. All the job was done in 16mm. And sometimes for certain circumstances for Eurovision, 35mm. So at the end . . .

SR: What kind of cameras were they using then, 16's?

WK: At that moment they were using Bollexe's because they had no money. And I was the first one in Belgium to buy—because we were working with our cameras—an Arriflex 16. At the end of the exhibition I bought a new Arriflex 35, a new Arriflex 16, a new car, and I had some money in advance. It was the era then when the synchronic sound started. Nobody was working in synchronic sound. So I did buy a projector because there were no Nagra's. Working synchronic with the camera was a kind of close blimped barney made with a kind of old pajama. So the exhibition was finished, the World's Fair was finished. I was not too happy about the work. Oh, I forget. At this period just after the exhibition I was offered a co-production with France, and I did a feature film as first focus puller, first assistant cameraman, using the new French zooms. People were not aware of zooms at that period, because I had no mechano device, no mechano device to control the zooms, there was no electronic zooming. And really I was obsessed by this zoom. My dreams were in zooms. So when I finished that film, I—it—made me come to France several times because of co-production. And I decided I was very young to work in feature films. So I had not so much of, how would I say, I was not looking at my future with a lot of enthusiasm because it did not seem clear what I was going to do. But my former employer in Belgium in television became out in the news of the, how would I say, head of a big magazine covering all the things happening in the entire world. I mean actually what we call hot news. I don't know what is the term, what is the term in English. So something was happening in Egypt or something was happening in the Congo. We were sending crews with cameramen being sometimes

sound man at the same time, and a newsman, a telecaster, and some-
times this was it. So I started to cover things like that. And this tele-
vision was working co-production with France and Switzerland. So for
them I covered a lot of wars. I covered, how would I say, all the
troubles in the Congo, all the troubles in Cyprus, all the troubles . . .

SR: It was dangerous.

WK: Yes, it was rather dangerous. I went to Viet Nam in the beginning.
I covered the Cuban revolution. I covered a lot of things for them. And
then I moved to France. And when . . .

SR: Did you learn things from that kind of coverage?

WK: I think I learned more from this kind of coverage than ever in feature
films, according to my personal experience. And I learned several for-
eign languages, and I approached a lot of very famous people. At that
given moment I think there was no political leader in the world I did
not approach. Well, I moved to France in '62 really in a very firm way.
I was working for this company, and at the same time I had thought
I would use my 35mm camera and I started to work on shorts. But
on shorts were very, very good directors. They became now, they are
now, the new directors, would I say. Sometimes they didn't make a lot
of success like Jacques Rozier who did *Adieu Philippine*. I did shorts
with him. I worked with Averty Jean-Christophe and I work with him
tomorrow. He became the most important director in television in Eu-
rope. And Maurice Pialat. I did several shorts with him. I liked Marin
Karmitz. All those directors are known now. They were just doing
shorts at that given moment. And I began to get, I started to get a
reputation as a man working with quite no light, working with high
speed film, with stocks not used in France, because in France we were
using Kodak. We were using Kodak in France. And the only available
high speed at that given moment was an East German high speed.
Nobody was wanting to use it because it was badly perforated; the
resulting pictures were not too standard. So I was using this material,
not only me, I have to say, Coutard already started, but he was working
with Ilford film I think. So he was already known, I was not. So I
worked in those shorts with that film.

SR: This was all in black-and-white.

WK: Yes, this is all in black-and-white. And then . . .

SR: But there were fast films available.

WK: There were, there were 600 ASA and I was pushing them double
and achieving very good results, fighting with the lab. At that given
moment because it wasn't the fashion. Now everybody accepts a high-
key image. Everybody accepts a low-key image. And it was not clas-
sical, and the timing people in the labs were teaching me how to do,

and telling me I was doing very badly, and I shouldn't do like that. So, for instance, for the first film I did for Jacques Rozier, a short film, very nice, I think, photographically they said to me, "It's too white," they said, "You should not do that." And then, well, I did all, I did 15 or 20 shorts. One day Agnes Varda called me. I knew her since a long while because I did a program for the Belgium television about her, and I photographed her. And I did another program on Fellini with Fellini also. And Agnes Varda asked me to make this film, going to be my first feature film, called *The Creatures* and it was in cinemascope. So it was my real beginning. It was very, very hard to do. We were shooting on an island, very little crew. I was handling the camera myself like always. I had two electricians, two grips and only a few bulbs and four quartz lights. Of course it was in black-and-white.

SR: Nobody else with the camera. I mean you didn't have a focus puller?

WK: I had a focus puller and another assistant cameraman. I was hauling the camera myself like I did mostly, except when the director didn't want me to hold it. And I think it was a mistake because at a certain moment I gave up holding the camera myself, having some director's pressure, and it's a mistake.

SR: Are there union pressures?

WK: There are union pressures, but you can't avoid that. It's a matter of money. Not about union, but if you pay the focus puller the rate of camera operator and the second assistant cameraman. Yes, you can get rid of those problems. And I did that. Like about Coutard people were telling, "Look, this Coutard, he is holding the camera himself. Very bold of him," and so on and so on and so on. And I did it after that while I did this film *The Creatures*. Not a very good film, but it was very interesting. I don't know if you saw it, this film.

SR: No, I haven't seen it. Did you use a Mitchell?

WK: No, not at all. We used a Camiflex. Rarely used a Mitchell, no. We used the Camiflex with post-sync sound. We had reference sound. And we had no dollie, just kind of a very strange sort of wood triangle with . . .

SR: Just like the way we make films in the States.

WK: Yes, yes.

SR: The way we make them in school.

WK: Yes. There were a lot of special effects in the film, the effects were not too good because some scenes are jumping because we couldn't afford to get a Mitchell. A Mitchell is very steady, but, well, the film was not a success. But it was for a production company linked with, the production manager was linked with Godard and Godard having been living his life like with wife with Coutard for let's say several

years, needed a sentiment of change or something like that. So he wanted another cameraman. So he hired me and I had no illusion I was knowing he was going to get back to his wife, should I say, to Coutard. And I did *Masculin-féminine*. And a lot of enemies were expecting me because, as you know, around people the New Wave, like around pop stars there were groupies. But they are around film stars, also about film directors like Godard. Everybody was explaining why he made a change and everybody was telling things embarrassing me in different ways. How it happened, how it was, and things like that. Well, and a lot of those people were not at the shooting as you know. So I did this film with Godard entirely on 4X and there I had a Mitchell because Godard likes a Mitchell, liked the Mitchell. And we did it very fast. I think it was done in three or four weeks. I was operating with quite the same crew I had in *The Creatures*. And the interesting thing is I think we did the film with two bulbs and one umbrella; the only lighting equipment we used.

SR: And what was it like?

WK: We were pushing the film very high and I was trying to avoid, I decided, to kill all the gray in the film and to work in black-and-white. So I pushed the film. This increased the contrast. It gave us a bit more grain. But we weren't wanting grain, but it killed the gray. So we had a real black-and-white film. And sometimes it was . . .

SR: It must have been just, you had to push it too, a lot of it was done at night, too.

WK: Yes, we pushed it. Yes, we pushed it. We worked in the metro with no light at all.

SR: Yes.

WK: We were able to pick even what was happening outside the metro.

SR: Yes, I noticed that because when I was in the metro the other night I was thinking of the film, as a matter of fact.

WK: Yes, yes. And I did an experiment because Godard . . . I had a kind of contest with Godard when we did the test, he wanting to work on Ilford film. Nobody worked, I used a few rolls of 4X on *The Creatures* but before nobody used 4X for an entire film. So I did tests 4X for Godard, and we projected the test. And he decided we should go on 4X, and 4X gives 500 ASA or something like that, and I pushed it for a 1000. Pushing processing time. And I thought the results were looking better. And we did the entire film in 4X. It was, I think it was, quite interesting and it was a bit different of the other films he did. But perhaps I'm wrong.

SR: No, no. I think it does, I think that it does have a different . . .

WK: I had an argument with Skolimowski about this film. Skolimowski told me, "I'm going to hire you because I saw Godard's film, but I don't want the same operator." And I told him, "But I'm the operator." "How did you frame so badly?" he said. I said I did exactly what Godard asked me. Godard asked me to cut the persons in two on the edge of the frame. It's on purpose. It's not just like that. You understand the problem. So a lot of people thought it was the way the thing was framed, but this thing was framed exactly how Godard was wanting the thing to be framed. And a few years after it, it was strange the way Skolimowski reacted.

SR: No. Well, I think that the framing I've noticed, I think the framing is pretty much the same throughout Godard.

WK: Yes.

SR: Up to a certain point I mean there's always that . . .

WK: It's very hard you know to unbalance your frame when you are used to balancing it in your reactions.

SR: Yes, but so I always attributed that to Godard, just . . .

WK: Yes.

SR: Because it seems that the film . . .

WK: Yes, I would any speaking about the visualization of Godard film, *Masculin-féminine*, that if we have to split the responsibility I think I had quite a full control of the lighting and he had terrible control of the framing. And we had one of our few fights on the framing. Also he was at a very nervous moment for himself. And there was a bit of tension on the set but not only between Godard and me but between Godard and everybody. And well, I think you have to answer at people telling that Godard doesn't prepare his things, and things are floating or happening like that; this is not the truth. Even if you have no script before starting his day, he sits in a café; he worked on his technical scenes and he knows perfectly what he wants to do.

SR: What about in the pans and things like that. How did you work?

WK: In the pans?

SR: Yes.

WK: Well, he was checking the starting and it was like, like he was an old Hollywood cameraman, camera operator, would I say. Only he couldn't control the hand-held work, and he wasn't wanting to be there sometimes for hand-held work. He was horrified to work in the streets. He was scared. And he was very nervous because he forgot at that very moment that I was a news cameraman and I could pick up a lot of things and he was not used to that. And he was hurrying everybody. Telling me, "Don't show your camera." A lot of things I was knowing myself by experience because I risked my life several times filming so

I was knowing how to handle the camera. But at the end we were quite on good terms. And, well, from what I know, the relations were the same with the other cameramen he used. I haven't seen Godard since years. I only meet him in the streets from time to time.

SR: I saw him one day when he was in the States with *Tout va bien*.

WK: Yes, yes.

SR: For me it was a great disappointment.

WK: Yes, it was a bitter disappointment for me also, *Tout va bien*. By the way, the cameraman of *Tout va bien* was my assistant, a second assistant cameraman in *Trans-Europ Express* by Robbe-Grillet. And he has become completely linked to Godard during a few years in a political group and he worked with him with the same group, with the sound engineer and some other film people.

SR: Now I don't think that, I don't know, we shouldn't talk about *Tout va bien*, but . . .

WK: No, no. But in Godard's film there are wonderful things. There are bad things. An artist has a right to make mistakes also.

SR: The thing that was for me personally disappointing is that in every film of his that I'd seen before, there was always something exciting, something new, even something like *Wind from the East*.

WK: Yes.

SR: But they always opened up possibilities. Things that you hadn't thought about doing with film before. And I didn't feel that . . .

WK: Well, I didn't feel it also, but it's very hard for me to speak about *Tout va bien*. And I don't know what Godard is going to do anyhow. Well, any other questions?

SR: Well, let's talk about, we covered a lot of things in talking, but what about your working with Robbe-Grillet or Skolimowski?

WK: Robbe-Grillet was very interesting, I think.

SR: I just saw *Trans-Europ Express* very recently.

WK: Yes, I think it was very interesting because I worked really like a newsman. He gave me the script . . .

SR: Did he know exactly, I mean he is different in that he was new to movies rather than . . .

WK: Yes. He did a film already before . . .

SR: Yes, but . . .

WK: In Turkey. And I met him in Turkey, I have to say, because when he was doing his first film, *L'Immortelle*, there was a very heavy crew. I was there as a second unit working for the same producer, but not for Robbe-Grillet, making documentaries with Pialat about Turkey. And he saw my work. I had no assistant even with Pialat. We were the poor kids of the production we were shooting. And he saw my work in the

dailies, and he decided at that given moment to take me for his next film. And it's very strange because I had to make *Trans-Europ Express* before *The Creatures*, before *Masculin-féminine*. And it came out as the third film. And he decided to be very fluid, should I say, in terms of technique so we decided we would never have a second take done like the first take. So everything was done once again with no light or very little light. I had one electric . . .

SR: What kind of film were you using again?

WK: 4X once again.

SR: Was that your choice?

WK: Yes, that was my choice. One electrician, one electrician I think, one grip, and . . .

SR: Did the cast have to carry everything in this?

WK: No, and three and three, yes, we were three at the camera, and a few persons just like that and three weeks of shooting. And even the lab was surprised because the lab was thinking the *Trans-Europ Express* was lit.

SR: Yes.

WK: And it was not lit.

SR: No. It's a different color tone very much.

WK: Yes. Once again I changed contrasts in the film to get certain . . .

SR: Yes.

WK: I don't know what it is called when the print is soft. But for me it was very interesting, but really I was working like a news reporter covering something happening, making anytime another version and the way Robbe-Grillet was making the film was editing it. And this was the way we agreed on it. It was I think, he was very complimentary about the work I did.

SR: Everything was done . . .

WK: Even on telephone or tripod, even hand-held.

SR: It was all done, like where it takes place. There was no studio.

WK: No, no. Never a studio. It was taking the real Trans-Europ Express. It was taken auto-routes in Antwerp and just because one sequence of the rape has been destroyed in the lab by coincidence, we did the matching sequence in the flat of the producer. And I lit it mostly with the real bulbs and changing the bulb by stronger bulbs and in the places where I was and it's an old film now . . . I try to think about it. It was an umbrella to reflect the light, like a fashion photographer's umbrella on Marie-France, on the girls' face. Robbe-Grillet was wanting to take me for *The Lying Man* [*L'Homme qui ment*], but it was a co-production with Czechoslovakia and on the deal he had to bring the cameraman,

so he brought into it a Slovak cameraman took over and I didn't
do the film. But I was approached to make the film.

SR: Yes. With *Trans-Europ Express* your news background must have
been good too, then, because you had to do everything in crowds.

WK: Yes, yes, yes. This is because I did the *Trans-Europ Express* with
very strangely, Trintignant. He had the part because of me. No, it's
the truth. Because I made a short with Trintignant a few years ago and
Robbe-Grillet, not knowing which actor, how do you say which actor,
what actor, to take. And in the conversation I said, "Why not Trintig-
nant?" and I called Trintignant myself, and he got the part. And then
Trintignant wanted me to do *Mon Amour, mon amour* with his wife,
and this was a real disaster, between his wife and myself. Because she
never considered I was the cameraman she wanted. She was wanting
to make a film with my operator, because I had an operator on this
film, being formerly an assistant cameraman of mine, but was mostly
a friend of hers. So she was counting, preparing all the things, was
discussing everything with the operator and was expecting me to just
sit and remain there, to how do you say, to lend my name. And we
didn't get along very well together. And since that moment until now
I have a very hard relationship with the Trintignant tribe.

SR: There is a very amusing interview with him but it was awful. Done
by, it was one of the American magazines. What about Skolimowski?

WK: Skolimowski, it worked very, very well. We worked in Belgium. We
were very glad. The producer, I knew her for a long while and, well,
then she proposed me to Skolimowski, and Skolimowski was at the
same time wanting to make a film with me, so we worked well. I was
speaking Russian with Skolimowski. I learned Russian myself.

SR: I had a year of it, so I admire you very much. I gave up after a year.

WK: So I forgot most of the Russian now, but at that given moment
Skolimowski was not speaking English, and we were speaking together
in Russian. Very strange Russian, but anyhow we were working to-
gether like that. And we got along, we got along very well. But I haven't
seen Skolimowski since that moment. He tried to get me once for a
film that then was not done. No, twice. And you know how it works
now in the industry, most of the films are made by package deals. And
very often the director says he has the right to choose a cameraman
but not very often it is, in fact.

SR: No, even Henri Decae was telling me that with a lot of these Franco-
Italian productions he was promised a job and it turned out that they
had to have an Italian cameraman or something like that.

WK: Of course, of course. I had it several, several times. Several, several
times I have been hired with no contract signed in advance. Really this

is the way I got out two years ago, because I was thinking to make a film and very strangely Decae did it. But I have nothing against Decae; he was not even knowing it.

SR: Yes.

WK: It was something like that. Sometimes there is a fight between film stars. When you have very big film stars they want their cameraman.

SR: Yes.

WK: So, it's like that.

SR: Yes.

WK: What about other films?

SR: Yes. What about your work with Welles?

WK: Well, I did two films with Orson Welles. One released and one unknown. Plus an experience in Budapest. Never finished; just one day of shooting. So I met Orson Welles. He was in pajamas when I met him for the first time, smoking a cigar, sitting in a big copper bed in the Hotel Rafael in Paris. And he made tests to start *The Immortal Story* with another cameraman and they didn't get along at all. So he wanted to change before the film really started.

SR: Yes.

WK: So through a lot of telephone calls I'd been asked to go and see Welles. And he was hesitating between myself and another cameraman. And I was booked to go to New York to make a film for television so I told him, I was very sharp, and I told him, "Tell me before tomorrow, yes or no." And he said to me, he was speaking about the way it was going slowly on the film. And I was telling him there is no 35 or 36 methods to go. You have to do that and that and bounce light to do that, to use that kind of stuff to remove all of this material you have if you want to get speed. And he said to me, "Yes. Answer tomorrow." And he hired me. So I was a bit scared the first day, I have to say, but very shyly I made one or two suggestions and very strangely he listened to me. And all the mirror sequences were done the first day of shooting. Candles, Jeanne Moreau, candles and things like that because I was facing Jeanne Moreau. And suddenly I turned my head back and I saw something in the mirror. It was a kind of distortion in the mirror. And I very shyly without knowing what was there to tell, I call to Orson, "Don't you think it would be better on the back side?" And he tells me, he shouts, "Sure, turn the camera." So this was starting and I had to say the first day of the rushes I was really scared and worried. Really, but he was delighted. So a very strange thing is when you work with very, very great directors, you have communication. More communications with as big a director, as far as you go in terms of cooperation. Because he's not scared.

SR: He knows what he wants.

WK: He knows what he wants and he's not scared to lose his credit, things like that. So it was kind of a contest. Sometimes we were between Welles and myself. And the very strange thing was his doubting sometimes. And on some sets, set-ups of Chinese servants cowering around Welles, supposed to be Macao but shot in Madrid in his house, I wasn't liking the framing. And I thought I was making faces. And Welles saw my face and he told me "What's happening?" And then he started to doubt all too much whether he was right. He was right. I was absolutely wrong. And then he told me, "No, let's shoot it." And we shot it. On those things I get a lot of suggestions and accept it.

SR: What kind of crew did you work with for him? Was it a full crew?

WK: No, I handled the camera myself. He started to make tests with an operator and then another operator was supposed to take over, but the operator was scared of Welles's reactions, because he was very violent in rushes. So I controlled the camera myself completely. And I did it myself and he liked it very well. And for the first time of his life I showed him a shot with 150mm, which was a long, long focus for him. Because we were in Spain and we had no traveling trucks. They didn't arrive in time. So I proposed a substitute to use a 150mm with pans as a substitute, and he accepted that. And he was a bit reluctant and scared. And he liked it very much using day for night, in fact, in projection. And then I was invited very often to his house in Madrid. And it was quite nice to work with him. And he was wanting, nobody knows he was wanting, to make a second part to this film to make it one hour and a half. And we went to Budapest to make a second part together and then we did one day of shooting and then Welles disappeared. He was not wanting to do the film. It was very funny because I was left at the hotel. Nobody told me and I was there like a hostage. Everybody in production came to ask me what was happening. Then I met him in Vienna. And then he hired me two years later for this film nobody spoke about.

SR: Yes, I saw a reference to it.

WK: Yes, it's called, it was called first *Dead Reckoning* and then *The Deep*. It was with Jeanne Moreau, with Laurence Harvey, with Michael Bryant; a thriller, very interesting.

SR: What happened? Nobody knows what happened?

WK: Nobody knows what happened. The film is not finished because some voices were missing. Very strangely I worked only on a part of the film, because I couldn't finish the film, because I was hired by another production. And I said it to Welles before starting and then my assistant cameraman, my first assistant Yugoslav took over and still

wanting to finish. Two weeks of shooting were missing and then I never heard of the film again. I had one wire one day from Welles asking are you free on such and such a date and I was not free. Since then I didn't meet Welles. But I was on very good relations with Welles.

SR: Were finances the problem?

WK: Yes, I think so. I think so. I think so.

SR: Certainly that's his problem.

WK: Yes, it was a very strange deal where Yugoslavia was giving services because they hired Welles as an actor for *The Battle of Neretva*. And instead of paying him money were giving him services for his film. Crew. Well, I don't know what happened. It was a very strange deal. But something happened and it didn't . . . I'm sorry because I would have liked for this film to have been shown because it was very, very interesting.

SR: Yes.

WK: And we were in a boat in the middle of the sea and we decided to shoot everything in back light. So it was easy, we had just to move the boat. Because we were in the middle of the sea, to be in back light at any moment that gave a very soft achievement on everybody's face, Jeanne Moreau. It was very interesting.

SR: Yes, well it had big names and everything.

WK: Yes, well, nobody knows if this film is going to be released one day.

SR: Do you try to keep the same crew with you if you can?

WK: I did it for several years and now it's most impossible in relation with the situation in France. Most of my crew, everyone became director of photography now so, and because I'm working a lot in television now, since two years I have no choice. I am obliged to work with television staff in commercials also . . .

SR: In television do you shoot in 35mm or 16?

WK: Both; now I'm shooting in 16 but two years ago I was shooting in 35. I did super productions. They, too, are done in 35, but they gave up 35. And now they mostly do it in 16. For instance, next week I'm starting a two weeks little feature about the French Revolution in 16 for television.

SR: What do you use? What cameras do they use for 16?

WK: They use Eclairs, mostly Eclairs.

SR: All synchronous sound?

WK: Yes, all synchronous sound. And television crews are quite good. They are very in tune to what I say. Most of the work is done handheld in things I've done in television. But they are very strict because of union rules. I don't hold the camera myself. I have an operator and sometimes it's very hard even to look through the view-finder for me.

Because it's state-owned television and it's very controlled by union. And sometimes I am very surprised to see what is going on the screen, the thing I lit. I have just finished *Dante's Inferno* for them, shot with Alain Cuny, a very good actor. And sometimes when I had, lately, when I had to time the film, sometimes I was very surprised to see what was on the film because I did not have time or possibility to control every framing.

SR: Is this in color now?

WK: Yes, this is in color, everything is in color. Very strangely I haven't been working in black-and-white for years. Next week for this film about the French Revolution I will work in black-and-white and it is going to be a surprise.

SR: Which do you prefer?

WK: Well, I don't know. I'll say both have their charms. It's a totally different way to work in color and black-and-white. In color I work with the colors and in black-and-white I work with contrast. I don't try to make too elaborated lighting in color, but I try to make an opposition colors. Well, it's according to the film, of course, what they ask me. But now I am so much involved in color that I forget there is black-and-white.

SR: Well, color films are slower, too.

WK: Right. They are slower and you must use a lot of lighting. But I very often still now work with very fast open lenses, and using a minimum of lighting because I like very much, this is my personal approach that you not handle it but use a very little amount of lighting, getting as close as you can to the realistic sheen, I would say.

SR: When you start to light a sequence, how do you generally approach a sequence?

WK: Well, I have my opinion, of course, when I've been reading the script. I don't believe at all in scouting locations with the director because we don't forget, we never quite do finish studios, so we scout a location and when we arrive it's totally different. We scout for light in the afternoon. We arrive in early morning. Or to the contrary. So Coutard said it one day and I am with him also in that I believe a lot in what you feel at the given moment where you are there and very, the way artists are mostly sometimes. So I think I don't have too elaborated things. I just react. And I do my light. Of course, sometimes I have a very strong idea about a color and I have to have the idea before, because I have to order the materials if I want to use yellow gels for the backgrounds or things like that. Have you got any other questions? Specific questions?

SR: No, let's see. We covered everything. Have you worked in wide screen process?

WK: Yes, I have been working in wide screen process. I've been working, my first film was in wide screen process. It was *The Creatures*.

SR: Which do you prefer, or what are the difficulties that you find?

WK: Well, I don't find any difficulties to tell you the truth. It's very strange because I was quite hired last week for an American film in Africa and they didn't hire me at the last moment because they said I had no experience in Panavision, but Panavision is just a trademark like Cinemascope or Francescope and I did . . . But there is no problem of balance and composition. What you need is a good action and knowing very well cameras, but there is no difference. I think it is a bit harder to frame, because you have less power of the end of the frame. But being an experienced operator I don't think there is a great difference.

SR: But from an artistic point of view do you like that shape better?

WK: From an artistic point of view I think there is a great amount of possibilities not used. Because everyone wants to fill the screen absolutely, and I don't believe so much in balance. I like, how do you say, asymmetric things also. And you have a lot of other possibilities in composition. Of course, if you work with a not too conventional director, because if you work, it's very strange the way you can talk about progress in photography, probably because as I told you at the beginning of this interview, I am more interested in, I make more experiences in doing commercials. At least I make one experience a week in a commercial. I'm going to see dailies in two hours and I experiment in new color in those dailies. And one can use this in these films.

SR: The commercials that they make in France are used for mainly where? I mean where are they shown?

WK: They are shown on television.

SR: There are commercials on television. I thought that, you know, even though it is state owned, there are still commercials?

WK: Yes, yes, there are a few minutes, but it's . . .

SR: I know I've seen them when I go to the movie theatres. It's quite like the States.

WK: Yes, because you work with art directors you usually have some demand. Movie directors are not asking you what's possible. And you know what is their state of the directors in France now. It's not very high. French cinema is not very high. This is explaining a lot of things. This is explaining why also some directors working a lot want to have a consort of yes men around them.

SR: Yes.

WK: Yes, and that explains also why it is hard if you've been linked with other films to work. But I think I will make another feature film in May, a very important one with a young director making his first feature film. It is going to be in the English language, feature film with Terence Stamp. And directed by a young 26-year documentarist mostly, making his first big experience. And very strangely, the unit will be done by friends having been working in the news before. Because also it must be very, how do I say, gentle, very soft in the way of moving because there are a lot of locations. And always, when I have a choice, I prefer the people to be less and paid very well, when I have a choice in the discussion with the production manager. Because instead of having four grips I prefer to have two or three very good ones than six.

SR: Yes, they don't do anything.

WK: Yes, and, well, to make good films is rather hard in France now because there are not so many good things to be done. Or would I say there are a lot of cameramen for the few good films to be done. And as I told Coutard myself, it's very hard for me to speak about Coutard, but perhaps he will tell you the contrary. But I think the problem is generation. We are just in between.

SR: Yes.

WK: And you have the choice. And I rejected a few projects. And having been rejecting a few projects, commercial films, nobody asked me for, this is an error, this is my mistake, also perhaps this is my mistake. But what I learned from the job is you have to work to get work.

SR: Yes.

WK: So I'm earning my life. This is not making television commercials now. And I was expecting to make this very important American film now I'm not doing. So I'm a bit upset. In fact, I shall make this year another important film so I think, and I think that film, you know, you were asking me how I would approach photography. I'm going to bring in this new film a lot of things I've been learning or experimenting in doing commercials. And I'm going there to experiment with feature films.

SR: We've seen in the States that French television commercials are actually quite famous, you know, they . . .

WK: Do you think so?

SR: I have. But even in the States, television commercials, what you'll find a lot of times are an advance of the feature films.

Willy Kurant: born February 15, 1934, Liege, Belgium

Shorts as cameraman:

1961 *Béjart* (d. François Weyergans)
1962 *Coups de feu à 18 minutes* (d. Daniel Costello)
1963 *Les Idoles* (d. Marin Karmitz)
 Auto (d. Jean-Claude Lubtchansky)
 Encore dimanche (d. Jean-Christophe Averty)
 Dans le vent (d. Jacques Rozier)
 La Demoiselle de Saint-Florentin (d. Serge Korber)
1964 *Pehlivan* (d. Maurice Pialat)
 Le Bosphore (d. Maurice Pialat)
 Corne d'or (d. Maurice Pialat)
 Istanbul (d. Maurice Pialat)
 Maître Galip (d. Maurice Pialat)
 Nuit noire Calcutta (d. Marin Karmitz)
 Le Type au ras du cou blanc (d. Alain d'Henaut)
 La Cage aux oiseaux (d. Jean-Christophe Averty)
1965 *Un Jour à Paris* (d. Serge Korber)
 La Vengeance d'une orpheline russe (d. Monique and François
 Lepeuve)
 La Brûlure de mille soleils (d. Pierre Kast, exteriors only)*

Features as cameraman:

1965 *Les Créatures* (d. Agnes Varda)+
 Anna (d. Pierre Koralnik)
1966 *Masculin-féminine* (d. Jean-Luc Godard)
 Trans-Europ Express (d. Alain Robbe-Grillet)
 Le Départ (d. Jerzy Skolimowski)
1967 *Mon Amour, mon amour* (d. Nadine Trintignant)*+
 Au pan coupé (co-ph. Jean-Marc Ripert, d. Guy Gilles)
 Loin du Viêt-nam (collaboration)
1968 *Histoire immortelle* (d. Orson Welles)*
 The Night of the Following Day (d. Hubert Cornfield)*
 Idea (d. Jean-Christophe Averty)
1969 *Michael Kohlhaas—Der Rebell* (d. Volker Schlondorff)*
 Tout peut arriver (d. Philippe Labro)*
 Le Temps de mourir (d. Andre Farwagi)*
 Bhakti (d. Maurice Bejart)*
1970 *The Deep* (co-ph. Ivica Rgkovic, d. Orson Welles, unfinished)*
 Cannabis (d. Pierre Koralnik)*
1971 *Le Feu sacre* (d. Vladimir Forgency)*
1972 *That's Las Vegas* (d. Frank Lang)*

All These Children (d. Erwin Leiser)*

Interview with Jean Rabier, March 12, 1973

SR: I would like to begin in the usual manner by asking you how you began in your profession?

JR: How I began? Since you are an American this will amuse you. I did not think of working in the cinema. I was at a technical school, and I lived in Neuilly not far from here. That was at the moment of the Liberation, and I was in the street waiting for the Americans who had to go by way of Neuilly Avenue for the first time. It was very interesting. And, at my shoulder, behind me, there was a professor, Monsieur Marc Cantagril; he was a math professor, and he made films about mathematics and geometry. He began to chat with me because I was a young man, and asked me what I was studying, etc. I told him that I didn't like technical studies because I didn't see myself working in a shop, for example. He suggested that I enter the National Conservatory of Arts and Trades where there was a chair in Telephonovision. But to enter as a mechanic, that is to say, to aid the professor and his assistant in the preparation of cinema courses. I certainly accepted very quickly, and I entered this laboratory. There, I had to begin by choosing between image and sound. But I didn't like sound very much because it seemed to me above all, well not above all, but more often, repair work. Whereas we didn't repair, we telephoned and someone brought us another camera; whereas the sound engineer had his soldering iron, etc. So it's like that that I chose the image, really without knowing much. I didn't know very well where I was going. And then I started out as assistant operator in a feature length film that was being shot in Africa. But in the meantime, by leaving I lost my place at the Conservatory of Arts and Trades. But since on the financial level it had been the equivalent of a feature film I said, "I'm just not risking anything, I'll find a second film." And like that I progressed, first with short films and then I followed the normal classical career.

SR: At what point did you join the union; did you have problems?

JR: Oh, it was very easy because there weren't many problems at that time in France, as there aren't many right now, since no one has to go to school to enter the cinema. Then, since I made short films that allowed me to become an assistant operator; when I had the number of films as an assistant I had the right to become a cameraman, and then I had the right to become chief-operator without any problem.

SR: It was like that that you were a cameraman for Henri Decae?

JR: Like that, yes, I began to be a cameraman. I was assistant to Henri Decae. I knew Decae. There, I'm going to back up for a moment, I was chosen as assistant operator for a feature film in Genacolor that took place during the Korean War in Korea. Henri Decae must have told you about it. But we didn't have a chief-operator, and the Eclair laboratory suggested Henri Decae. Then, with the director who I know very well, the director chose Henri Decae, and I was Henri's assistant, and I remained his assistant on several films, among others those of Louis Malle, and then Chabrol, who was making his first feature film, *Le Beau Serge*, chose Henri Decae as chief-operator and asked me to work as cameraman. That was my first film as cameraman.

SR: And you went on like that?

JR: Like that. I made several films with Henri Decae, and then, Henri Decae left with René Clément for Italy, and he took an Italian cameraman. And Chabrol, who was making *Les Godelureaux*, suggested to me that I work as chief-operator. I'd have to say that Henri Decae was a very important person for me and Claude Chabrol also.

SR: Yes, I already spoke with Henri Decae.

JR: With Henri Decae, yes, he told me. He's a charming person.

SR: Yes, very nice, and he has a very beautiful wife.

JR: Yes, she was his script girl.

SR: Well, when you begin to prepare with Chabrol or another director what do you do, what do you think?

JR: Well, I worry a lot, you understand, I worry a great deal. I am very unhappy, I suffer a lot. I am very uneasy. And I'm in a hurry for the first day of shooting to arrive. But when you work in the studio there is a lot more preparation than when you work on location. On location there is less preparation. You are interested in seeing above all. That's to say that what you do is spend a week in fixing reference marks. You work a whole week in marking the decors. And then in general, and perhaps I'm wrong in this, I make very few tests of makeup or hair styles. That means that there are sometimes small surprises that we must rectify in the first or second day of shooting. With the makeup that doesn't happen too often. It's most often a problem with a wig, with shape.

SR: Do you make any tests?

JR: Rarely.

SR: Do you work with the same crew?

JR: With the same crew, yes, yes. I have an excellent cameraman, a very great cameraman named Alain Loirot. He was the cameraman for Christian Matras, the chief-operator for Max Ophuls's films.

SR: It is because of that that you have a cameraman who does traveling shots so well, he did them for Ophuls. When you work with a cameraman do you prepare the traveling shot?

JR: No, not at all, absolutely not. It's between the director and the cameraman.

SR: And you work with the lights?

JR: Yes, absolutely, I give them total freedom. That's normal.

SR: And also with the framing of each shot?

JR: There are times, to be sure, when there are problems with light; this can happen in the corner of a set, or with a lack of space. I will have some influence over the small details; but not over the *mise-en-scène* of the shot. It's rather over the practical questions, possibilities of lighting.

SR: Yes, when you do exteriors, and I have seen exteriors that you have shot, it's difficult to tell if you used lights. There are times when I can't find the space for lights.

JR: That's a compliment. There are always, always lights.

SR: But in *Le Boucher* in the scene where the blood falls on the little girl, where did you put the lights?

JR: Those were reflectors, only reflectors.

SR: And with the countryside, at the beginning of the film?

JR: At the beginning of the film, after the credits, yes?

SR: You see the village.

JR: The village, but that's an exterior long shot.

SR: But how do you achieve the color without anything else?

JR: You know I learned a lot with an old director of silent films who actually still works now, with whom I make shorts when I'm free, out of kindness, who is 84 years old and who won a Premier Prix de Qualité de Rome, who is a painter, who is a friend of Henri Decae, and with whom I have made many short films with two or three flood lamps and two or three reflectors. And he told me not to spoil the light that exists in nature. But it's valuable with a director who knows where to place his camera because, you know, it's not being a director if you aren't concerned with aesthetic problems; you're only like a beginner then.

SR: You don't want to name names?

JR: No, it's not that there are names to name, but I'd like to say that if you don't know light, if you don't love light, if you don't love painting, if you don't vibrate with light, it can't be helped.

SR: For me the most magnificent thing in the films of Chabrol is the complete marriage of themes and images, I find this especially in *Le Boucher*, it's a small perfect film.

JR: Yes, yes, it's a small film on a small budget. But we were very rich . . . we didn't have money . . . we had some money, the normal amount, but not much, the estimate you could find out very easily, was relatively very small, but we were rich because we were free. And when we wanted to wait for the light, for example, for the tracking shot when Stephane Audran and Jean Yanne leave the wedding, that long tracking shot, we waited two-and-a-half hours without shooting, without doing anything. In the classroom we did the same thing. When we wanted to wait two hours, we waited two hours without shooting. And no producer came to ask me, "But what are you doing?"

SR: In the classroom you had lights?

JR: Certainly.

SR: But when you stayed outside?

JR: No, no the sun was natural, yes.

SR: I find this film magnificent.

JR: We like it too.

SR: In this film, this is also a general question; does Chabrol think about other films, Hitchcock for example, or others, in his shots? At the end of the film there is a shot which I thought was almost the same as a shot in *Vertigo*, when she drives him to the hospital. But perhaps it's behind the shot.

JR: Certainly it's recorded, but I mean unconsciously. Certainly Chabrol is a great admirer of Hitchcock.

SR: He used Hitchcock's tracking shots, but not in the same way. I think that with Chabrol it is close to an explanation of the theme and not just for suspense. Well, I have another question: in *Que la bête meure* when Jean Yanne and the other man are in the boat, where is the camera, and why doesn't it move?

JR: The camera moves a little, it was hand-held.

SR: Because I looked at the screen to see it move.

JR: It was held by an excellent cameraman who has become a director, Claude Zidi, who is filming right now; he started with *Les Charolots*. The camera was hand-held, and since everything moved, the boat moved, the actors moved, the horizon moved. You looked very well, yes.

SR: In a scene like that you also use reflectors?

JR: No, not reflectors, we couldn't use reflectors with the sail. It wasn't possible. We had a small generator set which enabled us to use two or three Italian quartz lamps of 500 watts each, that was all.

SR: In exteriors do you use carbon arcs?

JR: Yes, certainly. In general we have the right in our budget. In the films of Chabrol, one arc, a brute. When it's a more important film with a larger budget, you have two brutes.

SR: Well, you have like almost everybody, to use Eastman color.

JR: For two reasons, the first, you don't have much choice, and the second, even so, it's very good quality.

SR: But did you ever shoot in Technicolor, do you like Technicolor?

JR: I never shot in Technicolor. We shot in Techniscope as a format. We did some shots in Technicolor, but I never saw them.

SR: You use the same lab all the time.

JR: Yes, all the time.

SR: You stay with 35mm because of money.

JR: 35 instead of 70mm, yes, it's first of all a question of budget. More and more the films of Chabrol are films that are more and more intimate, and that earn less money than American superproductions.

SR: But it's also a kind of choice.

JR: Yes, yes, of Chabrol, yes, I think so.

SR: Do you use special filters to get colors that are not too realistic, muted colors?

JR: Yes, a little. I use gauze. There are films that I make entirely, almost all of the shots, with a gauze in front. I am going to make a film like that with a very good director who doesn't work much. That's Carlos Vilardebo, who has made well-known shorts about Egypt, you know. Well, we made a film in Portugal, a Melville story; well, we couldn't use Kodak film because they wouldn't give us credit. The film was abandoned by the producer. Well, I suggested to them to make tests with Ferraniacolor, an Italian stock, in Italy and with Agfacolor. Of course the director accepted. Someone gave him, as a gift, the film to make the tests of the two types of film, and we chose Agfacolor which corresponded very well with this kind of woodcut image, an old woodcut, a little halftoned. It's entirely halftone, the film as well. And the results were very satisfying. That pleased us enormously and was also generally appreciated.

SR: When you filmed *Le Bonheur* you chose another color. It's a very warm color.

JR: Yes, that also depends on the season, the region where you shoot.

SR: It's also a decision of the director?

JR: Of course. When he's aware of the light he chooses. Chabrol, it wasn't by chance that we went to Sologne in the autumn. It's because it corresponds. And if the film, *Les Noces rouges*, which hasn't been released yet because it's banned until the end of the month. I think now it will be released.

SR: What is the cause?

JR: Of its banning? Oh the elections. They say it's because of the trial, and it's equally because of the elections. We also chose the Sologne

region in the autumn, but late. This film is a little risqué, but it was really a blood wedding, the leaves were really red. I want to say that this is very important for Chabrol. He knows all of that very well.

SR: He is a director who thinks about aesthetics?

JR: Yes, very much. He takes all of this into account for setting his shooting dates.

SR: With Jacques Demy you shot *La Baie des anges* and *Les Parapluies de Cherbourg*. Was it like shooting with Chabrol?

JR: No, it's different, very different. They are two personalities that are completely different.

SR: I don't see the same visual aesthetic from film to film that I find with Chabrol. I can see great differences with Chabrol.

JR: That there are . . . you liked *Lola*? It was pretty. I find it was also . . . What happened was that *La Baie des anges* was made in the summer. Demy required an Agfacolor film that was very fast, that had an ASA of 1000, and he didn't want any light for the exteriors at noon on the Côte d'Azur. I was finally able to have four floods because I had a very quick electrician who plugged it in at the store of an ice cream seller, quietly. Because Jacques Demy didn't want anyone to make changes during the shooting. But he set up a 20 meter traveling shot for his *mise-en-scène*. You couldn't have a flood on the camera, because it would have been noticed, not for the traveling shot. And the fast film stock meant neutral gray in front of the lens. He wanted the light, he wanted the forced contrast, he really wanted these things. He posed many problems in having the charming Jeanne Moreau, at mid-day on the beach. It wasn't ideal.

SR: It was difficult.

JR: It wasn't agreeable.

SR: Well then, *Les Parapluies*?

JR: Well *Les Parapluies*, that was different, that was much easier, because of our choice of Eastmancolor. The only thing that he wanted, was that there weren't any shadows. That was the only thing that he demanded.

SR: I read that he completely changed the exteriors.

JR: Repainted entire streets, yes. That's true.

SR: And the interiors, they were shot in the studio?

JR: No, no, everything was done in Cherbourg. In a street of Cherbourg. Yes, there was a little store.

SR: It's difficult to shoot in such a little space.

JR: That's true. It's less practical, and for the camera, and the placing of the camera, and the lights, and also for the sound engineer.

SR: With Chabrol are the interiors in the studio?

JR: In general they are natural decors. We have worked in the studio. *Landru* was made in the studio, and *Le Scandale*, but everything else was in natural decors.

SR: In *Landru* the colors seem different. Was he looking for this?

JR: It's a little affected.

SR: It was a little like Technicolor.

JR: Yes. The color helped to set it back in time.

SR: I think that the colors were harsher than in other films of Chabrol, and than is usual with Eastman color. How did you arrive at these changes?

JR: You know, that came, it was a combination, a little from the colors chosen, the decor, and after, the costumes, certainly all equally, and afterwards, the way that the negatives were treated, instead of the shooting. We played with that certainly.

SR: Did you make tests?

JR: We almost never make tests.

SR: Well, when you start to light, how do you work?

JR: Oh well, we have bad work habits. We're very relaxed. The shootings are absolutely marvelous. Once you have tasted it, it's like a drug. It's terrible, we try to have a rehearsal with the actors and Chabrol. It's very difficult to have everybody at the same time. Sometimes they come, little by little. But it's not exact. We make marks on the ground a little, but not much. We rehearse without the camera, with or without the viewfinder. And then everybody disappears. Chabrol goes to play chess, or if there is a pinball machine he goes to play pinball. The actors go and rest in their dressing rooms in the trailers. Well, I find myself with the electrician. Sometimes the cameraman is there, not always. And I light, that's to say, I begin. The technique is not always the same, that's obvious. Well let's say generally the same. I begin by lighting the walls. That, I am certain, I know where they are. I know where the windows are. I know where the lights are if it is evening. If it's evening you want lights that will be photographed. I know a little where the actors will be. Starting with this I light, I light, I light peacefully, alone with my electricians, no one bothers me. They don't come to push me, to tell me to hurry up. I don't see anyone. Then, afterwards, I call them. I try to find the first assistant director to call everybody back for a rehearsal, this time with the camera. Well we do determine with a little more precision the places, and at this time I correct the shot. But we have a terrible fault during rehearsals, we joke. You can't do that with everyone. You'd be thrown out. With Chabrol you can do it a little. He knows that you actually gain a little time like that. Well the electrician makes jokes, etc. I don't set the

barn doors yet. I only set them after the serious rehearsal, cutting out the troubling parts and then the lights like that. We run together two or three rehearsals, and we quietly joke without making too much noise. It's like that.

SR: In general how many takes does he make?

JR: Chabrol is one of those directors who uses the least amount of film. That's to say I, personally, so to speak, I never cut a take unless it's really important. Even though, I assure you, I cut the take openly. But, in principle, I never cut the takes. Well, then there is the cameraman who cuts the take for a close-up in the shooting angle, for example, or for camera movements, or a bump in a traveling shot. And of course Chabrol, also. But he rarely cuts. He always goes to the end. He shoots the things that interest him in the shots. But this isn't always a sequence-shot, far from it, as you have noticed. It's like everybody else. He can use the beginning of the first, and then the middle of the third, and the end of the fourth. His editor is also good at cutting on movement. It's because of this that he lets takes go to the end . . . And more and more you could say that since we rehearse so poorly, that is a bit of a rehearsal for us—the first good take, the first good take with the film. In general he shoots . . . he keeps, in the shooting, two takes, often only one, sometimes two, and the total number of takes would be . . . three or four. When there is one very good one, in general we don't do another. Because often to have a second that would be better we would have to do several takes. Well, loss of money, loss of time, and if it is good . . . But sometimes the actors complain. For him it's good.

SR: You have to be certain of everything, that everything is good.

JR: He has an eye. He knows very well what he's doing. Nothing is by chance.

SR: And before the beginning does he tell you things about the lights?

JR: No, nothing.

SR: When you began to work together?

JR: In the beginning, no, he let me alone. A first film is difficult. It's difficult for a young chief-operator to make his first film. It's very difficult because you're very afraid. I was very afraid then. At least, me certainly, I'm among those who are very afraid. Well he knew that he shouldn't say anything, leave me alone, and then see what happens. He doesn't say much. He'll say, for example, this film will be a red film, this is a blue film, or this is a cold film, this is a warm film. We don't say much because we understand each other. I see like him. I really think like him, and I agree with his scenarios, with his ethics. This means we don't need to talk. It's very good.

SR: And with the camera?

JR: A little because it's the cameraman who speaks. Because Chabrol doesn't say enough. Well with me it's O.K. because it's certain, it's precise, the work of a chief-operator, I don't believe differently. But I won't say that with the cameraman who has to move in the decors. And Chabrol is not always very precise. When they rehearse he sees, and he talks to himself, but no one hears what he's saying—the lips move. And with the zoom always on the camera, we don't know if he's at 25mm or 200mm because he doesn't say anything. Well we say sometimes—I can't, I can't, no, no. It's always like that with him. You have to know that, but sometimes it's something you know afterwards.

SR: But the end of *La Femme infidèle* is very complicated.

JR: Oh, *La Femme Infidèle*, with the backwards traveling shot and the forward zoom. That's a beautiful shot, and the *mise-en-scène*, it's tremendous, the feeling, yes, yes.

SR: He talked a lot with the cameraman?

JR: Yes, they had the backwards traveling shot, at sometimes a zoom and a tilt.

SR: Does Chabrol look through the lens?

JR: As little as possible. He doesn't like to. He looks when the cameraman asks, to inspect something that he hasn't understood well. And I also don't look very often.

SR: But there must be some understanding between them, because there is a difference between two cameramen and what they might see as a close-up.

JR: Oh yes, at times like that I'll tell him—like this, or things are like this. You say things like that.

Jean Rabier: born April 21, 1927, Paris, France

Shorts as cameraman:

1951 *L'Eveil d'un monde* (co-ph. Edmond Séchan, d. Jacques Dupont)

Okoume (co-ph. Edmond Séchan, d. Jacques Dupont)

Trains sans fumée (co-ph. Paulis, d. Marc Cantagrel)

La Grande Case (co-ph. Edmond Séchan, d. Jacques Dupont)

Palmes (co-ph. Edmond Séchan, d. Jacques Dupont)

1952 *Voilà nous* (co-ph. Edmond Séchan, d. Jacques Dupont)

1955 *Les Araignées rouges* (co-ph. André Tadié, d. Tadié and Henri Lacoste)

La Banque (d. Carlos Vilardebo)

La Carcocapse des pommes (co-ph. André Tadié, d. Tadié and Henri Lacoste)

Le Cercle enchanté (co-ph. A. Vignier, Alain Levant, d. Marc de Gastyne)

Le Débroussaillage chimique (co-ph. André Tadié, d. Tadié and Henri Lacoste)

L'Homme notre ami (co-ph. J.-L. Picavet, Claude Beausoleil, d. Marc de Gastyne)

Les Pucerons (co-ph. André Tadié, d. Tadié and Henri Lacoste)

La Tordeuse orientale (co-ph. André Tadié, d. Tadié and Henri Lacoste)

Les Vers de la grappe (co-ph. André Tadié, d. Tadié and Henri Lacoste)

La Vie au Moyen Age (d. Carlos Vilardebo)

1956 *Israël, terre retrouvée* (co-ph. Henri Decae, d. Marc de Gastyne)

Propre à rien (co-ph. Henri Decae, d. Marc de Gastyne)*

1957 *Millet et son temp* (d. Marc de Gastyne)

Robinson (co-ph. Henri Decae, d. Marc de Gastyne)*

1958 *Le Château du passé* (co-ph. Henri Decae, d. Marc de Gastyne)*

1960 *Mille Villages* (co-ph. Jean-Marie Maillois, Roger Monteran, d. Carlos Vilardebo)

Soleils (co-ph. Jean-Marie Maillois, Robert Carmet, d. Carlos Vilardebo)

1961 *Orchestre et diamants* (d. Jacques Rancy)

Six Petites Bougies (d. Roger Cotten)

1962 *La Dormeuse* (co-ph. Michel Humeau, d. Maurice Pons)

Films as camera operator:

1948 *Les Paysans noirs* (ph. Roger Avignon, d. Georges Regnier)

1952 *L'Or des pharaons* (ph. Henri Decae, d. Marc de Gastyne)*+

Crèvecoeur (ph. Henri Decae, d. Jacques Dupont)*

1958 *Le Beau Serge* (ph. Henri Decae, d. Claude Chabrol)

1959 *Les Cousins* (ph. Henri Decae, d. Claude Chabrol)

A double tour (ph. Henri Decae, d. Claude Chabrol)*

Plein Soleil (ph. Henri Decae, de. René Clément)*

Les Bonnes Femmes (ph. Henri Decae, d. Claude Chabrol)

1961 *Léon Morin prêtre* (ph. Henri Decae, d. Jean-Pierre Melville)

Features as cameraman:

1960 *Les Godelureaux* (d. Claude Chabrol)

1961 *Cléo de 5 à 7* (d. Agnes Varda, credits in color)

L'Oeil du malin (d. Claude Chabrol)
Les Sept Péchés capitaux (ep. *L'Avarice*, d. Claude Chabrol)+
1962 *Ophelia* (d. Claude Chabrol)
Rogopag (ep. *Il nuovo mondo*, d. Jean-Luc Godard)
Landru (d. Claude Chabrol)*
La Baie des anges (d. Jacques Demy)
1963 *Peau de banane* (d. Marcel Ophuls)+
Les Plus Belles Escroqueries du monde (ep. *L'Homme qui vendit la tour Eiffel*, d. Claude Chabrol)+
1964 *Les Parapluies de Cherbourg* (d. Jacques Demy)*
Le Tigre aime la chair fraîche (d. Claude Chabrol)
1965 *Les Iles enchantées* (d. Carlos Vilardebo)*
Le Bonheur (co-ph. Claude Beausoleil, d. Agnes Varda)*
Marie Chantal contre le docteur Kah (d. Claude Chabrol)*
Paris vu par . . . (ep. *La Muette*, d. Claude Chabrol)*
Le Tigre se parfume à la dynamite (d. Claude Chabrol)*
1966 *La Ligne de démarcation* (d. Claude Chabrol)
Cloportes (d. Pierre Granier-Deferre)
1967 *Un Idiot à Paris* (d. Serge Korber)
Le Scandale (d. Claude Chabrol)*+
1968 *La Route de Corinthe* (d. Claude Chabrol)*
La Petite Vertu (d. Serge Korber)*
1969 *La Femme infidèle* (d. Claude Chabrol)*
1970 *Le Boucher* (d. Claude Chabrol)*
Que la bête meure (d. Claude Chabrol)*
L'Homme orchestre (d. Serge Korber)
1971 *La Rupture* (d. Claude Chabrol)*
Juste avant la nuit (d. Claude Chabrol)*
La Décade prodigieuse (d. Claude Chabrol)*
1972 *Docteur Popaul* (d. Claude Chabrol)*
1973 *Les Noces rouges* (d. Claude Chabrol)*
Nada (d. Claude Chabrol)*
1974 *Cold Sweat* (d. Terence Young)*
1975 *Innocents with Dirty Hands* (d. Claude Chabrol)*
Une Partie de plaisir (d. Claude Chabrol)*
1976 *Folies bourgeoises* (*The Twist*) (d. Claude Chabrol)*
Les Magiciens (d. Claude Chabrol)
1977 *Alice ou la dernière fugue* (d. Claude Chabrol)*

Interview with Edmond Richard, March 31, 1973

ER: You are going to ask me a question—obviously it's the idea of a director of photography that interests you, specifically in France or in Europe?

SR: It's, perhaps not exactly the same thing, but . . .

ER: No.

SR: Because I know there's a lot of difference between France and Hollywood.

ER: Yes, but more and more, all the same, we're trying to find our own spot, to get ourselves situated, you see. Because, that, I am, all the same, going to confide in you, if I say it's the opposite of my colleagues, I have right now become a man of the cinema, but I wasn't basically a man of the cinema, see. I must admit to you, I must rethink a little, I must confess to you that my background is that of an aeronautic engineer . . . This was a difficult background during the war. These kinds of schools were generally, how to say, a little prohibited. But all the same we succeeded, a kernel of young engineers, to follow our studies, and to come out as an important class at the end of 1946. And for about a year I was a test flight engineer. It was as the result of an accident that I provisionally abandoned aviation because, I must frankly tell you, I was broke at that time. That happens, you see, and to earn my livelihood, and to prepare an aerodynamic license, I went to work for André Debrie. When all is said and done, I must, all the same, remember that André Debrie was a promoter throughout Europe, and I might say throughout the world, from the point of view of cinematographic material at all levels, from shooting, to developing, from printing to projection. And André Debrie said things like his father, Joseph Debrie, who was a friend of Lumiere, and who, all in all, was following the footsteps of his father. He was a remarkable man. He accepted me, for three years (I finally stayed with him, you see, he made me an interesting proposition, and I was in research). For three years I studied a range of things dealing with developing and printing. And I realized that in this profession, which was a craft of artisans, but which, all the same, had an artistic part which was creeping in, that excited me. That is my strong derivation, and also where I was married. My wife is Italian, and I confess that after the accident that I had, I made a decision. Therefore the beginning of pure technology, research, really laboratory problems. Then André Debrie, was all the same, a hard man, very autocratic, let's say. I don't like having someone at my shoulder. I quarreled with him, and I left him. We parted nicely at the end of . . . It was at the time of the famous idea of linking cinema and television, you see. Where you would photograph—besides, it's an interesting anecdote—you would photograph on a cathode tube, you see, an image televised from the Eiffel Tower, and the image would be reprojected in a theater through the intermediary of 16mm film, developed directly. This was the famous, great experience which took place in 19 . . . the first in 1951, I think, and already André Debrie

was looking for an osmosis between television and cinema. Then I had an idea, just in my head, and I contacted a lot of people who did production, and I was at a standstill for a year because of a plastic thing. To make, direct myself to taking photographs. That's to say, there was André Coutant, during that period who was also, how to say, also a man who was formed by Debrie and who, above all, specialized for the Eclair establishment in taking photographs. Well, I was interested, and it was there that I started to work for Coutant as an engineer on this famous apparatus which is still on the market, the camiflex. You see, this was the first camera which . . . let's say not the first reflex camera, but let's say the [first] portable reportage [camera].

SR: Yes, well, this interests me, because I am also interested in the beginnings of cinéma vérité.

ER: Yes, well, this was before. At that time, let's see, it's not today, well after 1947, '48, '49, '50 . . . at Coutant, '51, maybe a little later, I studied mainly sensitometry, applied to cameras. We were at that time already in the lead, the shooting apparatus automated the cameras in such a way to liberate directors of photography from technical contingencies. I made a light meter. Then I obviously had reactions from, you are going to understand, directors of photography, who wanted to see that, above all, the engineers weren't going to interfere in their domain. No, it's true, it's very strange, and it was an error on their part, because I had the idea, with Coutant, of liberating technique. When you . . . there is still a basis, that I understand in this profession, if one would want to be liberated from technique, however in complete discipline. It's not specific in the cinema, and I think you have to make use of it, in a way that you are not a prisoner of technology, but that it's at your disposition. Well you see, to say it another way, my scientific knowledge let me dominate the technology. And as for shooting, that, at Coutant's, I had the opportunity to contact and be in communication with some directors of cinematography. And, from a common agreement with Coutant, I said, "I must take the chance," as a technical consultant for color. I had already done the first day-for-night effects in *La Reine Margot* [Dreville, 1954]. Let's see, we shot *La Reine Margot* in 1953. Well, today I can say, that it's a quarter of a century, no that's not true, wait, yes, it's a quarter of a century that I have been busy with the cinema. That makes about 25 years. That's not bad. Well, I abandoned Coutant, the cameras, with technical knowledge and research on color and became a technical color consultant. I noticed that the Americans, and Technicolor, I had already worked at Technicolor, they had this idea of a color consultant. And in my naive candor I say this frankly, I thought that, in Europe, I could

introduce this idea. Well, this went over for two or three years, I worked. This was the beginning of color, so the directors of photography, obviously, were a little confused with the advent of color. So I was hired by producers as a color consultant, I did all of the technical side, so I liberated the director of photography of technical contingencies that he was . . . could amuse himself with painting with his lights as he wanted. And during this time and parallel with it, I studied him. My springboard, my chance, was to be a color consultant for three years, and to a little, the word is rather grand, but a little, "inset" [*encarter*] the directors of photography, that's to say each, to see the style of each one. Parallel with this there were some holes because, progressively, the producers reacted, they said to themselves, "Look, why do you need a color consultant?" Little by little I realized that the question of color consultants was difficult to have catch on in France. So I drifted from that a little. It was then that someone mentioned my name. The French government was looking for an expert to go to countries who were on the way to evolving, like Yugoslavia, and I went to Yugoslavia as an expert of the Minister of Economic Affairs. The Yugoslavian government asked me, considering my extended knowledge, to form a supertechnical commission for Yugoslav cinema to set up a director of photography in the technical domain and special Yugoslav achievements. And after, I made about a dozen films in Yugoslavia, around six months of the year. And I can say that Yugoslavia was my springboard for research, you see. I'll admit this quite openly; I like this country very much, and I experimented as much as you can experiment in the area of shooting. And it was there that I met—after all—no—I returned to France, and I made with Rogert Hubert, one of . . . I consider one of the greatest directors of photography at the level of Mr. . . . Mr. Alekan and Thirard, Matras, all of the great. Hubert is, all the same, *La Belle et la bête*, you see; he's a man who has, all the same, brought something to the cinema. He taught me, really in the purely photographic area, the elementary laws of photography, you see, and also he made me understand that the direction of photography isn't simply only technique, but that there should be a balance between art and technique. And, you don't know . . . it's difficult to disassociate one from the other, you see. So, I had another layer of depth, you see. And I went to Yugoslavia again for a film, and it's like that, after all, that the real turning point occurred for me, and that was meeting Orson Welles. Orson was on his film, preparing *Le Procès*, Kafka's *The Trial*, he was looking for a director of photography, and I had the opportunity to be presented to him. And it was, besides, a strange adventure, because he had asked the producer for—it's a

very amusing anecdote because it's something that deeply touched me—he asked the producer for a real technician. He wanted a technician who would liberate him from the technical so that he could act himself; because contrary to what one might think, they say he is a super-technician, but he is instinctual, but he has a horror of technicians. Besides he wrote that a lot of times when *Le Procès* came out. I remember that he hated super-technicians, that he even hated them, the word is strong, but he said it and I answered him, because he's one of those who needs the most super-technicians since he has so many improbable ideas that you always have to be there. And then, I remember very well the night that we met. I remember it because it was so important for me; I had long hair at that time, you see, I wasn't even that young then; it was in '60, yes, '60, the preparation for *Le Procès*. And he asked after the conference that everybody had been at, he said to the producer who was Michael Salkind, who was at that time the oldest producer, he was 82, you see, to whom we owe many films, who launched Garbo and all that. He's quite a figure of the cinema. He told him, he telephoned that night, he told him, "Listen, I asked for a technician, you sent me an artist." No, I'm not joking, it was a paradox, it was completely . . . And the next day there was a meeting, and Orson has a peculiar characteristic, that's when he has a conference, you discuss in a rambling manner, and at the end the people ask, the technicians ask, "But what exactly do you want, Mr. Welles?" "Well," he says, "messieurs, we've been talking for an hour, I think that I've said it all." In other words, I understood, that you have to listen to Welles and try, through his words, to extract what it was that he wanted. And he was looking for, at that time . . . You have seen *Le Procès*?

SR: Yes.

ER: Good. Well, he was looking for those famous grand decors for the typewriters, those huge offices, you know, Kafkaesque, devilish even, and he couldn't find them. The Yugoslavs didn't know, and I proposed the Exposition Fair. It was Sunday, and the Yugoslavs told me, because I spoke Yugoslav fluently, they told me, it's impossible to visit that. I said, I'll arrange the visit. Because I had just shot in the large halls, I knew the guards, we went in through the back, and I arranged the visit. But there was a peculiar thing, completely Wellesian; he said, "These are my decors, but I want an even bigger pavillion." I said, "There's the American Pavillion." And it's true, it's odd, but a diplomatic incident, we couldn't, in Yugoslavia, go into the American Pavillion. I said, "Why can't we get in?" I took them all in front of the American Pavillion. You go around the pavillion, it was a huge

parallelepiped, but all of the other side was open, all that was needed was a key, according to the Yugoslavs, but you didn't need a key. There was a huge open panel, you know, with huge fences that I made work, and then Orson said, "I hesitated at night," he said, "I now present to you my director of photography." You see. It's an interesting anecdote to tell because, it's there, really I can say dove into the cinema. With this phenomena, because it's really a . . . for me it's a very, very important event. This I confess openly . . .

SR: Yes, I think that also with this film there must have been a lot of technical problems.

ER: Ah, yes, exactly, with the problem of Kafka, it was in black-and-white, you see. And that, that, posed a problem for the direction of photography. It's much more difficult for me to work, to create an atmosphere in black-and-white than in color, you see. And that I think . . .

SR: But I also think that, because in color, the color hides a lot more.

ER: There! The color, to say the exact word—there's always a colored image. But to know which image, and to control it, that's very complex. Besides, something amusing, what you were saying because color hides, that's accurate. When I meet a director *réalisateur*, or if he calls me, it's almost unanimous; they all want to make films in color, and immediately they say to me, "But isn't there a possibility of making a film in color, without color?" But, I guarantee that that's accurate. To say it another way, you see, color ultimately troubles them, that's what I'm saying. You drift, perhaps, you still stumble in color, you see. Color, let's say the cinema is 50 years old, so it's a young art; well, but between music and painting, you must admit. And you can consider that, I think that, in the years to come, you will see, with now a technology that's advanced, black-and-white practically eliminated, which I regret, however, the color will, I think, take a different form, because the technology of emulsions has advanced, and lenses also. To say it another way, now, we have at our disposition everything to try perhaps, to act and to put into service finally, you said it to me just a moment ago, that photography—finally it's a personal point of view for me—I think that every director of photography, rather chief operator (because I think the word director of photography is a little presumptuous, a little exaggerated). Let's say chief operator or cameraman, I find that more valuable, see, when there are many cameras there is a man of the orchestra who is responsible for the whole shooting crew and who must be for me at the disposition of the idea. Good, that, you see, we are all, the shooting crew, at the disposition of the idea. This idea may be that of the scriptwriter, that the director must

realize, or the director's own idea, but we are, as one might say, a pawn. When the train is set on the rails by the production, the only master is the director to defend his idea. And that's our problem, and often I fight with certain current directors of photography, that's that we have the unheard of opportunity, the directors and we, ourselves, to have a support which is the film. It happens to me sometimes when I have conferences in other countries or even in France, since I've been a member of this technical commission, and I recall, it's a little recollection, let's say, that I am sometimes humble, and I have an enormous respect for this great demoiselle, you see, that's an image, which is negative-color. Because you mustn't forget that it's on her [it], after all, that's the support. It's on this emulsion, this film—this great demoiselle, she must be married, she's not alone. You see, you are going to see the comparison; there is a positive on the other side, otherwise you couldn't disassociate the negative and the positive. It's a couple, because finally the work comes out on the positive in the theater. The public sees what? It's a means of transference, the positive-negative thing. You have to end up at the screen. And if you only want the screen, it is a destruction of the idea, well, you have to have the technical chain. Unfortunately it is, as I said, at best respected from the beginning to the end. That's, then, one of the roles of the director of photography. His second role is to have tried, after being master of technique at best, to have tried to go into the meaning of the scenario to create an atmosphere. Well, you see, there, there's where the artistic part comes in. Because when I light, I'll confess very frankly, if you ask me how I light, I would be able to tell you. The techniques exists, I'm assured of that, my security, you understand, and as Orson sometimes says, "Let's go, dive." You see. When you have regulated everything, you can dive, but he wouldn't allow anyone to jump without security. To say it another way, it's exactly like when you get in an airplane, there nobody can sell you the idea of jumping without a parachute. While with him, he has to jump with a lot of parachutes. See, I'll roughly show you the problem. It's because of this that you have seen these last years, let's say, these last five years, a great evolution. One feels that the young directors and young directors of photography, young is not pejorative, because there's no such thing as age for me, you see, it's a question of heart, it's the interior; I have seen very young people with old ideas and very old with ideas, let's say, revolutionary. They're going to see that with the latest film of Luis Buñuel, which was also pleasurable for me to make.

SR: I'd like to talk to you about that. Of course that's the film that won an Oscar.

ER: Yes, he even won an Oscar. He's a man who is 72 years old and who has a youthfulness that is unbelievable. You see, when someone talks to me about young and old, well then I react because it's not true; there is a youthfulness of heart. Well, you see I have located the problem, my personal point of view [*optique*, fr.]. I think, you see, that I haven't done badly on this worldwide tour. This point of view is going all the time [plays on *optique* and *tourne*]. This point of view has developed more or less unconsciously, you see. Well obviously there have been reactions. Because they said in '68, the big thing, cinema open to the whole world. Why not, I absolutely agree, but unfortunately look at what they got, in the East or in the West, in an impartial manner; me, I am a man who sells a neutral material, therefore totally apolitical, I have shot under all forms of government, under Eastern government, American government, totalitarian government, so I do my technical things, and I have realized one thing. They say that on one side there is the ability to produce good and that on the other side there is no such ability. This is an error. There always is, one side is like the other, a kind of ability that is manifested differently. Those people who commit themselves to an idea, such as it might be, whether they are from the East or the West they have to give an accounting, whether it is financial or moral, to someone. To say it another way, they have to have a certain . . . a certain, more exactly, a certain respect for the work that they do. They can't botch it. So, at the minimum, I would like to come to say, that professional qualification should not be underestimated. That's to say, it's necessary—this might be an innate professional qualification—but you have to have both love and belief for this profession. Unfortunately I can say, that at this very time, the cinema psychosis, see, understand well what I want to say, exists. And 50 percent, I'm cutting it in half all the same. Fifty percent have the opportunity in the cinema, moreover, how shall I say, in seeing the impact of the cinema psychosis, in considering that this profession [*métier*] is almost like photography besides, something miraculous. I consider it truly a profession [*métier*]. Look, let's take an example, you can almost compare it to literature: there are experiments, and there are books that are vulgarizations, there are books of value, and then there are poems. Cinema is, perhaps, a support to all of this literature, a modern support, also audio-visual. What is it, it's this. You understand, it's because of this that it's difficult, in such a short time, you see, to make a sampling from all of that, but it comes together again all the same. When—an example that I might take that perhaps will better explain my idea—this is: they ask of us, even if, to drive a car, take a marvelous race car, they ask us all the same for a driving permit, at the minimum. Still with less, they put an engine between

your hands, they give you a film, a camera, lenses, everything to carry
out something. I am making a parallel with a car. Good, take two
drivers, one will do brilliant things, and the other will have accidents.
So, I ask, at least as a minimum, for all the young people, and then
for all who are in this branch, that's at least a minimum professional
qualification. And I have asserted that during these last few years this
professional qualification is a little degraded, you see. This is a verifi-
cation which isn't only my responsibility, that's obvious, but it's some-
thing that has bothered me a little, and that I have tried to understand.
And it is also obvious that it's not something to which you can bring,
let's say, an absolute judgment. It's a question of relative value, you
see. But I can understand that the cinema is fascinating because, fi-
nally, it's a marvelous profession, and each time that we made a film,
even a short, each time we put a piece of film in the camera, you have
to take something out at the other end. But imagine what one calls on,
one calls on a whole series, a complete chain of people who have very
precise qualifications. And on the whole, it's . . . you come to the
conclusion that you can't be alone. You have to work with a crew. It's
because of this that that idea of a crew, that idea of professional qual-
ification is degraded. That's one of the first conclusions. One feels now,
I see during the past two years, a recovery. That's to say that uncon-
sciously it's been seen that risks can't always be taken, you see. It's
been established almost everywhere there were often in stock kilo-
meters of film, that couldn't be edited. That, that's one of the first
established facts. So I could say that things are returning little by little
to order. And no one considers anymore . . . it seems, let's be prudent,
that the cinema, after the little loss of speed, you have seen it? It's
seen in America, and a little all over this phenomena which is very
hard to make plain, and also to make understood, but all the same, the
television, the car, the weekends, you see all these evolutionary things
finally have resulted in the cinematographic industry, more exactly, the
exploitation, has seen a certain de-consecration. And that these re-
cently, then, that I think the last three months, I have noticed that in
France the young people, the public, is shifting again, and goes to the
cinema. I saw in America, I saw in Japan, I saw in Canada, I returned
from Germany, I returned from Italy, everywhere one feels that the
public . . . its' television station is no longer enough. You see, I know
well that . . . for the business of the day there is a demi-cassette, there
are all these little programs in a box, you understand, but there is a
psychosis all the same, there is a competition, I think, of the environ-
ment. That, that's a chance all the same. I think it's our chance, ob-
viously, above all what we ask for now, it's to see ideas. There! There

were enough. Europe, above all, let's say, in France, I don't want to criticize France. Let's understand each other well. Ideas have been lacking for the last few years here I think, ideas; there were some key ideas which made a noise, but in a local area. That's to say that we have had difficulty leaving our borders. And you see, the Italians had attacked in force. The English, the Anglo-Saxons, well that obviously, they were turned around quickly when the New Wave arrived "hop"; they fell on their feet in an extraordinary manner. Now it's understood also and balance is being recovered, and I think that, now, perhaps a new form of cinema will reappear. Totally different, you see, but with perhaps more respect than, let's say around ideas of the cinema at the gateway of the whole world from the first person who passes in the street. Look, it's an image, but altogether, it was perhaps a fault, it was an infatuation of the moment, and I think that, we are being looked at, people who make the cinema are always considered a little like curious beasts. We are always considered more or less as abnormal. I confess we are gypsies. But that's not pejorative; we go all over the world but I think that, I don't know if you have read *Brave New World* of Huxley. That's something extraordinary. In this Kafkaesque world, you see, what is coming more and more, you sense, all the same, is a reaction from the young. One senses that placing them under a bell jar won't please them forever, you see. Then, perhaps it wouldn't displease me to be among those who they put in pens while they say, "Look, here are the people who make films like artisans," and perhaps they'll come to see us in a zoo like strange beasts. I would be willing to be among those, you see, on the whole. All the same it's not a kind of conclusion, but it's all the same, a beautiful profession. You see, we have, yes, yes, it's a very beautiful profession, because each time it's a prototype. I've been saying this to you just now; you think you have seen everything, but that's not true. Each time there are new problems. Besides I've seen it among the directors that, with whom I've shot. Who are from Orson Welles to René Clément to Jerry Lewis, and also a lot of others besides, and also Luis Buñuel and one of the youngest, Gérard Pires, and some acrobats, you see. Well, it can be seen, all the same, that those who love their profession defend it. Well, right away I've given you a truly personal point of view.

SR: Yes, that's exactly what I'm looking for.

ER: You see when I see, for example, certain people of our profession who botch it a little, that hurts me, you see. I have enormous respect for everything that touches the cinema because I consider all the same that it's a means of expression that is so beautiful; obviously, it's like everything, like literature, like music, and painting. It's difficult to

judge it. It's still a little soon. Above all that, watch to conserve these films, I don't know if you have watched French television recently, well it's fed almost 80 percent by films. Yes, it's lucky that the public looks at old films on the little screen. Don't forget, all the same, that the little screen is perhaps, more intimate. You see, and on the whole narrative and . . . for the quality of movement with large events. But I don't know. I think that the cinematographic spectacle hasn't had the last word, and at the risk of repeating myself, I think that we are beginning simply. I don't know if it's a kind of conclusion, I try personally, you see, not to harden myself and to be open to all the ideas of directors, you see, to try to understand them, which is the most difficult thing, because sometimes there is a director, there are directors who are more or less artists. That's to say it's difficult to judge who is more the artist than the technician, see, there is a balance that is difficult to judge. And for us, we are after all, intermediates between him and this technique, that's to say, on one side you have to understand this artistic idea and to transpose it with technical elements. That's not always easy. Above all, when the idea is properly stated, that's why I can truly say to all those who want to choose this career, they have to choose it with faith; if not, it's preferable that they go sell carrots. It's . . . I think that . . . in the main the few words that I've said to you, I have well established the idea that I personally have of this profession. There, I believe that . . . I don't know if I have explained clearly enough, the question that you asked me.

SR: Yes, yes. Is there a film that you have made that you like best?

ER: Falstaff, and in *Falstaff* I can also tell a curious anecdote. It's that Orson was in front of the camera almost all of the time. He had enormous confidence in me and my crew, and he put me in front of the camera. It got me used to seeing what it is to be in front of a camera, and I acted the "woman's tailor." I learned my text very well. When he put me in front of the camera I couldn't open my mouth. Well that's a gag, and also a real truth. I would rather be in command of an airplane than to be in front of a camera. I say it frankly. And so I understand, I understand the difficulties of actors also. And I respect them equally and I give them latitude when I light them. I try not to, how shall I say, not to have the technique put constraints on them, and their positions measured in millimeters. In a way to liberate them to the maximum, because I know how difficult this is, if you throw yourself into the text, put yourself in the skin of a character while having to think about technical things, that's not possible. It must be . . . this technical aspect must be innate. It's also a formation which is very strong in America. American actors, well this isn't a compliment, it's

a statement of fact, are . . . have a formative base, let's say, a parallel can be made with what I explained to you in the domain of chief operators. They have been formed by a discipline; they know how to walk, they know how to take their place instantly so they are liberated, they can act not being constrained by having to think about this place or that place. And in Europe it's hard for us to get this from actors. It's not above all a criticism, you see . . . it's a . . . it's a statement of fact. I may be wrong, but I have noticed, it's like I said.

SR: Ah, perhaps it's because in America there are divisions and movie actors don't usually work in the theater, they only do films. Here they do both.

ER: Perhaps. I confess that affectively it's a problem that escapes me. Because to be in front of a camera, for example, a good number of my colleagues, I'm giving an example, great directors of photography, have become directors. It's really an idea that never occurs to me. I've made several shorts but *mise-en-scène*, a director is all the same, except for certain great directors, is all the same conditioned. I think, you see. There is a . . . there are many imperatives, and I don't think that they're free to such an extent. And, you see, to direct the actors, perpetual concessions are necessary; for the production, for what they want to do, to say it another way, they violate themselves, not always doing what they want. Well, they sacrifice something. And then, sacrificing something . . . I also sacrifice something, so to say, but I have the impression of being, of having more latitude; me, in my sphere, in my own little sphere. When on a set everything is turned off; well, there isn't any thing except sound. To say it another way, I find it nice enough to be able to manipulate the lights. You understand what I want to say? Because from the moment one lights there is something on the film, if you turn everything off, sometimes it's nice to have a little piece without anything. You pass into a zone of shadows, but you return all the same to a zone of light, and the balance between shadow and light I believe is one of the secrets of photography. And that is one thing that, for me, gives me a certain liberty, at a certain moment, say, to be able to say, cut. Light, obviously. See. You have understood the idea. And outside the most beautiful light is the sun and when there isn't any, the sky. That obviously, that, one has to try to compose. There are problems. To say it another way, you're never finished.

SR: For me, when I saw *Le Procès*, I saw it this week because I knew I would be talking to you, and for me it was difficult to understand how you did it, a film which was quite dark but with a lot of depth of field.

ER: Ah yes, it's unforgettable, I confess that *Le Procès*, the problems posed by Orson in *Le Procès* are unimaginable because he has some-

thing extraordinary, Orson, that's that he draws very well, So, he brings a design. Good, on this design everything is outlined: there is the size of his actor, and the length of the shadow. And the shadow has a direction. To say it another way, you have to know how to read his sketch in a way that you can see how to get the rapport between the size of the actor and the size of the shadows. It's enough to make a working drawing, then it's a scientific drawing, at that moment, to know at what height the light will be at. So the big sources of light must be sensed through his designs. There's where he is instructive. So there's a key to be found. But when you've found the key, and it's very obvious that it has to be found very quickly, when Orson arrives he can't compose his image in darkness, the first lighting already has to be done, in balanced light. He composes the image walking around with his camera, "tock, tock, tock," the precise points, key-points, where the actors are going to act; so the rest, from one point to another, that doesn't interest him. You pass through zones in the shot where you can do what you want. Those are holes for him. But the key-points, they specify the atmosphere that he wants. So the first rough outline: he asks for it after some time, he leaves with his actors which he likes a lot. Because, he knows what it is to be in front of a camera, and I sense, it's not for me to judge Orson, but I don't know if he is really very, very comfortable in front of a camera. That, you sense that in front of the camera, he prefers, I think, to be behind rather than in front. Even if he was here I would tell him, you see. Because, I met him not long ago, when we looked at *Le Procès* again, and we discussed it again, and I even scolded him, besides, because I found that he hadn't, since *Falstaff*, done anything big. He did a little show on television, but he shoots, as he says, 'beefsteak' operations in front of the camera. And that distressed me deeply. Because this man still has something to say. That's very obvious. And in *Le Procès*, if you knew all of the acrobatics that we did, it's unthinkable. We had three crews, a French for the day, a crew for the mystic hour, that's to say 'mystic hour' you know, right in the twilight, we were a little crazy. Everybody went out with hand-held cameras to be able to have, you know, accurately the light which was going down, and the balance. Then a Yugoslav night crew. You sleep, and I slept with him, two or three hours, not more. And in the morning, hop, you left for the sets and the crew was ready on their feet to know where he had decided to put things. You see the adventure; it was for me, with him that I had the best adventures. Above all with *Falstaff* later. He asked besides for *Falstaff* . . . we had in *Falstaff* . . . he gave the order to try . . . that's to say he wanted to find again the atmosphere of a woodcut. That was

translated by me with technology, it was necessary to extrapolate, and we lit the entire film with arcs, not an incandescent light, see, behind a red filter so as to eliminate the half tones and have only black-and-white light values. There is the problem of *Falstaff* and also for the design.

SR: Yes and the problems with the battle.

ER: Yes and this battle is extraordinary because there were three lists of the montage, he came from time to time but very quickly, he gave us drawings, I need this, this, this, this. And that was quite New Wave, we worked hand-held camera in hand.

SR: Well, do you run the camera yourself or do you have an operator?

ER: Yes, but often have, I have many cameramen with whom I work, and the punctuation what I call, there's always a small hand-held camera, and Orson tells you . . . and even other directors have taken this method, to try out several shots in the action, that which I call the punctuation, as I just said, you see. Because these are in shots that you can't reshoot. You have to catch them during the action. And that's a process that I learned from Orson. I always have a camiflex in my hand, he tells me, "hop," get me a few puncutations. Tock, tock, a blow here, a blow there, you see. And that's a discipline of his. And I learned that from him, and in many other films I apply it, you see, except in the films of Buñuel, where, well, where that was . . . Buñuel told a story and the photography went his way, because he asked me, I remember, he only said a word, Buñuel—I jump a little from one to the other because that just came back to me—he said to me I want a caustic and sophisticated film, *Le Charme discret de la bourgeoisie*, you see. Caustic and sophisticated, that's an opposition, but that meant what it meant. That translated for me, from the point of view of decor and light by a decor that absorbed light, no brilliance, see, flat images. All the light was absorbed by the decor, but, all the same, in the decor there were certain actors who came out in a sophisticated decor, but not brilliant. And the atmosphere of the film was a little exhausted; he was satisfied.

SR: And you also changed the atmosphere for the nightmare.

ER: Ah, yes. But that, he wanted very little to be distinguished. He wanted these things noticed very, very little. He didn't want feats of lighting. He wanted above all, you've noticed, one is always . . . one hesitates always. One doesn't know where the dream is, except for the two, the first dream. When there is . . . it's really precise, where the man, the first tells the dream . . . his dream, when he returns, you understand, he's at the point of death, and the second, the second dream also which is told, with . . . the soldier. These are two very precise things. These are known, but before, you don't know, you

realize that this was a dream and the second time a dream of a dream. See. So that's an artifice which is very beautiful, and which is thrilling because we made this film very quickly.

SR: Does he always work quickly?

ER: Very quickly, with Luis Buñuel it's really a precision . . . when he has said so many days, it's so many days, so many minutes per day, precise, with his television monitor and we fixed up aviation earphones and he directed [*mettait en scène*] on his monitor. This was fantastic for him. He found a youthfulness again, because he heard very well. The boom operator was always on duty during the whole film so that he could hear everything that went on on the set. There were several times, he would sometimes bang on his, at his post, it was extraordinary. The atmosphere was wonderful. But I confess that . . . in another kind of idea, all the same, with René Clément, the film that we made with René Clément, who has a mathematical precision. And he demands a precision. That's completely, see, he demands another style also, it's another style. It's also a thing . . . a great experience for me.

SR: It seems to me that you search for those things, how shall I say, the most difficult to do.

ER: Yes, yes, listen, there's a sort of fatality. It always falls on my shoulders, things where there are problems. I don't know, it's a fatality. Besides, I remember Jerry Lewis came here, and with Jerry Lewis it was unforgettable, in the 10 days that I was with him, I also learned an enormous number of things. It was wonderful. We did, in the winter circus, some incredible acrobatics. He was also quite a person.

SR: Well, it's not a question of style but of finding directors who present challenges?

ER: Yes, that's correct, but of course I don't know exactly how that happens, I don't look for it, but it happens. It's very exciting to work with people who present problems. It's the same with a short I'm making for the Germans with a helicopter. And also for a film that I made with a Swiss director in Japan on the parallels between the two theaters, the Kabuki and the modern, it was extraordinary.

Edmond Richard

Features as cameraman:

1962 *Le Procès* (d. Orson Welles)
1966 *Chimes at Midnight* (d. Orson Welles)
 De l'amour (d. Jean Aurel)
1968 *L'Astragale* (d. Guy Casaril)

1967 *Manon 70* (d. Jean Aurel)
1969 *Cervantes (Young Rebels)* (d. Vincent Sherman)*
 Sex Power (d. Henry Chapier)
1970 *Fantasia chez les Ploucs* (d. Gérard Pires)
1972 *Le Charme discret de la bourgeoisie* (d. Luis Buñuel)*
1974 *Fantôme de la liberté* (d. Luis Buñuel)*

Notes

Chapter 2

1. *Telehor*, 1–2 (Czechoslovakia, 1936), p. 33.

2. *Film Form*, ed. and trans. Jay Leyda (Cleveland, 1957), p. 39.

3. Ibid., p. 40.

4. Ibid., p. 42.

5. (New York, 1973), p. 310.

6. XIII, No. 1 (Winter, 1972). XVI, No. 3 (Autumn, 1975).

7. *Signs and Meanings in the Cinema* (London, 1970), p. 164.

8. Trans. M.D. Hottinger (U.S.A.), p. 6.

9. *The Cinema as a Graphic Art*, trans. Stephen Garry (New York), p. 158.

10. (Boston, 1970), p. 10.

11. Ibid., p. 15.

12. *Linguistics and Style* (London, 1964).

13. (Paris, 1973).

14. "Defining Style," p. 12.

15. Ibid., p. 13.

16. Ibid., p. 23.

17. Ibid., p. 28.

18. Ibid.

19. Ibid., p. 32.

20. *Linguistics*, p. 54.

21. Ibid., p. 52.

22. "Defining Style," p. 34.

Chapter 3

1. "Style and Medium in the Moving Pictures," *Film, an Anthology*, ed. Daniel Talbot (Berkeley, 1969), p. 32.

2. *Illuminations* (New York, 1973), pp. 217–51.

3. Michael Taylor, trans. *Film Language, a Semiotics of the Cinema* (New York), p. 98.

4. *Communications* 15, 1970, pp. 11–51.

5. "Messages," p. 15. The translation is taken from *Film Language*, pp. 76–77. When possible I have used this text as the source for translations of Metz. Where no English source exists, the translations of French texts are my own.

6. "Messages," p. 14.

7. Ibid.

8. Ibid., p. 36.

9. Ibid., p. 38.

10. Ibid., p. 40.

11. Ibid.

12. Eco, *Theory of Semiotics*, p. 33.

13. *Knokke-Heist Catalog*, Fifth International Experimental Competition, 1974, p. 46.

14. *Painting, Photography, Film* (Cambridge, 1973), p. 28.

15. *Art and Visual Perception, A Psychology of the Creative Eye* (Berkeley, 1974), p. 314.

16. Arnheim, p. 321.

17. *Film Language*, p. 97.

18. "La connotation, de nouveau (1971)," *Essais sur la signification du Cinéma*, v II, (Paris, 1972), p. 164.

19. *Film Language*, p. 96.

20. Ibid.

21. Ibid., p. 97.

22. "Connotation," p. 169.

23. *Elements of Semiology* (Boston, 1970), p. 45.

24. Ibid., p. 91.

Chapter 4

1. (New York, 1972).

2. pp. 73–74.

3. Charles Higham (Bloomington, 1970), p. 35.

4. Ibid., p. 73.

5. *Visual Perception*, p. 315.

Chapter 5

1. Two sources have been combined to provide the information presented in this section: Jacques Siclier, *Nouvelle Vague?* (Paris, 1961), p. 39, and Georges Sadoul, *Le Cinéma Français* (Paris, 1962), pp. 101–02.

2. Sadoul, p. 103.

3. *Cahiers du Cinéma*, X (Jan. 1954), pp. 45–46.

4. "Les Nègres de la rue Blanche," *Cahiers du Cinéma*, VII (August–Sept. 1954), p. 38. All translations from *Cahiers* are my own.

5. *What is Cinema?* II (Berkeley, 1971), p. 33.

6. *Cahiers du Cinéma*, VIII (Apr. 1955), p. 46.

7. Ibid., p. 15.

8. J.A. Place and L.S. Peterson, "Some Visual Motifs of Film Noir," *Film Comment* (Jan.-Feb., 1974), p. 30.

9. No. 20 (1959), p. 39.

10. Ibid.

11. Ibid., p. 40.

12. Ibid., p. 39.

13. *Hollywood Cameramen*, p. 24.

14. Ibid., p. 35.

15. Ibid., p. 14.

16. Ibid., p. 75.

Chapter 6

1. Cited by Annette Kuhn, "Trotting Out the Blue Riders," *The Village Voice* (May 23, 1977), p. 73.

2. Jean Renoir, *Renoir, My Father*, trans. Randolph and Dorothy Weaver (Boston, 1962), p. 243.

3. Ibid., Chapter VII, p. 251.

4. Ibid., p. 252.

5. "Light of Day," *Sight and Sound*, XXXV:1 (Winter, 1965–66), p. 10.

6. *Hollywood Cameramen*, p. 55.

7. *AFI Dialogue on Film*, III:7 (July, 1974), p. 42.

8. *Linguistics and Style*, p. 28.

9. Ibid.

Bibliography

Serial Publications

Almendros, Nestor. "Neorealist Cinematography." *Film Culture* 20 (1959), 39–43.

Barthes, Roland, "Rhétorique de l'image." *Communications* 4 (novembre, 1964), 40–51.

Baxter, Peter. "On the History and Ideology of Film Lighting." *Screen* 16 (Autumn, 1975), 83–106.

Bitsch, Charles. "Rendons à John Alton." *Cahiers du Cinéma* 10 (janvier, 1956), 45.

"Checklist 32—Jean Rabier." *Monthly Film Bulletin* 32: 383, 188.

"Checklist 88—Willy Kurant." *Monthly Film Bulletin* 39: 463, 178.

"Le Cinémascope—Lo Duca: Quelques notes; François Truffaut: En avoir plein la vue; Jean-Jose Richer et Michel Dorsday: Dimensions et proportions." *Cahiers du Cinéma* 5 (juillet, 1953), 20–25.

"Le Cinémascope—Maurice Schérer: Vertus cardinales du cinémascope; Herman G. Weinberg: Ipso Facto, Alexandre Astruc: Le Cinéma total; Jacques Doniol-Valcroze: Operation Chrétien; André Bazin: Fin du montage; Michel Dorsday: Allelula; Jacques Rivette: L'Age des metteurs en scène." *Cahiers du Cinéma* 6 (janvier, 1954), 36–48.

Eco, Umberto. "Semiologie des messages visuels." *Communications* 15 (1970), 11–51.

Eikhenbaum, Boris. "Problems of Film Stylistics." *Screen* 15 (Autumn, 1974), 7–32.

"Entretien avec Jean Rabier." *La Revue du Cinéma* 243 (novembre, 1970), 88–91.

Eyman, William Scott, interviewer. "James Wong Howe." *Take One* 3 (March-April, 1972), 18–22.

——————. "On and Off Poverty Row: Scott Eyman Interviews William Clothier." *Take One* 4 (Nov.-Dec., 1973), 8–14.

Fieschi, Andre, and Mark Shivas. "Interview with Claude Chabrol." *Movie* 10, 16–20.

Goodwin, Michael. "Camera: Laszlo Kovacs." *Take One* 2 (July-Aug., 1970), 12–16.

"Great Cameraman." *Focus on Film* 13. Special Issue.

Higham, Charles, and Joel Greenberg. "North Light and Cigarette Bulb, Conversations with Cameramen." *Sight and Sound* 36, 192–96.

Hudson, Roger. "The Secret Profession, Roger Hudson Interviews Two Lighting Cameramen." *Sight and Sound* (Summer, 1965), 112–17.

"Interview with Nestor Almendros." *Film Dope* 1, December 1972.

Kernan, Margot S. "La Femme Infidèle." *Film Quarterly* 23, 56–58.

Koszarski, Richard, compiled and introduced. "The Men with the Movie Cameras, Sixty Filmographies." *Film Comment* 8, 27–57.

——————. "Moving Pictures: Hal Mohr's Cinematography." *Film Comment* 10, 48–53.

Langlois, Gérard. "Les montreurs d'ombres: I Henri Alekan, Ampère-Maître." *Lettres Françaises*, 1343 (5–21, juillet, 1970), 14–16.

——————. "Les montreurs d'ombres: II Henri Decae, l'accoucheur de la nouvelle vague." *Lettres Françaises*, 1344 (22–26 juillet, 1970), 16–17.

——————. "Les montreurs d'ombres: III Sacha Vierny 'ouvrir l'oeil.'" *Lettres Françaises*, 1345 (29 juillet-4 août, 1970), 16, 18.

_____. "Les montreurs d'ombres, Hommes-caméras: IV Jean Boffety, V Willy Kurant." *Lettres Françaises* 1346 (5–18 août, 1970), 13–14.

_____. "Les montreurs d'ombres, IV [should be VI] Alain Derobe: 'Ne pas croire au mystère de la photo.' " *Lettres Françaises*, 1348 (26 août-1 septembre, 1970).

_____. "Les montreurs d'ombres, VII Denys Clerval: vers l'avenir." *Lettres Françaises* 1349 (2–8 septembre, 1970), 18.

_____. "Les montreurs d'ombres, VIII Nestor Almendros: L'homme aux miroirs." *Lettres Françaises* 1352 (23–29 septembre, 1970) 18–19.

_____. "Les montreurs d'ombres, IX Roger Fellous: une visée électronique." *Lettres Françaises* 1354 (7–13 octobre, 1970) 17.

_____. "Les montreurs d'ombres, X Edmond Richard: Au royaume des inventeurs." *Lettres Françaises* 1356, (21–27 octobre, 1970) 17.

Levitin, Jacqueline. "Mother of the New Wave: An Interview Agnes Varda." *Women and Film*, 62–66.

Metz, Christian. "The Imaginary Signifier." *Screen* 16 (Summer, 1975), 14–76.

Michener, Charles. "Hollywood's Image Makers." *Newsweek* (July 22, 1974) 65, 68.

Milne, Tom. "De L'Amour." *Sight and Sound* 35 (Summer, 1966), 148–49.

Nogueira, Rui, and Nicoletta Zalaffi. "Conversation with Chabrol." *Sight and Sound* 40 (Winter, 1970–71), 2–6.

Ogle, Patrick. "Technological and Aesthetic Influences Upon the Development of Deep Focus Cinematography in the United States." *Screen* 13 (Winter, 1972), 45–72.

Overby, David. "Chabrol's Game of Mirrors." *Sight and Sound* 46 (Spring, 1977), 78–81, 99.

Place, J. A., and L. S. Peterson. "Some Visual Motifs of Film Noir." *Film Comment* 10 (Jan.-Feb., 1974), 30–35.

Prédal, René. "Les Grand Operateurs." *Cinéma 72* 168 (juillet), 84–113.

_____. "Les Grand Operateurs." *Cinéma 72* 171 (décembre), 101–16.

_____. "Les Grands Operateurs." *Cinéma 73* 172 (janvier), 94–105.

_____. "Les Grands Operateurs." *Cinéma 73* 173 (février), 87–95.

Renoir, Claude. "Problèmes d'opérateur ou écrire pour ne rien dire." *Cahiers du Cinéma* 11 (janvier, 1952), 41–43.

Rivette, Jacques. "Lettre sur Rossellini." *Cahiers du Cinéma* 8 (avril, 1955), 14–24.

Schrader, Paul. "Notes on Film Noir." *Film Comment* 8 (Spring, 1972), 8–13.

Schwartz, Howard, interviewer. "Cinematographer Conrad Hall." *AFI Dialogue on Film* 3 (October, 1973), entire issue.

Truffaut, François. "Les Nègres de la rue Blanche." *Cahiers du Cinéma* 7 (aout-septembre, 1954), 48.

Turim, Maureen. "The Aesthetic Becomes Political—a History of Film Criticism in *Cahiers du Cinéma*." *The Velvet Light Trap* 9, 13–17.

Vaughan, Dai. "The Space Between the Shots." *Screen* 15 (Spring, 1974), 73–85.

"Vilmos Zsigmond Seminar." *AFI Dialogues on Film* 3 (July, 1974), 40–44.

Wood, Robin. "Arthur Penn in Canada." *Movie* 18, 26–36.

Books

Allen, Don. *Truffaut*. New York, 1974.

Alton, John. *Painting with Light*. New York, 1950.

Armes, Roy. *French Cinema Since 1946*. 2 vols. New Jersey, 1970.

Arnheim, Rudolph. *Art and Visual Perception, A Psychology of the Creative Eye*. Berkeley, 1974.

Balshofer, Fred J., and Arthur C. Miller. *One Reel a Week.* assisted by Bebe Bergsten, foreword by Kemp R. Niver. Berkeley, 1967.

Barthes, Roland. *Elements of Semiology.* Boston, 1970.

————. *Writing Degree Zero.* Boston, 1970.

Bazin, André. *What is Cinema?* selected and trans. Hugh Gray. Berkeley, 1967.

————. *What is Cinema?* vol. 2. selected and trans. Hugh Gray. Berkeley, 1971.

Benjamin, Walter. *Illuminations.* New York, 1973.

Bessy, Maurice. *Orson Welles.* New York, 1971.

Bitzer, Billy. *Billy Bitzer His Story—The Autobiography of D.W. Griffith's Master Cameraman.* New York, 1973.

Braucourt, Guy. *Claude Chabrol.* Paris, 1971.

Bresson, Robert. *Notes on Cinematography,* trans. Jonathan Griffin. New York, 1977.

Brown, Karl. *Adventures with D.W. Griffith.* ed. and intro. Kevin Brownlow. New York, 1973.

Cameron, Ian, ed. *The Films of Robert Bresson.* London, 1969.

Campbell, Russell, comp. and ed. *Photographic Theory for The Motion Picture Cameraman.* New York, 1970.

————. *Practical Motion Picture Photography.* New York, 1970.

Clair, René. *Cinema Yesterday and Today.* trans. Stanley Appelbaum, ed. and intro. R. C. Dale. New York, 1972.

Clouzot, Claire. *Le Cinéma Français depuis la nouvelle vague.* Paris, 1972.

Collet, Jean. *Le Cinéma en question.* Paris, 1972.

————. *Jean-Luc Godard.* New York, 1970.

Crisp, C. G. *François Truffaut.* New York, 1972.

Durgnat, Raymond. *Nouvelle Vague the First Decade.* England, 1963.

Eco, Umberto. *A Theory of Semiotics.* Bloomington, 1976.

Eisenstein, Sergei. *Film Form* and *The Film Sense.* ed. and trans. Jay Leyda. Cleveland, 1957.

Enkvist, Nils Erik. *Linguistics and Stylistics.* Paris, 1973.

————, John Spencer, Michael J. Gregory. *Linguistics and Style.* London, 1964.

Gibbs, C. Ryle. *Dictionnaire Technique du Cinéma.* Paris, 1959.

Gilson, Rene. *Jean Cocteau.* New York, 1969.

Godard, Jean-Luc. *Godard on Godard.* trans. and commentary Tom Milne, ed. Jean Narboni and Tom Milne. New York, 1972.

Graham, Peter. *The New Wave.* New York, 1968.

Hennebelle, Guy. *Quinze ans de cinéma mondial.* Paris, 1975.

Higham, Charles. *Hollywood Cameramen: Sources of Light.* Bloomington, 1970.

Leprohon, Pierre. *Hommes et métiers de cinéma.* Paris, 1967.

————. *The Italian Cinema.* trans. Roger Greaves and Oliver Stallybrass. London, 1972.

————. *Les mille et un métiers du cinéma.* Paris, 1947.

Lévi-Strauss, Claude. *The Raw and the Cooked, Introduction to the Science of Mythology:1,* trans. Johan and Doreen Weightman. New York, 1969/70.

Lukacs, Georg. *Marxism and Human Liberation.* ed. and intro. E. San Juan, Jr. New York, 1973.

Maltin, Leonard. *Behind the Camera: The Cinematographer's Art.* New York, 1971.

Martin, Marcel. *France.* New York, 1971.

McBride, Joseph. *Orson Welles.* New York, 1972.

McCall, Anthony. *Knokke-Heist Catalog.* Fifth International Experimental Film Competition. Belgium, 1974. Entry 46.

Metz, Christian. *Essais sur la signification au cinéma.* 2 vols. Paris, 1971, 1972.

_____. *Film Language, A Semiotics of Cinema.* trans. Michael Taylor. New York, 1974.

Millerson, Gerald. *The Technique of Lighting for Television and Motion Pictures.* New York, 1972.

Mitry, Jean. *Esthetique et psychologie du cinéma.* 2 vols. Paris, 1963, 1965.

Moholy-Nagy, Laszlo. *Painting, Photography, Film.* trans. Janet Seligman. Cambridge, Mass., 1973.

_____. *Telehor 1–2.* Czechoslovakia, 1936.

Nilsen, Vladimir. *The Cinema as a Graphic Art.* trans. Stephen Garry. New York.

Nogueira, Ruy. *Melville.* New York, 1971.

Panofsky, Erwin. "Style and Medium in the Moving Pictures." *Film: An Anthology.* ed. and comp. Daniel Talbot. Berkeley, 1969. 15–32.

Petrie, Graham. *The Cinema of François Truffaut.* New York, 1970.

Renoir, Jean. *Renoir, My Father.* trans. Randolph and Dorothy Weaver. Boston, 1962.

Roud, Richard. *Godard.* Bloomington, 1970.

Sadoul, Georges. *Dictionnaire des Cinéastes.* Paris, 1965.

_____. *Dictionnaire des Films.* Paris, 1965.

_____. *Le Cinéma Français (1890–1962).* France, 1962.

Siclier, Jacques. *Nouvelle Vague?* Paris, 1961.

Sontag, Susan. *Against Interpretation.* New York, 1966.

Sternberg, Joseph von. *Fun in a Chinese Laundry.* New York, 1973.

Wagner, Jean. *Jean-Pierre Melville.* Paris, 1963.

Wood, Robin and Michael Walker. *Claude Chabrol.* New York, 1970.

Wolfflin, Heinrich. *Principles of Art History, The Problem of the Development of Style in Later Art.* trans. M. D. Hottinger. U.S.A.

Wollen, Peter. *Signs and Meanings in the Cinema.* London, 1970.

Young, Freddie, and Paul Petzold. *The Work of the Motion Picture Cameraman.* London, 1972.

Index